IMAGES
of America

TRIGG COUNTY

The Scenery is Fine Here at

CADIZ

You'd Enjoy it Immensely

This scenic *c.* 1910 postcard is representative of many similar styles used when postcard sending and collecting was a popular hobby. It is fortunate for postcard collectors today that this style was popular; the images relate the stories that words cannot. (Courtesy William Turner.)

ON THE COVER: In May 1905, road workers Garland Cunningham and Edd Hall are pictured with others including (in no order) Lena Peal, Ida Leneave, Otho Bruce, Lina Hall, Dora Cunningham, Vivian Bruce, Dorene Cooper, and Watt Lancaster. The road crew has been operating the county's first road-grader, a horse-drawn steel reversible road machine, in the Trigg Furnace community north of Rockcastle. The two-story frame Hillman Home was built atop the hill around 1850 by Daniel Hillman. It featured both front and side double porticoes, six-over-six window sashes, and shutters—typical architecture of the era. Daniel Hillman occupied the home until his death in 1885. His widow, Mary, remained in the home until her death in 1908. (Courtesy William Turner.)

IMAGES
of America

TRIGG COUNTY

Thomas D. Harper
Foreword by William T. Turner

ARCADIA
PUBLISHING

Published by Arcadia Publishing
Charleston, South Carolina

Library of Congress Control Number: 2010937036

For all general information, please contact Arcadia Publishing:
Telephone 843-853-2070
Fax 843-853-0044
E-mail sales@arcadiapublishing.com
For customer service and orders:
Toll-Free 1-888-313-2665

Visit us on the Internet at www.arcadiapublishing.com

Images of America: Trigg County is dedicated to my daughters, Riley Elizabeth Harper and Addison Jane Harper, so that they may learn to honor and share the rich heritage of their home; to my wife, Sarah Slaughter Harper, for her love, support, and encouragement; and to my grandmother Frieda Bridges Sumner, for inspiring my curiosity and love for history and family.

CONTENTS

ACKNOWLEDGMENTS

The author would like to extend his appreciation to all who have provided photographs, historical information, and encouragement during the preparation of this publication; it has truly been a labor of love. It is his sincere hope that this book will become a valuable tool in the preservation and future research of the history of Trigg County. While all who have aided in this process are appreciated, special thanks is extended to the following. Without these devoted friends and family, this publication would not have been possible: William Turner; Frieda Sumner; Sarah, Riley, and Addison Harper; Janie Sumner; Miller and Nan Slaughter; Anita Harper; and the Trigg County Historical and Preservation Society. Unless otherwise noted, all images are courtesy of the author's family.

FOREWORD

It has been a privilege to witness the efforts of Thomas Harper, a student of history, as he has chronicled the progression of Cadiz and Trigg County, Kentucky, through three centuries of its history, landmarks, people, and their culture.

In this year, 2011, Trigg County and Cadiz mark the 191st anniversary of their creation. This historian considers with pride the fact that he is a descendant of 11 pioneer settler families who came to call Trigg County home, some even before it was created. Descent from the Turner, Blakeley, Goodwin, Haggard, Atwood, Franklin, Huggins, Bogard, Griffin, Cook, and Rogers families has instilled within the emotion of this man a deep and abiding love and appreciation for the heritage of Trigg County.

The motivation for my interest in the county originated with the planting of seeds of inquiry and curiosity by my great uncle, Kentucky state senator Tom Turner, and my great aunt, Anna Rawls Turner, wife of J. Minos Turner. Recognizing a teenager's interest in old photographs, documents, and artifacts, they made a concerted effort to see that their collections of Trigg County's history passed into younger hands.

Through a geographic projection around the county, this book presents a cavalcade of many long-forgotten memories of how the county emerged across the years. It is well written and vividly documented. This Arcadia publication will serve as an outstanding reference for people of all ages interested in Trigg County and will be an exciting addition to any local bookshelf.

Sincere appreciation is expressed to those individuals who shared from their collections the rich photographic legacy of Trigg County. They have made a contribution beyond price.

—William T. Turner
Christian County Historian

INTRODUCTION

When it was created on January 27, 1820, Trigg County became the 66th county in Kentucky. Located on the southwestern edge of the Pennyroyal region, it is bounded by the Tennessee state line to the south and by Kentucky Lake to the west and contains 421 square miles. It was formed principally from Christian County and a small portion of Caldwell County.

The city of Cadiz has served as county seat since May 15, 1820, when it was proposed that the seat of justice of Trigg County be "fixed on the lands of Robert Baker, where he now lives on Main Little River on the top of the eminence above the spring, to include the lot whereon his stable now stands, it being the most central, convenient, and eligible site for that purpose." Baker transferred the stable lot, along with an adjoining 50 acres of land, to the county. The order books, papers, and other important documents of the county were moved to the home of Robert Baker and held there. The choice of Cadiz as the county seat did not go unchallenged, and the decision was put to a vote on March 6, 1822. Three additional sites were surveyed, but ultimately Cadiz was again chosen as the county seat; Cadiz received 295 votes, Boyd's Landing received 204, Warrenton drew 69, and Center received 59. Nearly 100 years later, on November 29, 1920, a fire destroyed most of downtown Cadiz, including the Trigg County Courthouse. This was the second time the county courthouse had been destroyed by fire; a previous courthouse was burned by Confederate soldiers in the spring of 1865.

Though the industry has changed significantly over the years, the primary employment source in Trigg County has always been agriculture. Many Trigg County farmers now hold full-time employment off the farm and maintain their farming operations on the side. As agriculture has evolved in recent decades, larger farming operations have become the norm, and small family farms have largely become a part of the past. Today, in addition to farming, many Trigg County residents work in manufacturing. Trigg County has been slowly moving closer to urban centers in the Pennyroyal region for decades through the innovations of 20th-century transportation. Steamboats were vital in the county's early iron industry but were largely replaced by railroad and automobile traffic as rails and roads connected the citizens of the county to Hopkinsville, Paducah, and other urban centers. Transportation continued to modernize the region with the building of the interstate highway system, including I-24, which connects Trigg County to its largest neighbor, Nashville, Tennessee, and makes the community a gateway to the south.

Beginning in the 1920s, the U.S. government began acquiring land in Trigg County for military and civilian uses, including Fort Campbell. In the middle of the century, construction began on dams that would flood the Cumberland and Tennessee Rivers in Trigg County, creating a source of affordable electric power and displacing hundreds of Trigg Countians. The creation of Kentucky and Barkley Lakes would create a new industry, tourism, but it would alter the relationship between Trigg Countians and the government for generations.

Trigg County and Cadiz continue to grow and change. This was evident in the heart of downtown as the county courthouse was demolished in October 2007. The demolition of the courthouse has made possible the construction of a new state-of-the-art justice center.

One

BETWEEN THE RIVERS

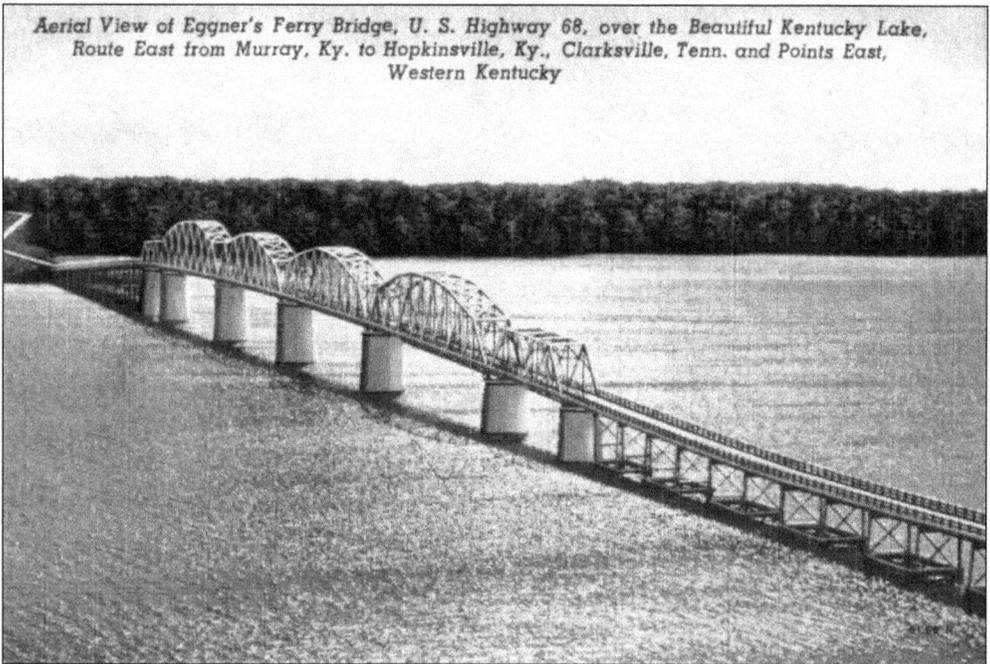

Aerial View of Eggner's Ferry Bridge, U. S. Highway 68, over the Beautiful Kentucky Lake, Route East from Murray, Ky. to Hopkinsville, Ky., Clarksville, Tenn. and Points East, Western Kentucky

Eggner's Ferry Bridge, a two-lane steel and reinforced concrete bridge connecting Marshall and Trigg Counties, was opened on March 25, 1932, before Kentucky Lake was flooded. The bridge was closed for five months in 1943 so that it could be raised to accommodate the waters of the new lake. (Courtesy John L. Street Library.)

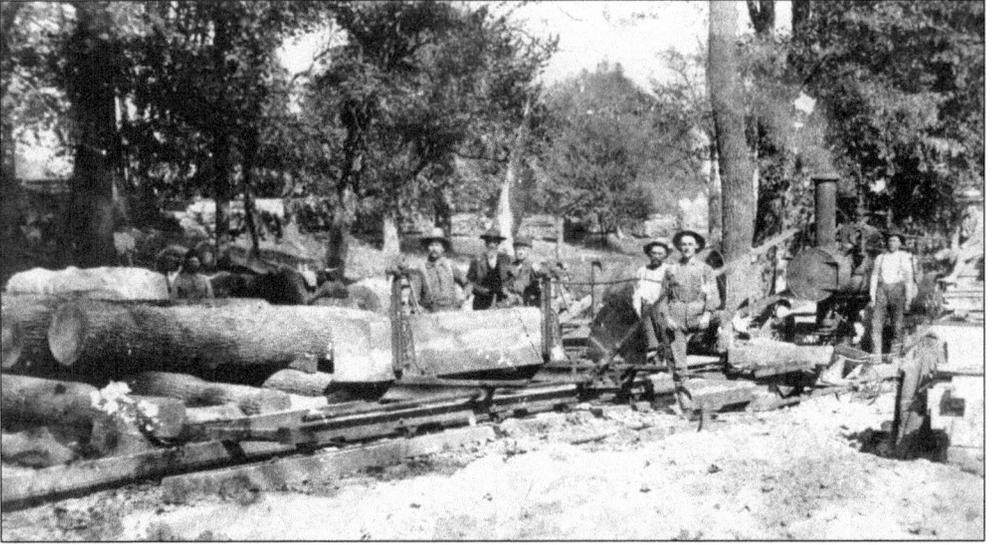

This scene from the Laura Furnace community of Between the Rivers during the early 1900s features a steam-powered sawmill and depicts the common enterprise of converting the region's timber into usable wood products. The harvesting of sapling timber to be rendered into charcoal to fire iron furnaces was vital to the economy of the communities between the Tennessee and Cumberland Rivers—as was the reaping of mature logs that were converted to lumber and cross ties. (Courtesy Jim Wallace.)

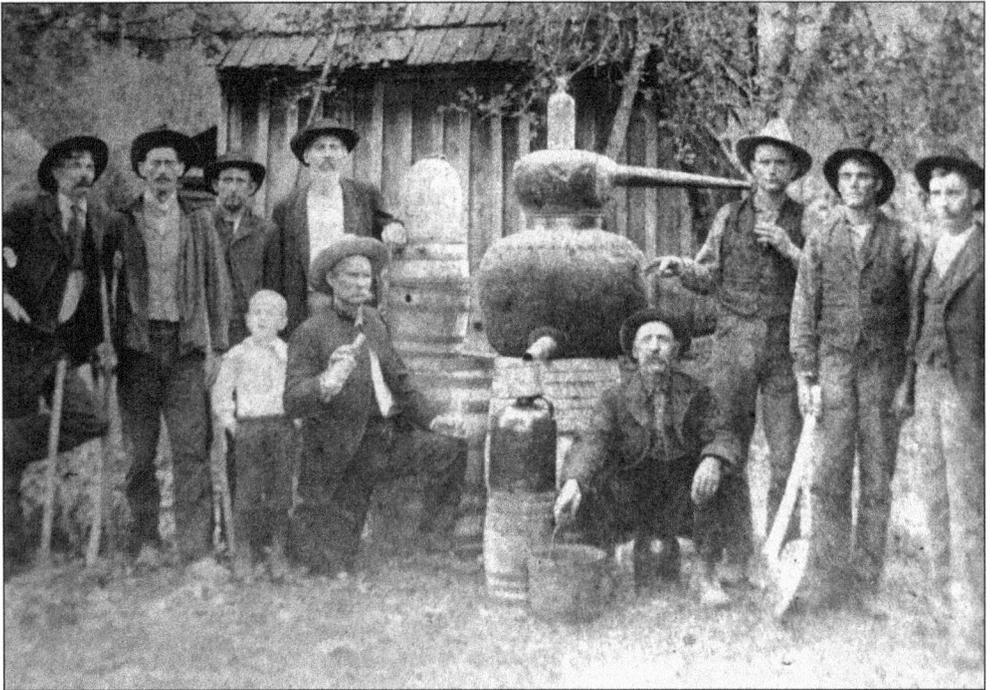

Although Between the Rivers became well known for the quality whiskey it produced in clandestine stills, this c. 1900 image depicts a legal brandy still. Moonshine became a product of only a portion of area residents—and a source of anger and embarrassment for many of those who disapproved of and took no part in the illegal bootlegging. (Courtesy Jim Wallace.)

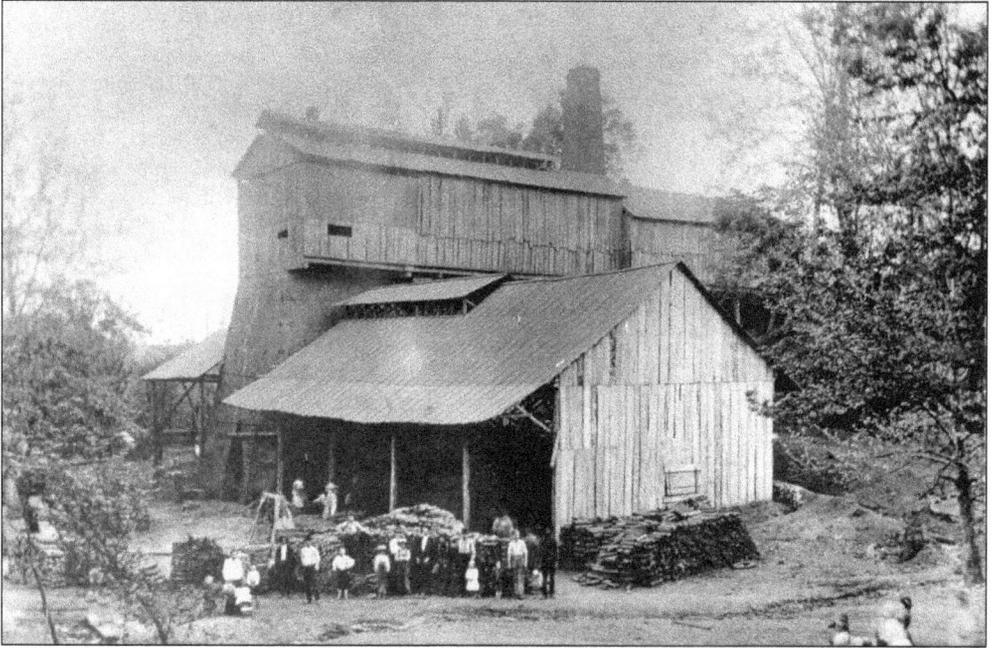

Constructed by Daniel Hillman Jr. west of the Cumberland River in 1852, Center Furnace would come to be called "the granddaddy of them all." Center often employed as many as 100 men. Operations ceased around 1880. The site is near the present location of the Woodland's Nature Center in the Land Between the Lakes National Recreation Area. (Courtesy William Turner.)

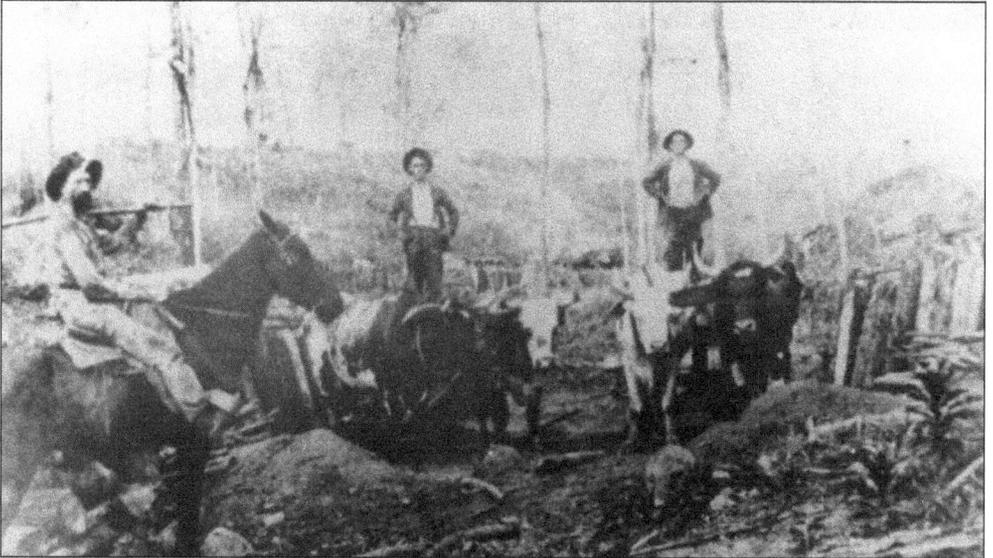

This scene features the laborious "coaling" process. Charcoal, limestone, and iron ore were the three components needed to extract the iron from the ore and separate it from the other elements. Limestone was used in the furnace because it does not burn, and it can withstand the high temperatures required to liquefy the ore. The burning charcoal was the source of the heat that radiated through the limestone and melted the iron ore. The molten iron was poured into molds, creating the pigs that were then shipped to the nearby mills to be used in the manufacture of rails and other iron products of the age. (Courtesy William Turner.)

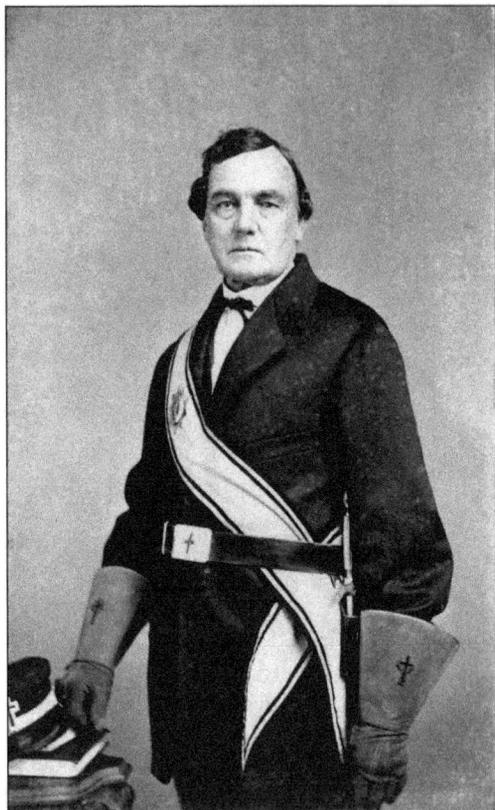

Daniel Hillman Jr. (pictured) and his partner, Dr. Thomas Tennessee Watson, purchased the Tennessee Iron Works in 1846 and relocated it to the east bank of the Cumberland downstream in Lyon County. In 1852, Hillman built Center Furnace west of the Cumberland River in Trigg County. He also built Trigg Furnace near Rockcastle in 1871. Hillman, Fulton, Empire, Center, and Trigg Furnaces would supply the Tennessee Iron Works with pig iron until it was sold in 1880. Daniel died in Hopkinsville on January 3, 1885, at the Western Kentucky Lunatic Asylum. His wife, Mary, ran the business until her death in 1908. (Courtesy Tennessee State Library and Archives.)

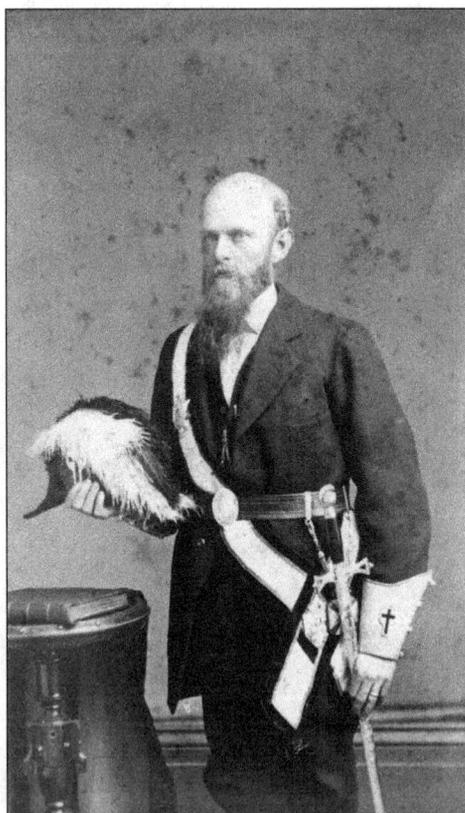

On his 21st birthday, February 2, 1865, Thomas T. Hillman's father presented him with a $50,000 interest in the family business. In 1879, "Tenny" and his wife, Emily, moved to Nashville, where he pursued other business interests. He soon found that he, like his father, had iron in his blood. In a few short months, "Tenny" and Emily were living in Birmingham, Alabama, where he and H. F. De Bardeleben built Alice Furnace. Alice began operation on November 30, 1880, and Thomas was made president and general manager. (Courtesy Tennessee State Library and Archives.)

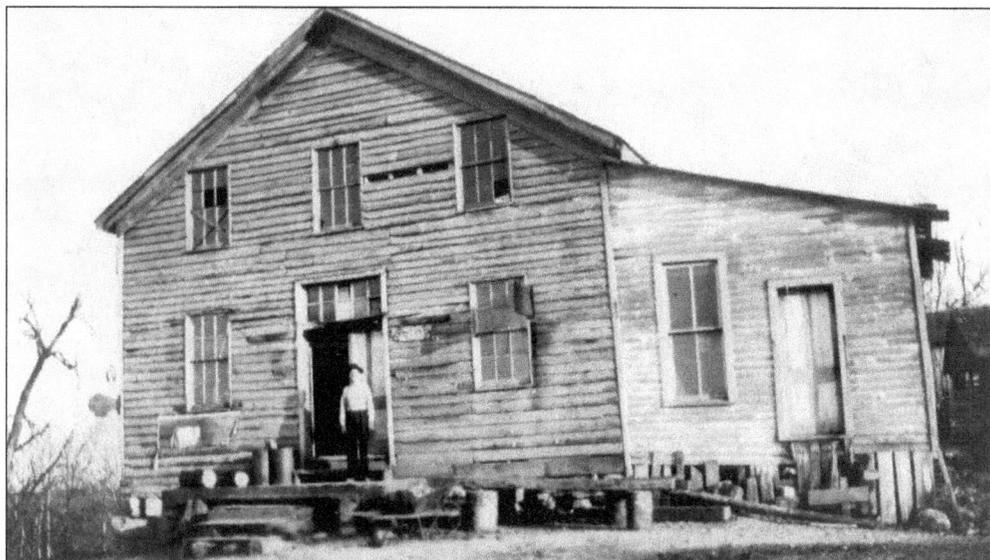

Postmaster Buddy McCauley stands in Hematite Commissary and Post Office. The addition on the right side of the building housed the office of J. Preston White, overseer of the operations at Center Furnace under White, Dixon, & Company, a partnership between White, his father and brother, W.C. White and Ben T. White, and George W. Dixon. The store was in operation from around 1900 to 1912. (Courtesy William Turner.)

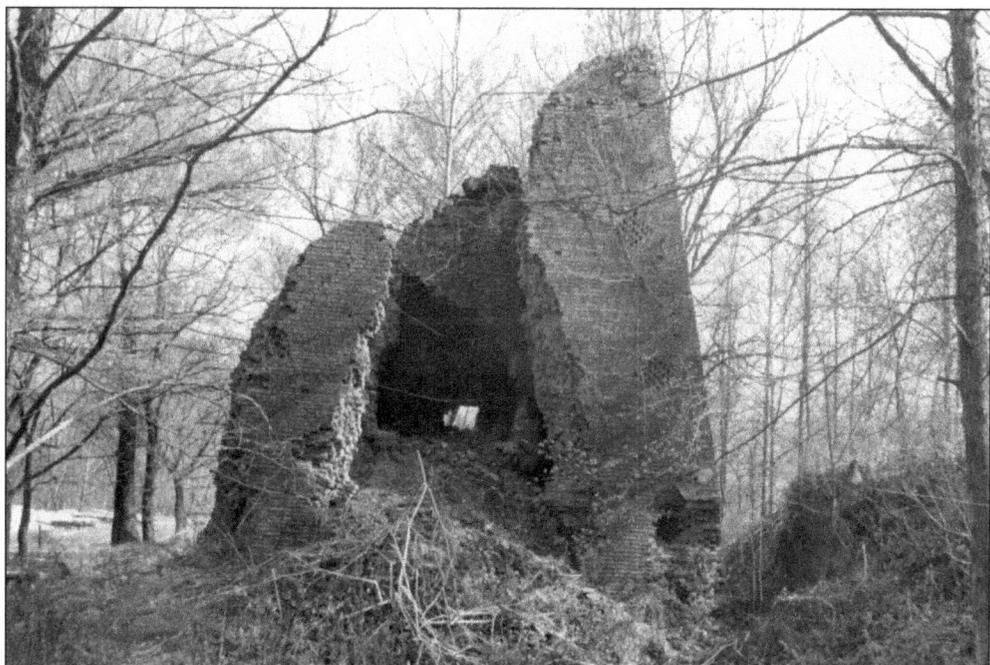

In this c. 1975 photograph, the only thing remaining of Center Furnace is the heart of the furnace, where the fires burned more than a century before. Numerous factors resulted in the decline of the iron industry in Trigg County; among them was the depletion of timber and ore from the land near the furnaces. (Courtesy William Turner.)

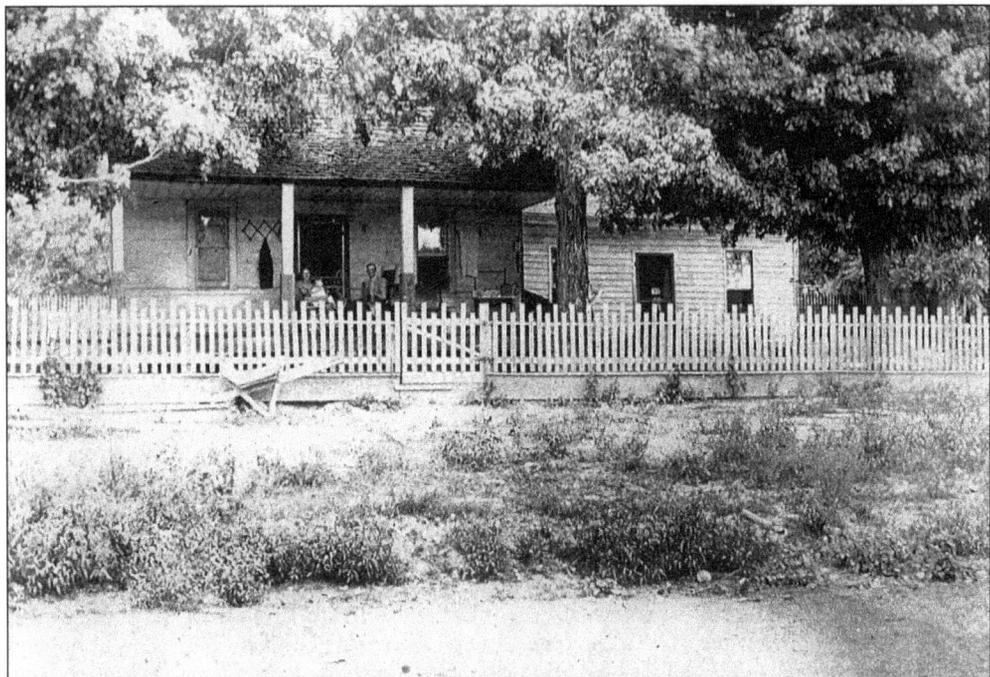

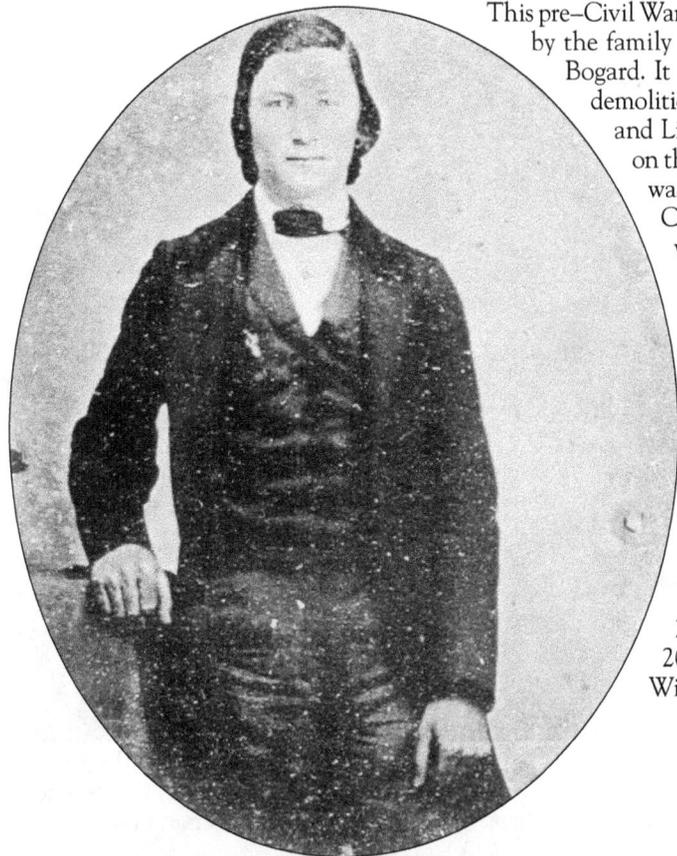

This pre–Civil War frame house was long occupied by the family of Charles and Elitha Griffin Bogard. It is featured above just prior to demolition around 1912, when Charlie and Lizzie Carpenter Wilson, seated on the porch, resided in the home. It was from this "house divided" that Charles Bogard's son, Joe (left), was taken by Civil War guerillas of unknown allegiance, castrated, and hanged—likely in retaliation for the service of one of his older brothers. Joe had remained at home in Golden Pond with his widowed mother while John and William had gone off to war, John wearing gray and William wearing blue. Young Joe's kidnapping and murder occurred on June 22, 1864, one day before his 20th birthday. (Both, courtesy William Turner.)

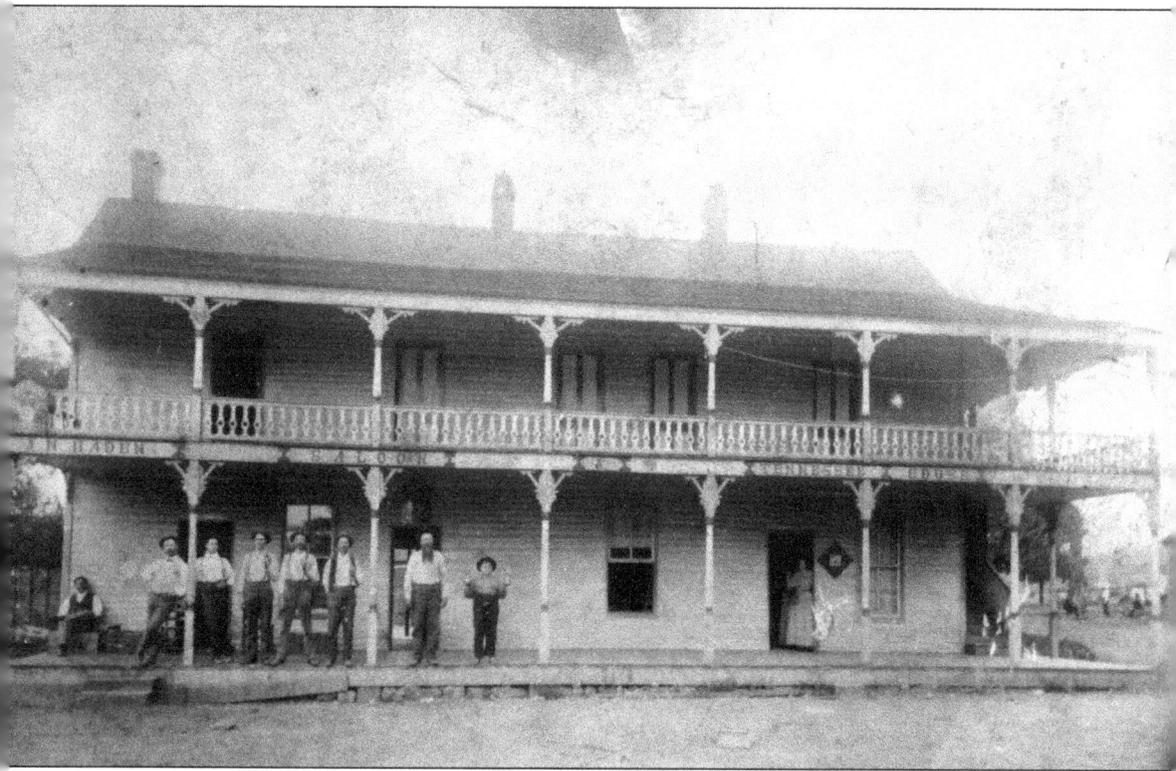

Anchoring the western end of the Golden Pond business district was the Tennessee House, pictured here around 1903. Seen in the photograph from left to right are E. White Rhodes (seated), Dr. John Keeting, Joe Bogard, Willie Williams, saloon-keeper John Collins, Jeff Gatling, proprietor James N. Haden, Carl Futrell, and Amanda Luton Haden (doorway). The Tennessee House, along with most of the Golden Pond business district, was destroyed by fire on August 1, 1936. (Courtesy William Turner.)

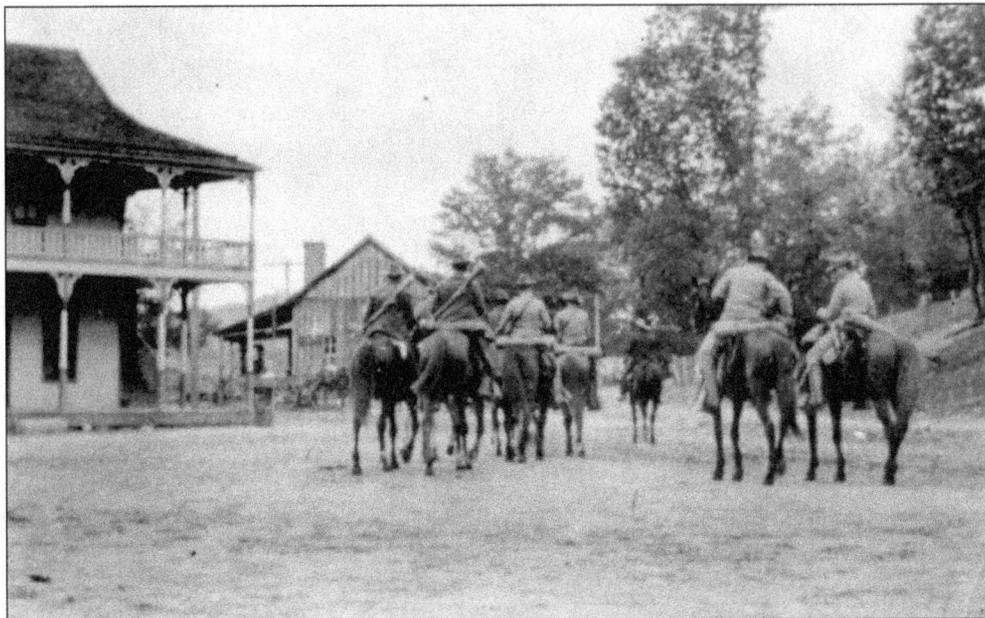

In 1908, the Kentucky Militia, under the command of Capt. E. Walker, camped near Golden Pond to conduct surveillance and patrol the Between the Rivers area for Night Rider activity. Dr. David Amoss of Cobb in neighboring Caldwell County led the Night Riders in a bloody revolt against the impoverishing prices of the tobacco empire led by North Carolina's James B. Duke. (Courtesy Jim Wallace.)

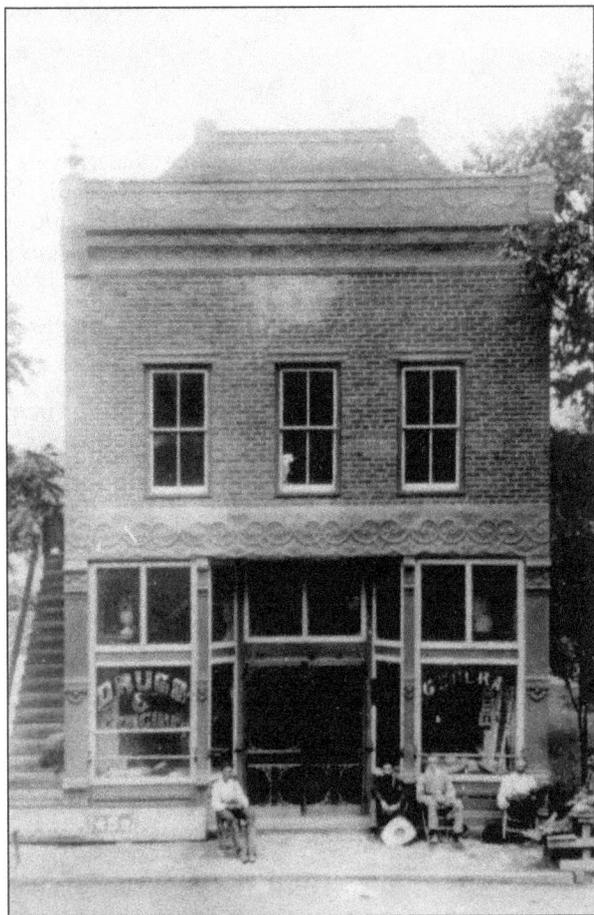

Wilson and Ryan operated as a general mercantile, providing its patrons with almost any item they might need to maintain a household and farm—from groceries and medicines to nails and chicken wire. This early 1900s photograph includes four unidentified individuals sitting in chairs across the front of the store. (Courtesy Jim Wallace.)

Farmer and merchant Taylor Bogard operated Bogard Brothers' general merchandise store with his brother William in the late 1800s. Taylor's son, Joe, operated the business as Bogard and Company following his father's move to California in 1902. This building would later house E. W. Rhodes, W. P. Williams, W. G. Ahart and Sons, and H. B. Leneave and Son. (Courtesy Jim Wallace.)

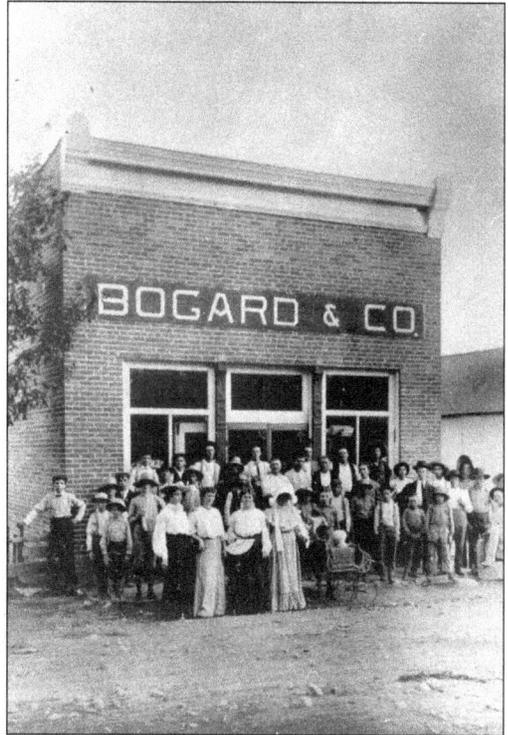

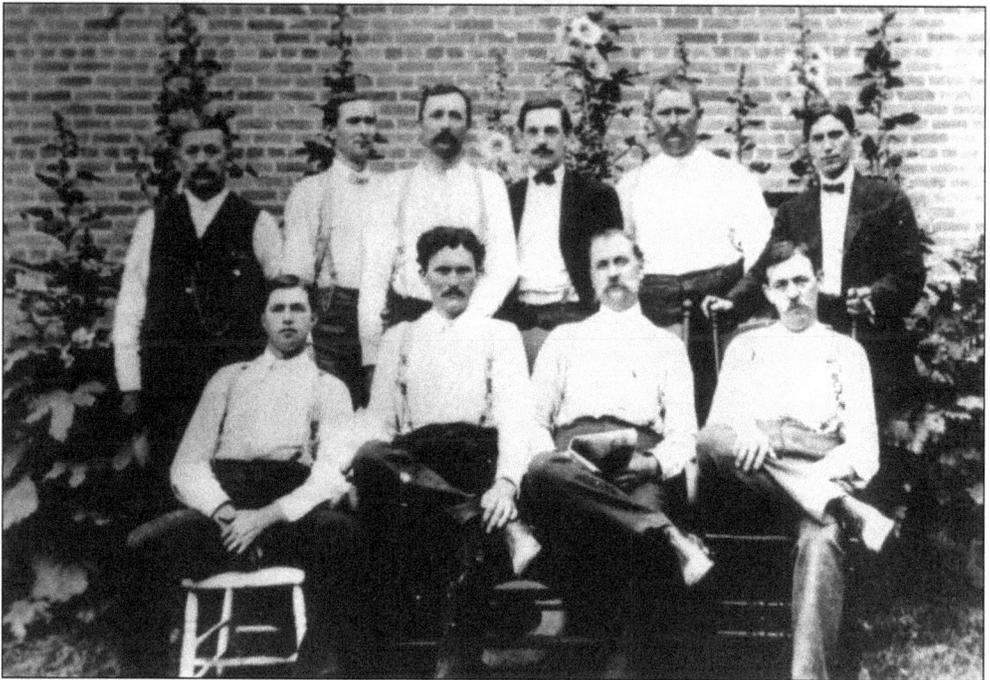

The distinguished gentlemen in this c. 1900 photograph represent the core of the era's farming and business community. From left to right are (seated) Joe Bogard, Jim Lane, J. D. Gatlin, and Ralph Ryan; (standing) E. W. Rhodes, Will Williams, John Collins, Dr. Dabney, Charlie Cunningham, and an unidentified salesman. (Courtesy Jim Wallace.)

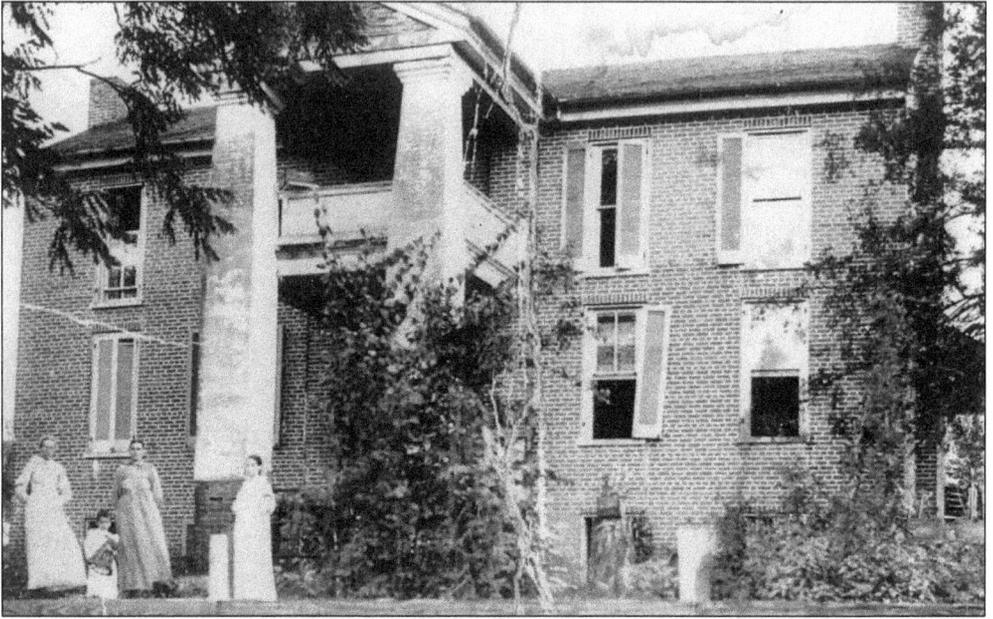

This brick home was constructed around the 1840s and occupied by the Taylor Bogard family from the 1870s until 1902. Bogard's first wife, Georgia Ann Luton, died in 1887, and he married Mary Olive Futrell in 1890. Taylor sold all of his Trigg County property in 1902 and moved with his family to Sebastopol, California. The family later relocated to Woodburn, Oregon, where they owned and operated a general store until Taylor's death in 1923. Taylor and Ollie are interred in the Bogard Cemetery. (Courtesy William Turner.)

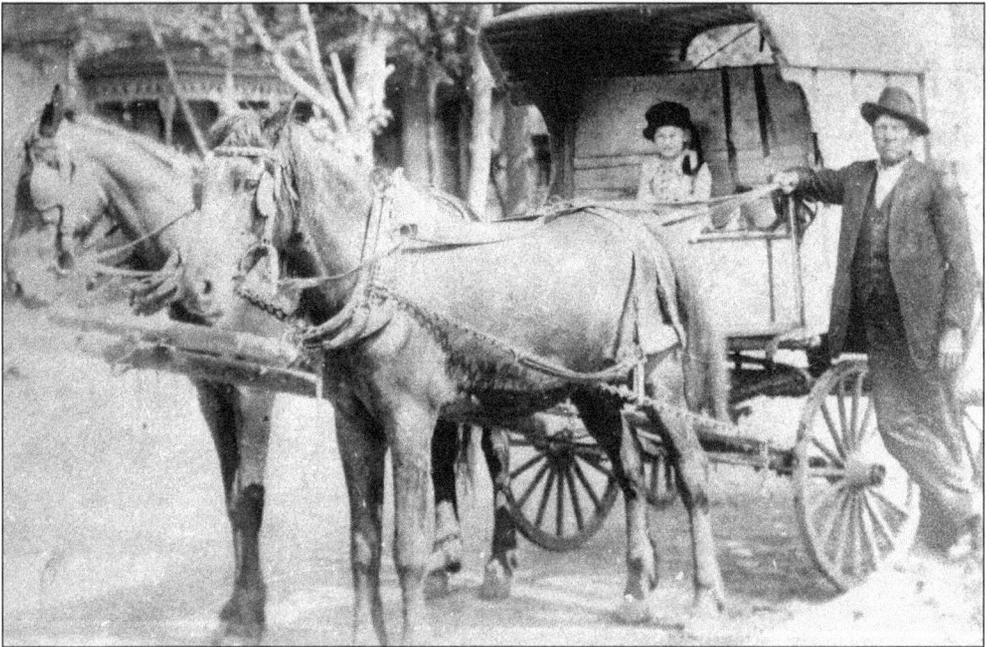

In this 1915 photograph, Ed Morris, mail hack, stands alongside his carriage with an unidentified child. Morris travelled the dirt roads between Golden Pond and Cadiz by horse-drawn carriage, delivering the mail. (Courtesy Jim Wallace.)

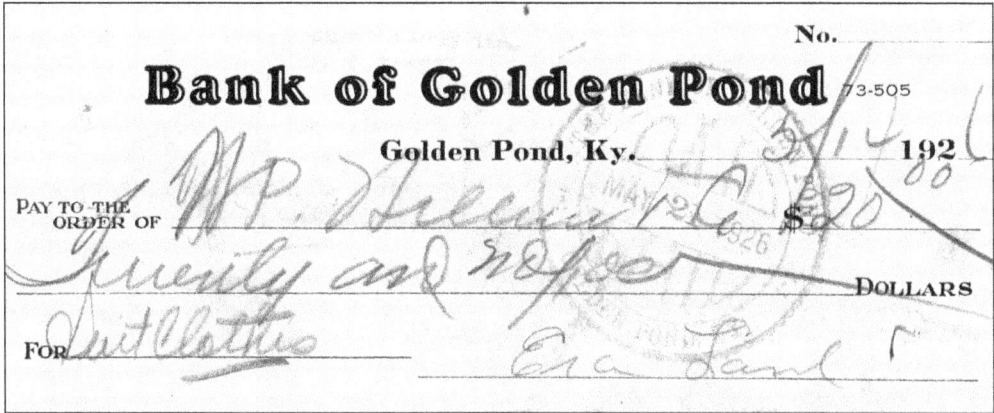

The Bank of Golden Pond was in operation as early as 1907, with a capital stock of $15,000. The bank closed before 1940 due to deficiency of funds caused in part by "suspicious" accounting practices. The check above was issued by Era "Pete" Lane on May 14, 1926, for the purchase of "suit clothes." (Courtesy Mark Lane.)

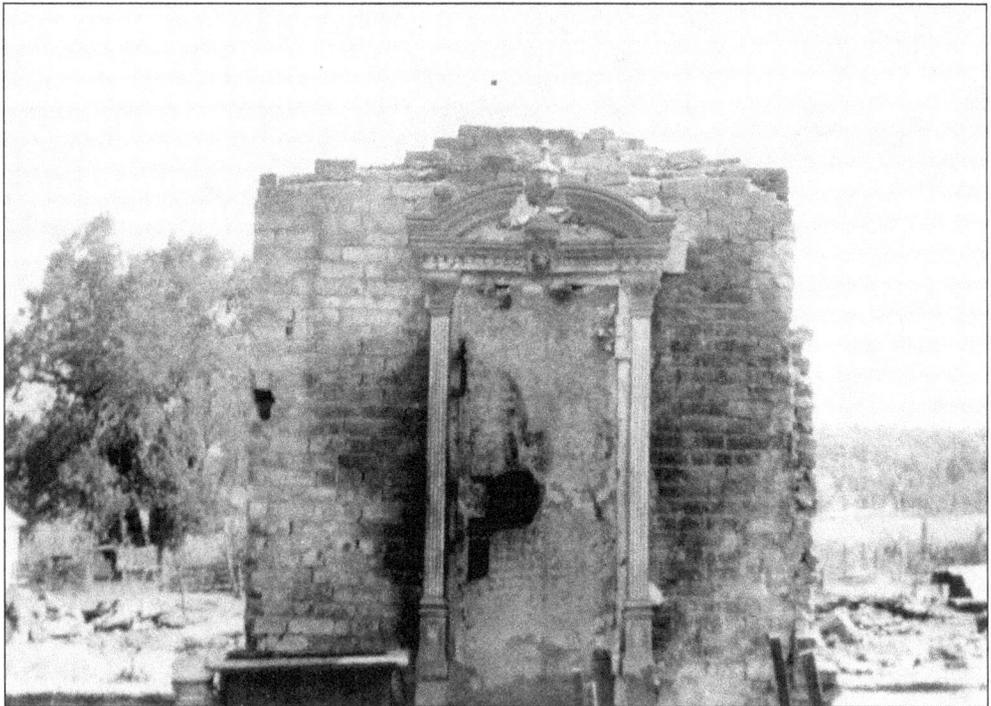

Fire swept the town of Golden Pond on August 1, 1936. Destroyed in the blaze were five business houses, a church, a hotel, a bank, and a lodge building. High winds caused the fire to spread the entire length of the business district west of its source. Most of the buildings were frame structures built after March 1898, when fire had destroyed much of the town. The vault was all that remained of the Bank of Golden Pond. (Courtesy Jim Wallace.)

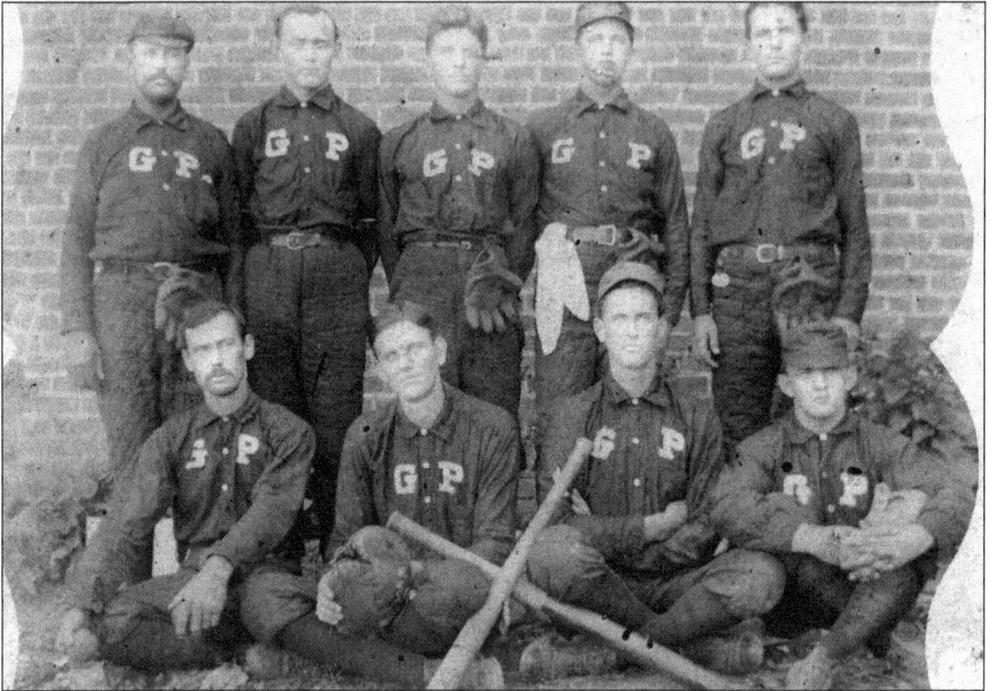

This photograph of the Golden Pond baseball team provides a rare glimpse into the leisure time of these hardworking people. Second from the left on the bottom row is Nile Newton, and second from the left in the top row is Grundie Turner. (Courtesy Jim Wallace.)

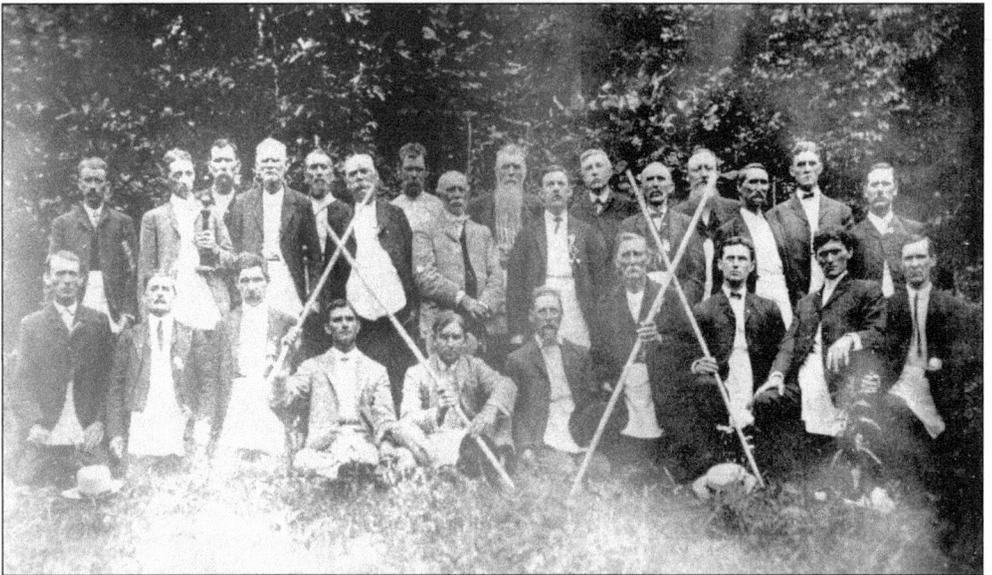

This 1906 gathering of Berkley Lodge No. 567 occurred south of the Woodville Bridge near Golden Pond. Seen here from left to right are (kneeling) Bob Ross, D. D. Creekmur, Henry Luton, George New, Doug Crute, A. T. Lampkins, Sam Ford, Calvert Wallace, Jim Lane, and Will Williams; (standing) Lyn Williams, Bob Williams, A. M. New, Pat Hicks, John Gordon, Bob Newton, Dewitt Luton, Dr. J. H. Lackey, Alex Joyce, Ralph Ryan, John Shaw, L. R. Wallis, Jim Hayden, Cullen T. Bridges, J. C. Lippet, and John Downs. (Courtesy Jim Wallace.)

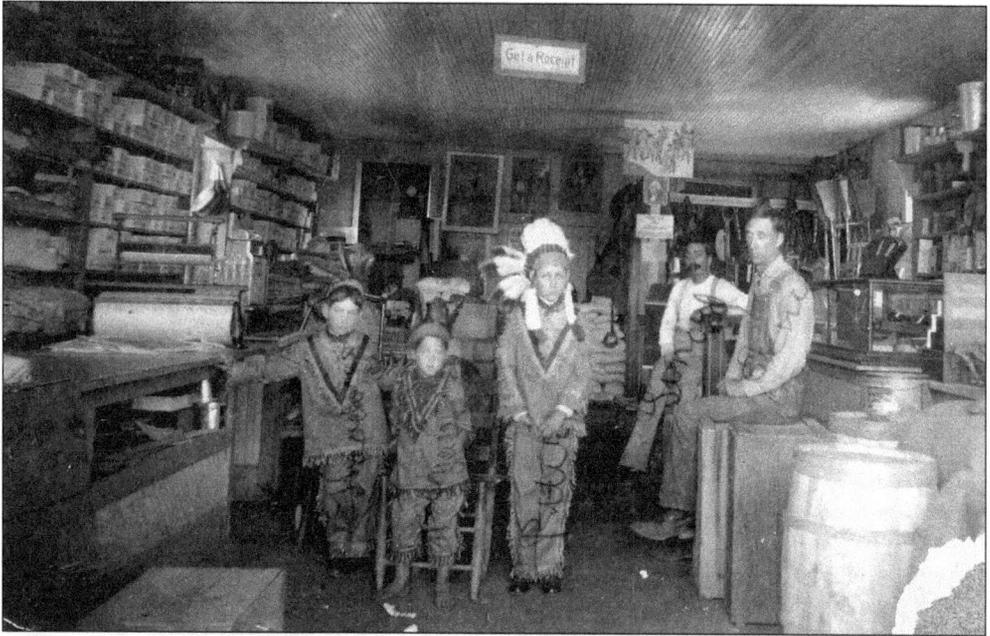

Bleidt, Kentucky, consisted solely of the general store and post office. This building provided a gathering place as well as the everyday items area citizens needed. Appearing from left to right around 1918 are Theodore, Ragon, and Peter Bleidt (dressed in Native American costumes) and proprietors Leonard and Ernest Bleidt. (Courtesy Clara Lawrence.)

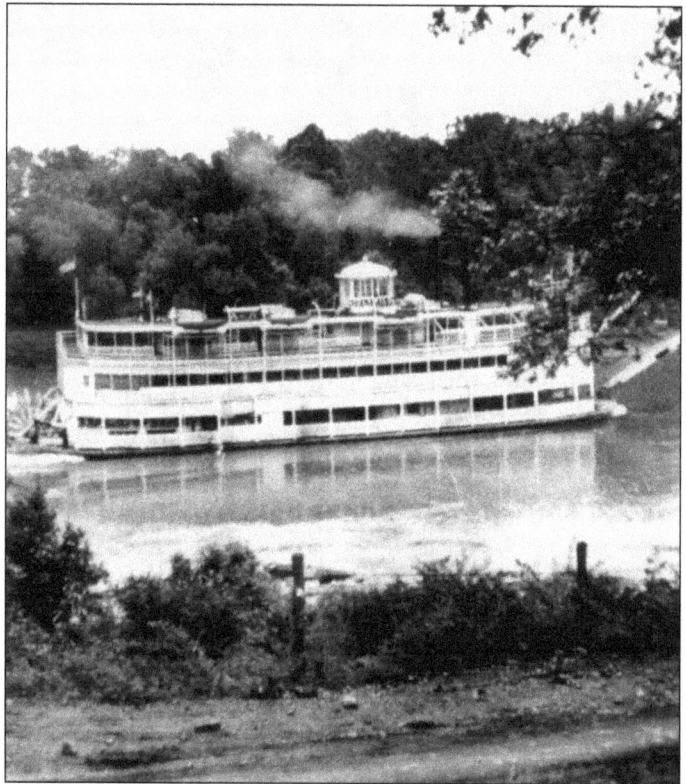

The excursion boat *Idlewild* is shown sailing the Cumberland River near the Devil's Elbow. Built in 1914, the steamboat served variously as packet, excursion boat, and ferry. In February 1928, it was sold to the New St. Louis and Calhoun Country Packet Company and then to J. Herod Gorsage, who renamed it *Avalon*. The *Avalon* fell into disrepair and might have seen the end of its days had the boat not been purchased at auction by Jefferson County judge executive Marlow Cook. The *Avalon* was rechristened the *Belle of Louisville* and is presently moored at Louisville's downtown wharf. (Courtesy Jim Wallace.)

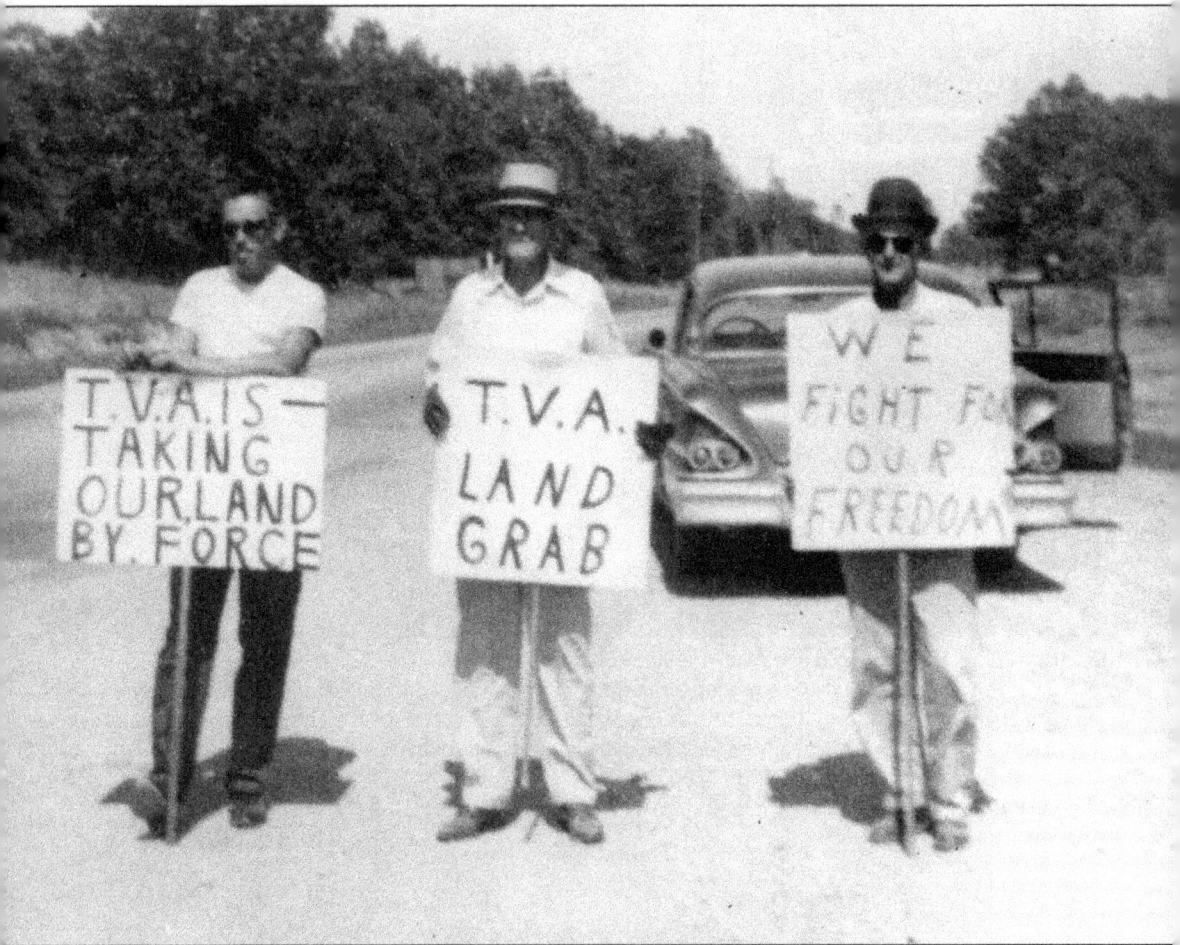

The 1960s brought radical changes to the culture and landscape of Between the Rivers. By 1933, bridges had been constructed over the Tennessee and Cumberland Rivers, and in 1938, the U.S. government acquired the holdings of the Hillman Land Company. In the 1940s, Kentucky Lake engulfed the fertile lowlands to the west, and the Great Depression maintained its stranglehold on those whom the lake had not displaced. By the end of 1965, Barkley Lake had swallowed the western valleys, and the remaining landowners from Grand Rivers to Dover were being strong-armed into selling their land to the Tennessee Valley Authority. Standing from left to right here are Wallace Litchfield, T. P. Sholar, and Rex Peal. They express the sentiments of the area's remaining residents, most of whom were feeling the TVA's pressure to sell out and leave their ancestral homes. (Courtesy Jim Wallace.)

Two

CANTON AND ROCKCASTLE

As early as 1799, a party of immigrants settled on the Cumberland River near where the town of Canton now stands. Among these early settlers were Abraham Boyd and his father-in-law, Adam Linn. Linn Boyd was born in Nashville, Tennessee, on November 22, 1800. At the age of two, he was living in what would be his boyhood home, Boyd's Landing, Kentucky (later Canton). Boyd was elected to the Kentucky General Assembly in 1831 and to the U.S. House of Representatives in 1835. He was re-elected to the house in 1839 and remained in office for eight consecutive terms. During his final two terms, he served as Speaker of the House. Boyd was elected lieutenant governor of Kentucky in 1859; too ill to assume office, Boyd remained in Paducah, where he died on December 17, 1859. (Courtesy Library of Congress.)

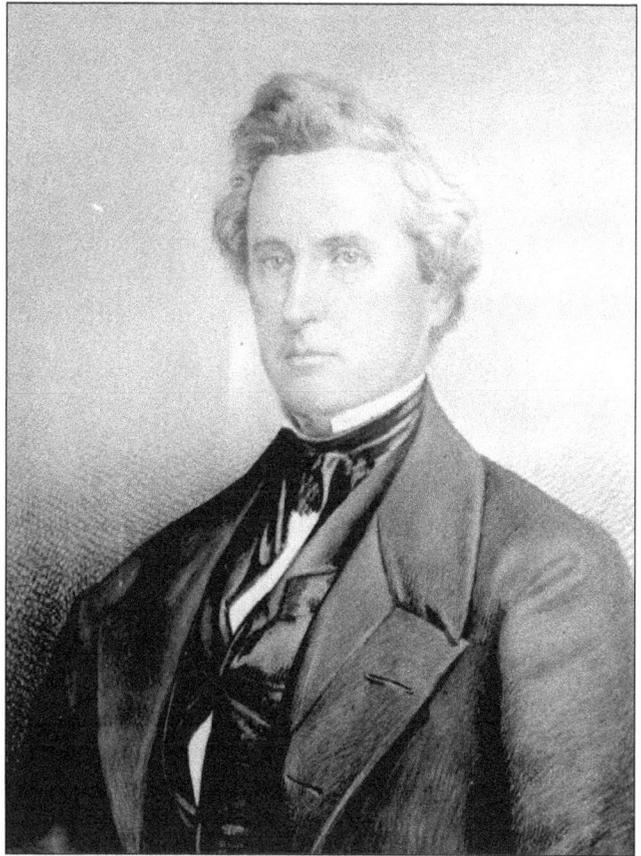

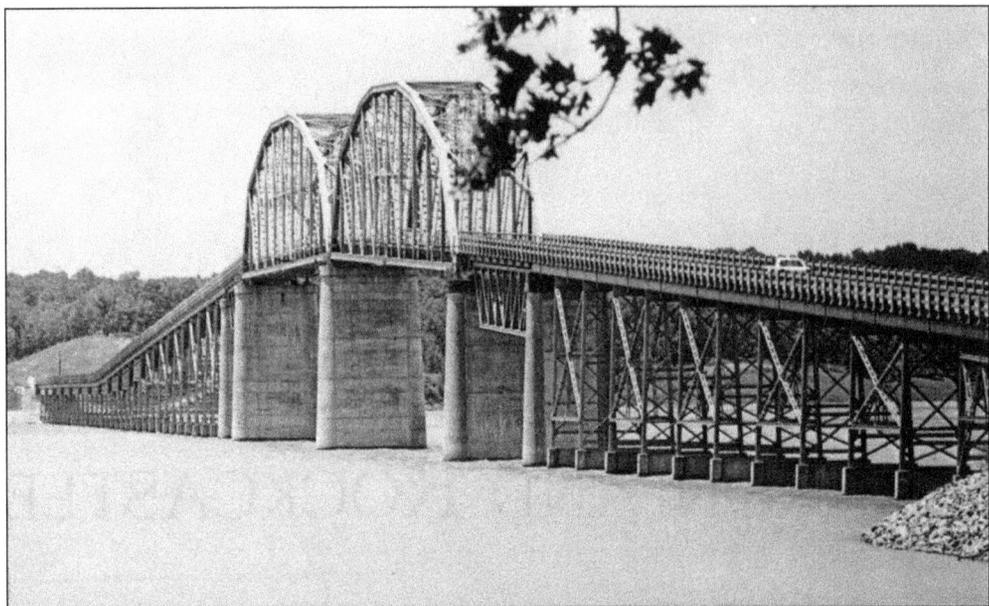

Erected in 1932, the Henry Lawrence Memorial Bridge was raised several feet in 1963 to accommodate the rising waters of the Cumberland River when Barkley Lake was formed. It was an engineering feat of unusual interest, and traffic was diverted to a ferry for a short time.

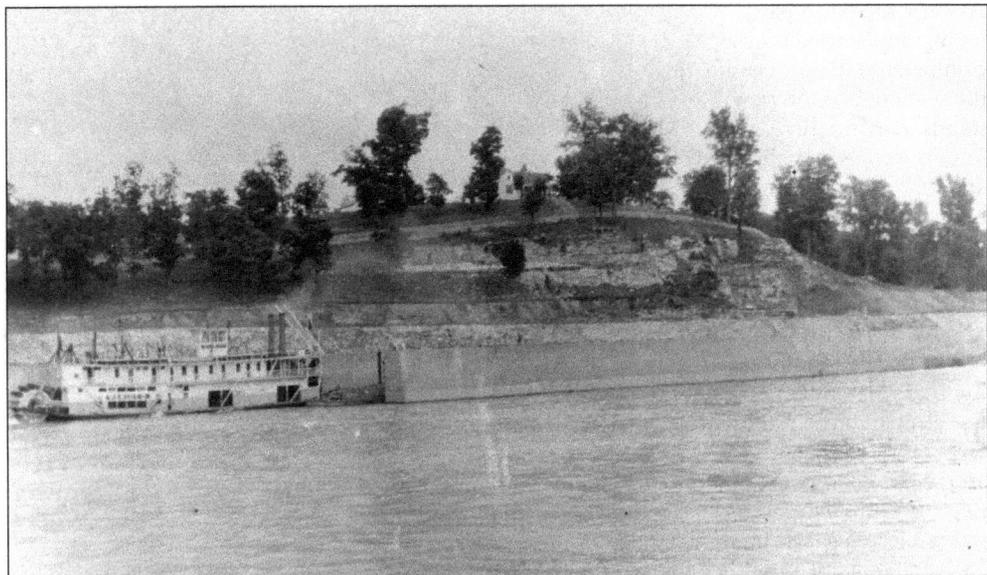

In 1871, Col. S. T. Abert surveyed the river for the Army Corps of Engineers. His report called for the construction of 30 locks and dams for slack-water navigation. The project provided access to the great coalfields of Kentucky, the timber of the Upper Cumberland, and the iron of the Western Highland Rim below Nashville. In 1887, engineers designed the first lock and dam (No. 1) to be built on the Cumberland above Nashville, and construction began in 1888. By 1900, six stone or concrete-and-timber dams had been built below Nashville, and eight had been built above the dam. In 1924, a combination of 15 locks and dams raised the river by at least 6 feet from Burnside to Smithland. The steam-powered tug passing through Lock E in this photograph bears the name *Warioto*, the Native American name for the Cumberland River. (Courtesy William Turner.)

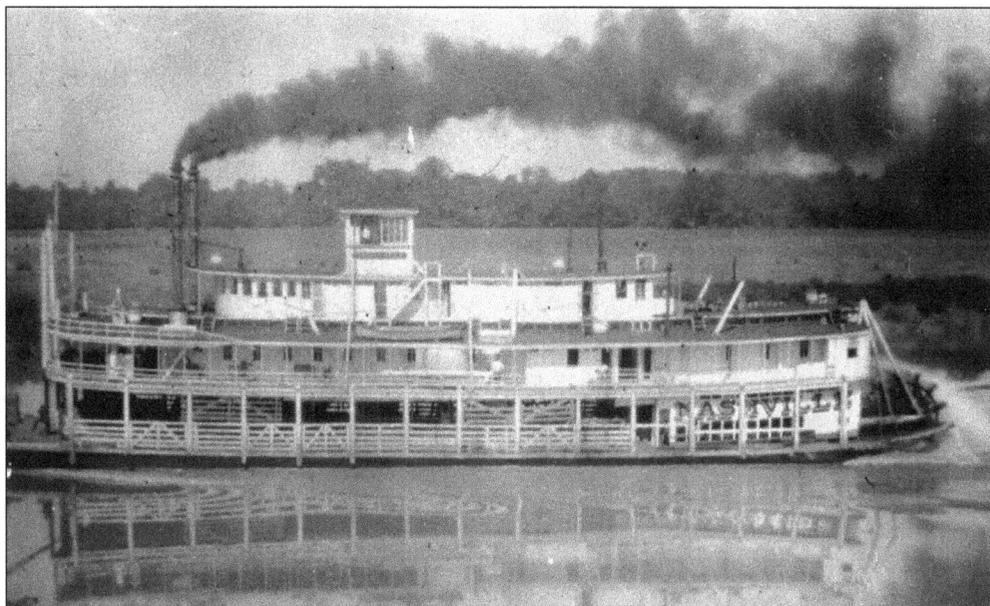

This photograph of the *Nashville* on the Cumberland River near Canton was taken around 1915. The *Nashville*, built in 1910 for Evansville-to-Nashville trade, was captained by Shep Green, master, with Harry Sayre, clerk. The boat was retired in 1918 due to high labor costs and a scarcity of coal. Nashville Trust took her in a forced sale on December 12, 1918. Williams Brothers of Evansville bought her in April 1919 and ran her on their Louisville-Stephensport-Evansville route. They rebuilt her in 1922 and renamed her *Southland*. (Courtesy Paul Fourshee.)

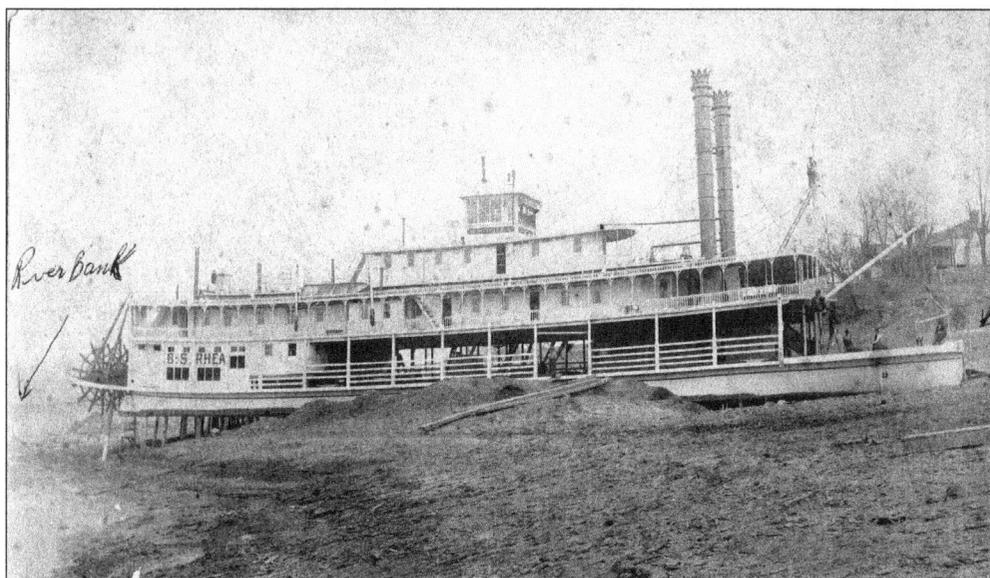

Grounded during high water, the *B. S. Rhea* was propped up with logs as the Cumberland's floodwaters receded in 1893. Built by Howard in 1886, she was named for B. S. Rhea, the "Corn King of Tennessee." Built for the Ryman Line, she ran from Nashville to Paducah connecting with the *C. W. Anderson* on the upper Cumberland. Capt. John Barrett of Cincinnati bought her for the Louisville-to-Cincinnati trade in 1894. The *B. S. Rhea* burned at Cincinnati while laid up for low water on November 5, 1895. (Courtesy Betty Cunningham.)

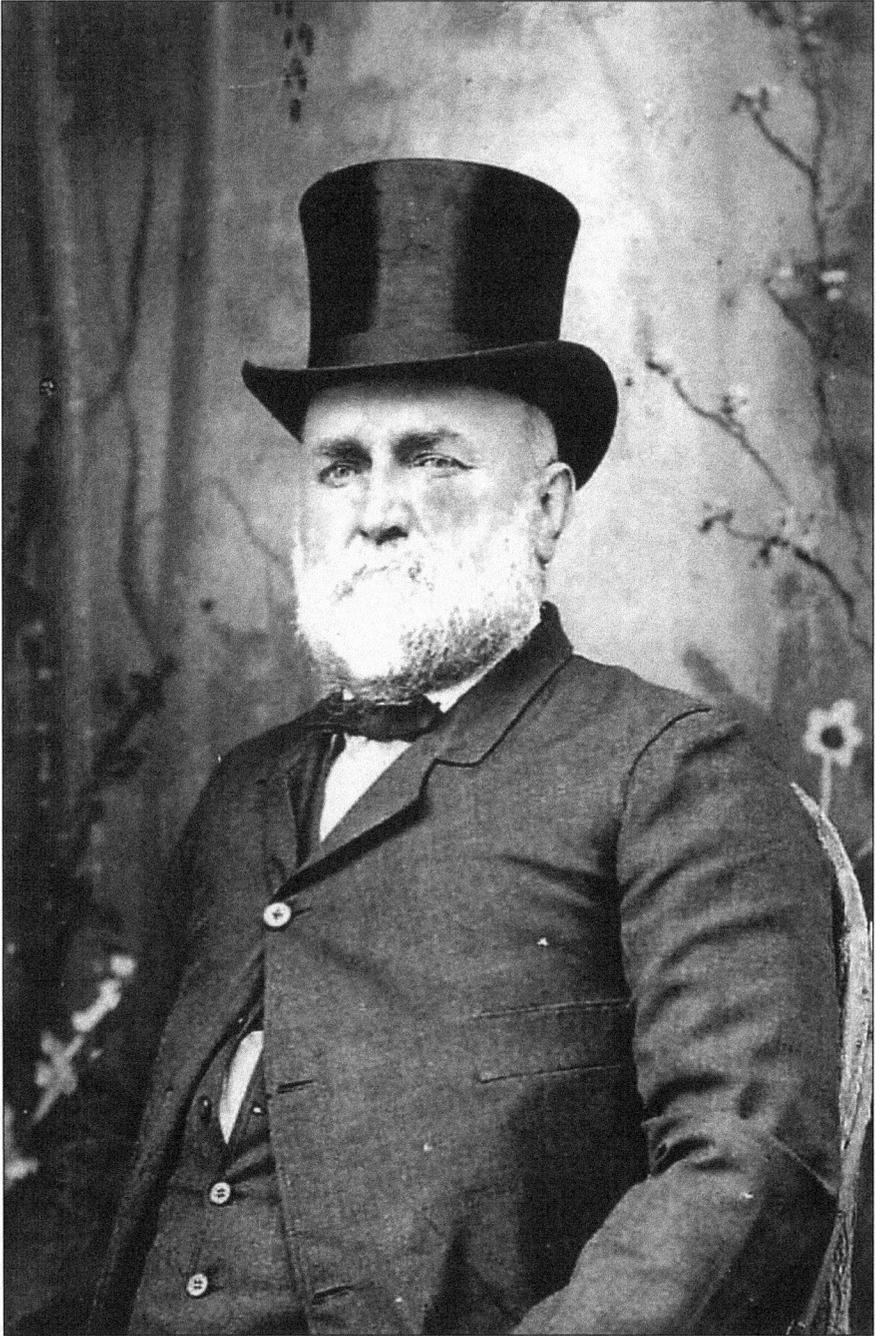

William J. Fuqua (1829–1897) was an organizing member of the Canton Masonic Lodge No. 242, AF&AM, in 1852. When William H. Perrin mentions him in his 1884 history of Trigg County, he states, "W. J. Fuqua . . . has perhaps amassed a greater fortune than any we have spoken of." Fuqua owned at least five businesses in Canton (including a drugstore and a livery) in addition to being the town's undertaker. Fuqua would later establish his son Terry Hart Fuqua as the undertaker in Cadiz, and in time, Terry would acquire a third undertaking business in Hopkinsville. (Courtesy Dr. Terry Fuqua.)

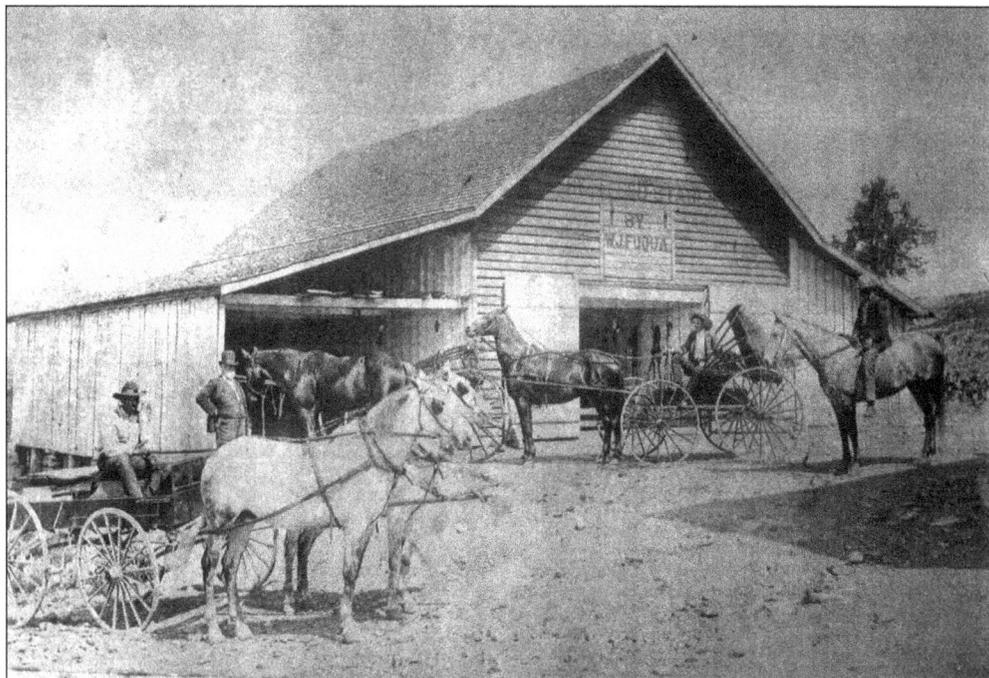

William J. Fuqua can be seen at the left side of the stable wearing his ever-present black silk hat. The sign above the main doors of the stable in this *c.* 1895 photograph reads "Livery and Feed Stable by W. J. Fuqua." Stan Bridges (1866–1924), the great-great grandfather of the author, served as a clerk in one of Fuqua's Canton enterprises. On July 30, 1890, Bridges (right) wrote in a letter to his future bride, Jennie Thomas, "Mr. Fuqua has gone to Hopkinsville again this week in my buggy. I believe that he will wear it out for me; he is very good to me though." Stan had ordered his new buggy from Tommy Mills's store in Nebo, Kentucky, in March 1889, and had it delivered to Canton by steamboat. (Above, courtesy Dr. Terry Fuqua; right, courtesy Frieda B. Sumner.)

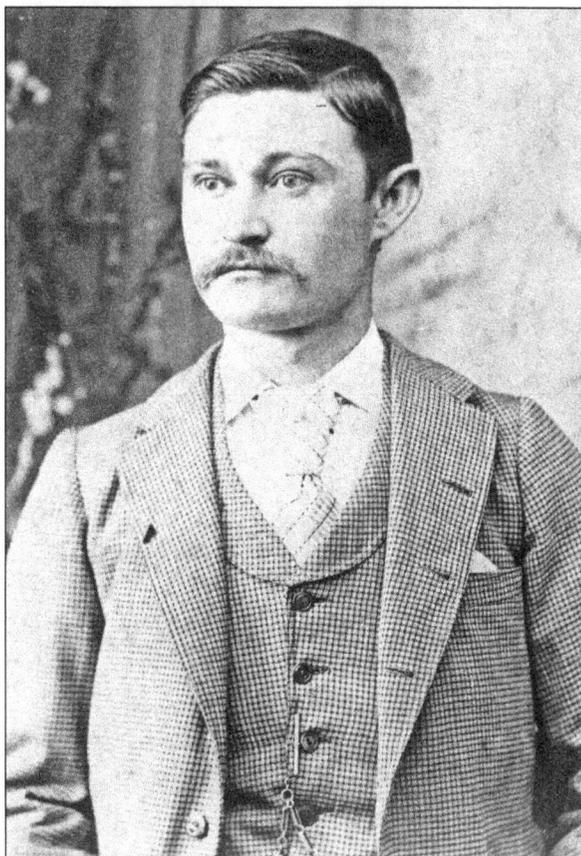

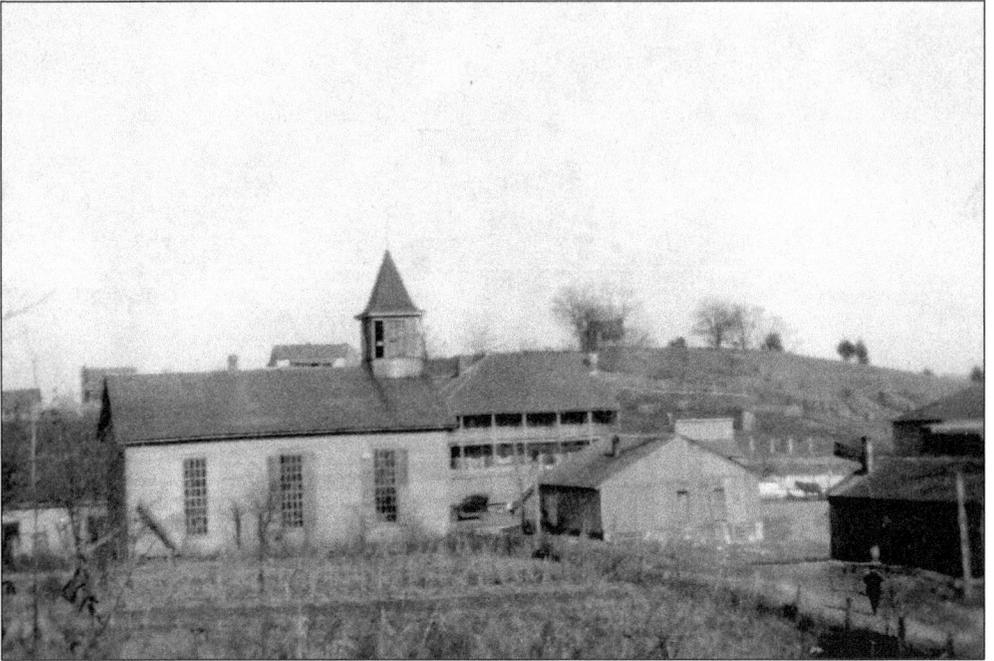

This rare *c.* 1900 photograph provides an uncommon view of Canton, focusing on the western side of Union Church. The lens also captures a view of the rear of the post office and warehouse located along Main Street and the front of the Brick Inn. (Courtesy Betty Cunningham.)

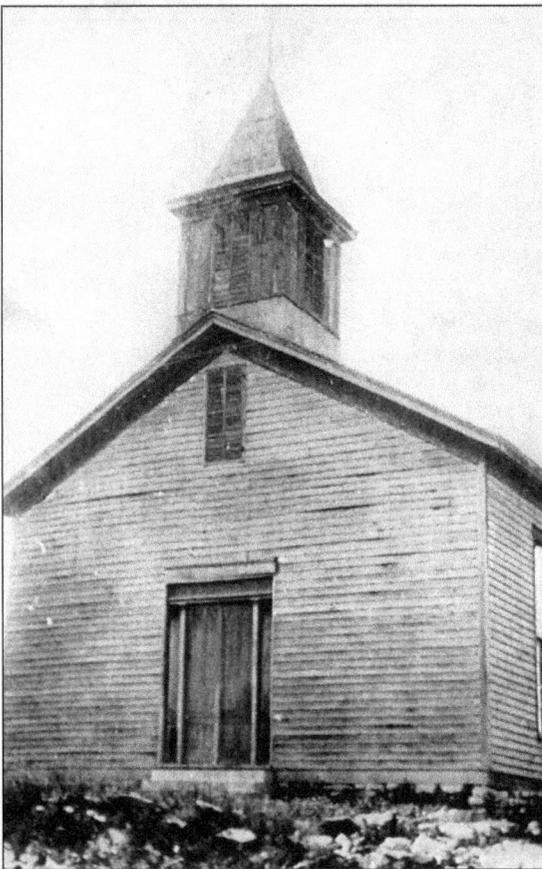

Located on a hill east of the Cumberland River Ferry, Union Church was constructed around 1874 by the congregations of three separate denominations. On October 19, 1930, ownership was transferred to the Canton Baptist Church. The historic Union Church fell to the wrecking ball in 2005. (Courtesy Nell Wallace.)

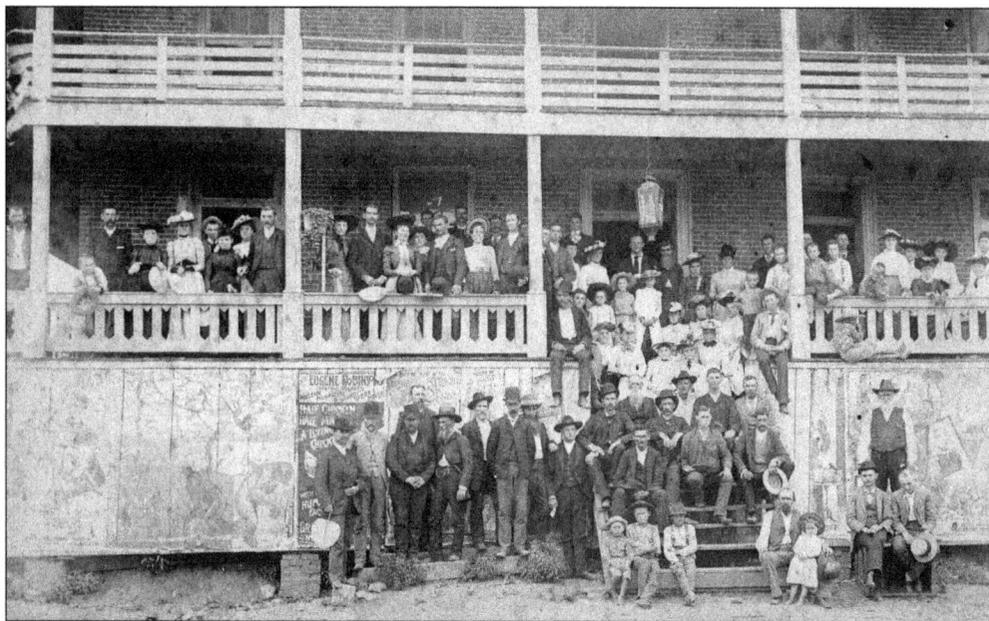

A large crowd is shown gathered at the Brick Inn in this photograph, taken prior to 1890. Stanley Bridges, a clerk in W. J. Fuqua's store, sits second from the right in the lower right corner. Standing next to the post at the top left of the stairs are G. A. "Ghent" Bridges and his wife, Nettie Cunningham Bridges. A circus advertisement can be seen spanning the length of the porch beneath the railing. Among the distinguished early guests were French general Marquis de Lafayette, Pres. James K. Polk, and Jenny Lind, the famous "Swedish Nightingale," who once performed at the inn. (Courtesy Betty Cunningham.)

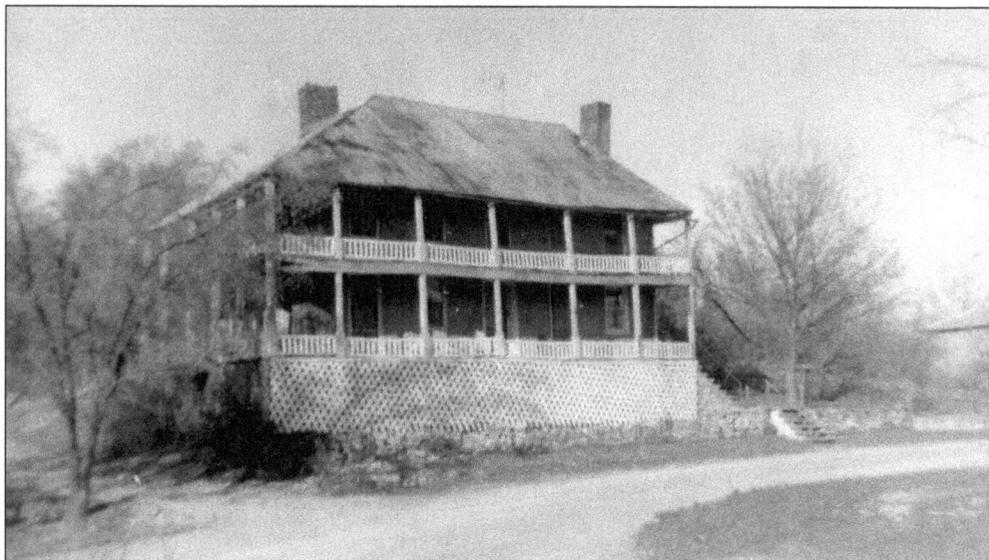

Constructed for Abraham Boyd around 1819 in the Federal style, the Canton Hotel is a two-story, five-bay brick building with the south and west walls laid in Flemish bond. Splayed jack arches are employed above all openings, and nine-over-six pane sash windows pierce the south, west, and north elevations. The roof, altered around 1900 to accommodate the addition of the wraparound porch, is hipped on the west and gabled on the east end. (Courtesy William Turner.)

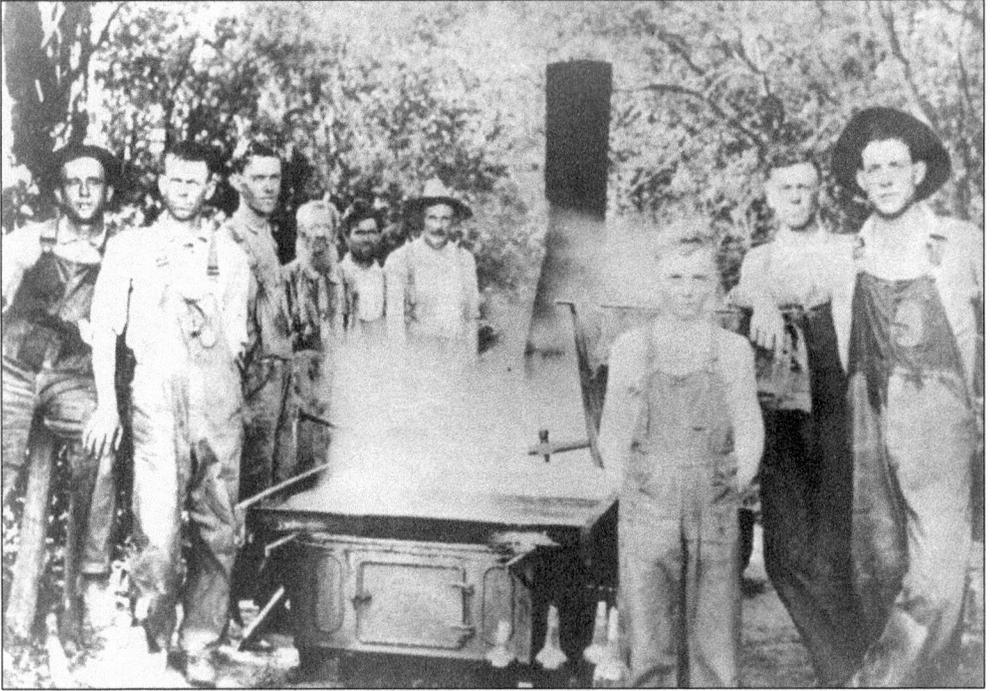

Making sorghum molasses was an occasion for a community gathering and a day of festivity in Trigg County. This c. 1914 photograph was made around Calhoun Hill near South Union Church. Standing from left to right are Nay Herndon, Harlon Calhoun, Will Calhoun, Skinner Calhoun, Matt Calhoun, George Francis, Roy Calhoun, Jim Calhoun, and Bluford Bridges. (Courtesy Charles and Celia Littlejohn.)

The Canton schoolhouse was located near the Cumberland River along what is now U.S. Highway 68 at the junction of Boyd's Landing Road. Canton was a thriving community in the late 1860s and supported as many as three area schools. The earliest confirmed high school in Canton dates to 1901. (Courtesy William Mize.)

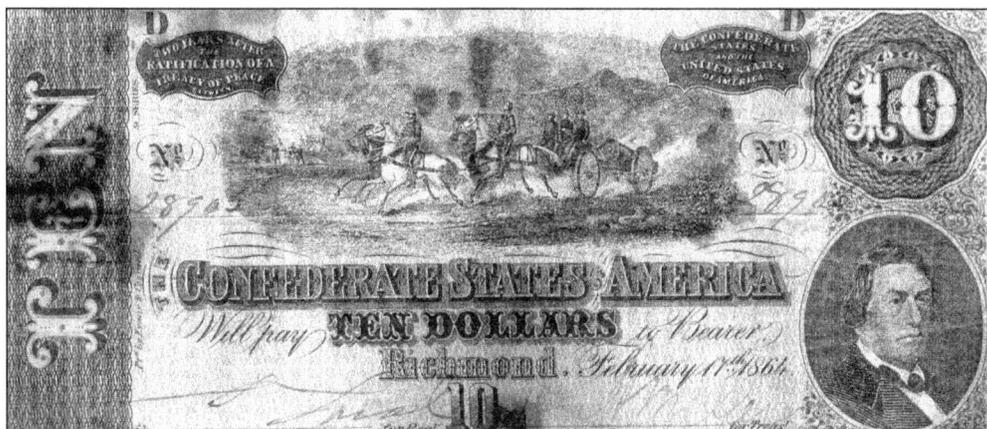

This $10 Confederate note was the last month's salary of Trigg County soldier John Caldwell of Company A, 9th Kentucky Infantry, CSA. Caldwell gave the note to A. C. Burnett in Cadiz on July 10, 1912. (Courtesy FNB Bank.)

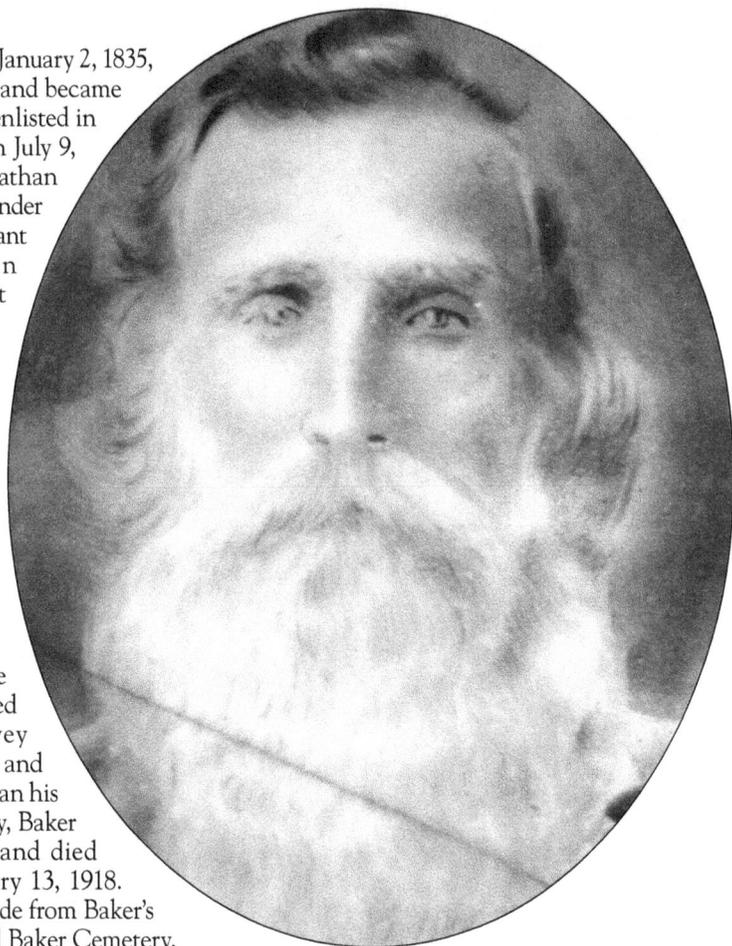

Born near Rockcastle on January 2, 1835, Hazard P. Baker grew up and became a farmer in Canton. He enlisted in the Confederate army on July 9, 1861, and served under Nathan Bedford Forest and later under Gen. Joe Wheeler. Lieutenant Baker was second in command in the escort of Pres. Jefferson Davis during his attempted escape after the fall of Richmond. At the time of capture on May 10, 1865, Capt. Givan Campbell had taken a small party in search of supplies, leaving Baker in command of the escort. Baker was one of five Trigg natives in the escort at the time of the capture. (Others included Minus Pursley, Harvey Sanders, W. N. Ingram, and W. A. Howard.) Other than his one skirmish with history, Baker lived an ordinary life and died of pneumonia on January 13, 1918. This photograph was made from Baker's tombstone in the Hazard Baker Cemetery.

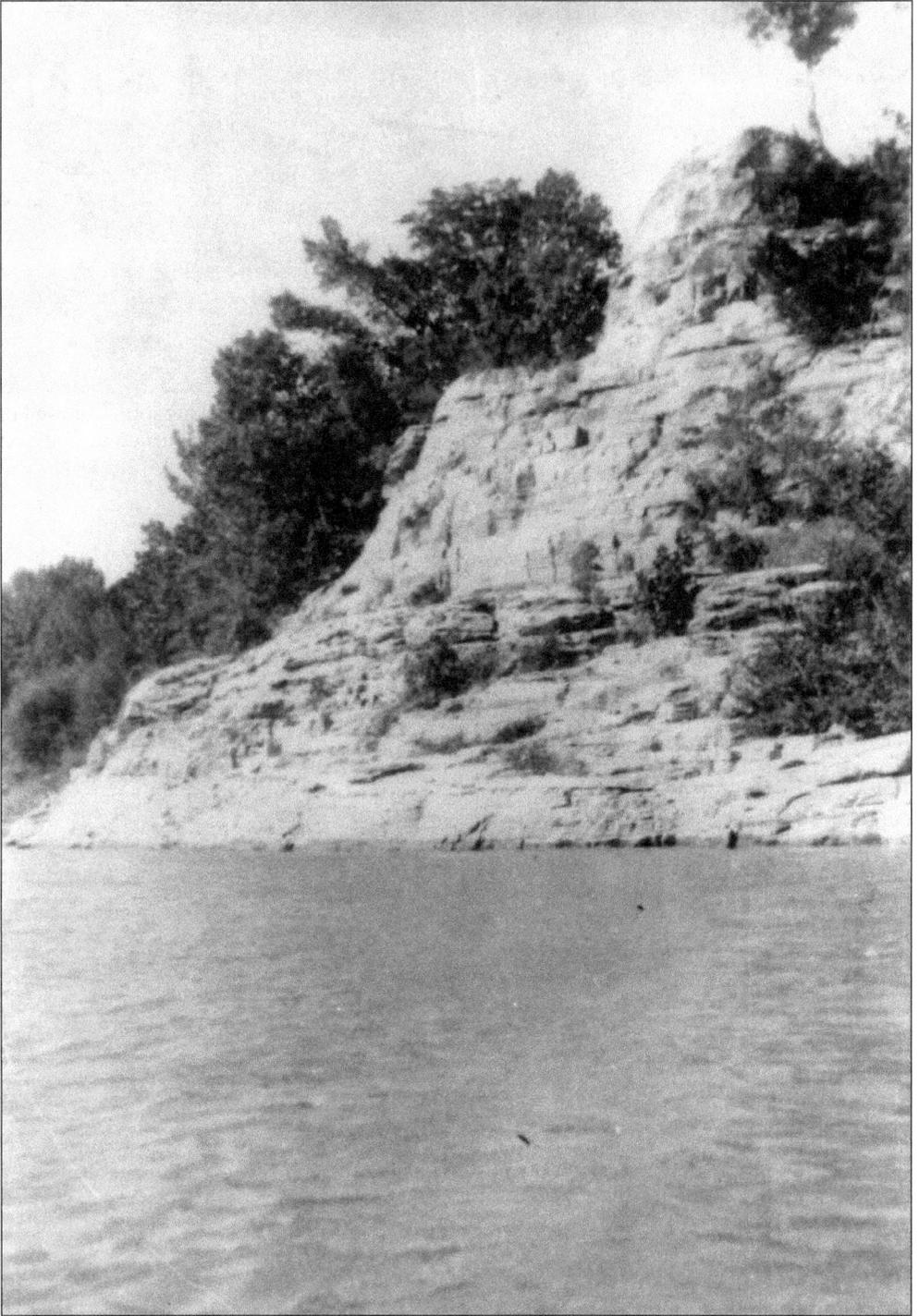

This pre-1966 photograph shows the rock from which Rockcastle gets its name. This large limestone bluff rose above the Cumberland, appearing like a majestic castle to river traffic. Although obscured by water throughout most of the year, "the Rock" is still a distinct natural landmark to boaters on Barkley Lake. (Courtesy William Turner.)

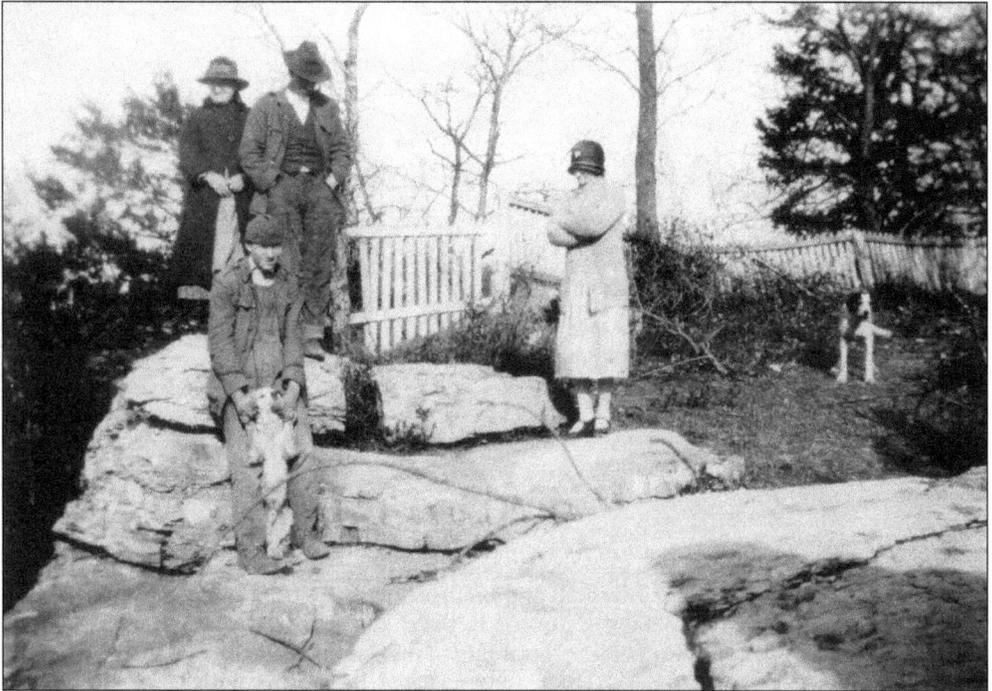

In 1930, George and Clara Wallis Cotton were living on Rockcastle Bluff in the Doctor Standrod House. The couple is seen here standing at the highest point in the photograph. The young woman to the right is Clara Cotton, George's daughter from his first marriage. The young man holding the dog is either George's son Claude or an orphan named Roman who lived with the Cotton family. (Courtesy Frances Cunningham.)

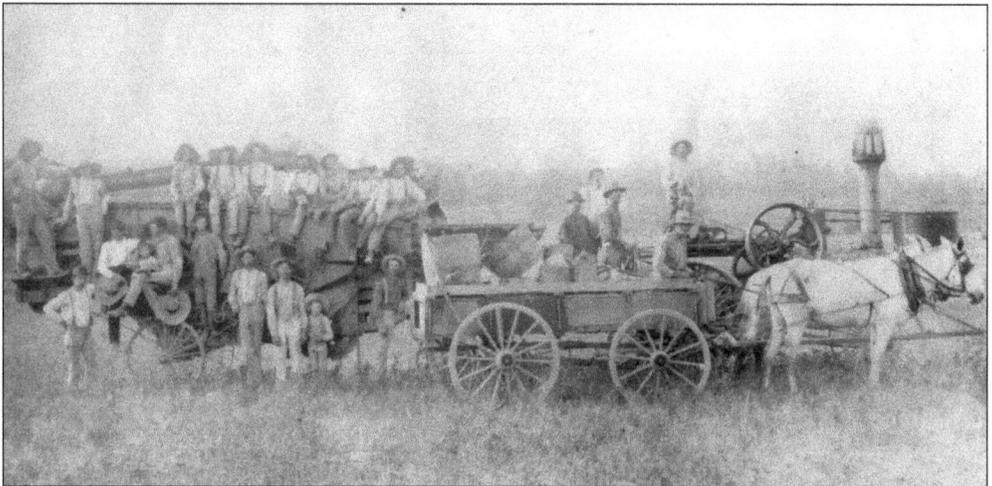

This 1909 scene shows a steam-powered wheat thrasher owned by William Thomas "Tom" Litchfield (1844–1929) near Rockcastle. Litchfield was a farmer, sawyer, and Confederate veteran. Litchfield married twice; he first wed Sarah Hall (1847–1939) in 1864. The couple had eight children; among them was Susan Adelia Litchfield, who would become the wife of Sanford D. "Dud" Gray. Adelia and Sanford were the great-great grandparents of the author, Thomas Harper. Litchfield was 34 years older than his second wife, Azza Wimberly (1878–1959), who would bear him 10 more children. Litchfield is pictured holding the reins of the wagon. (Courtesy Barbara Tyler.)

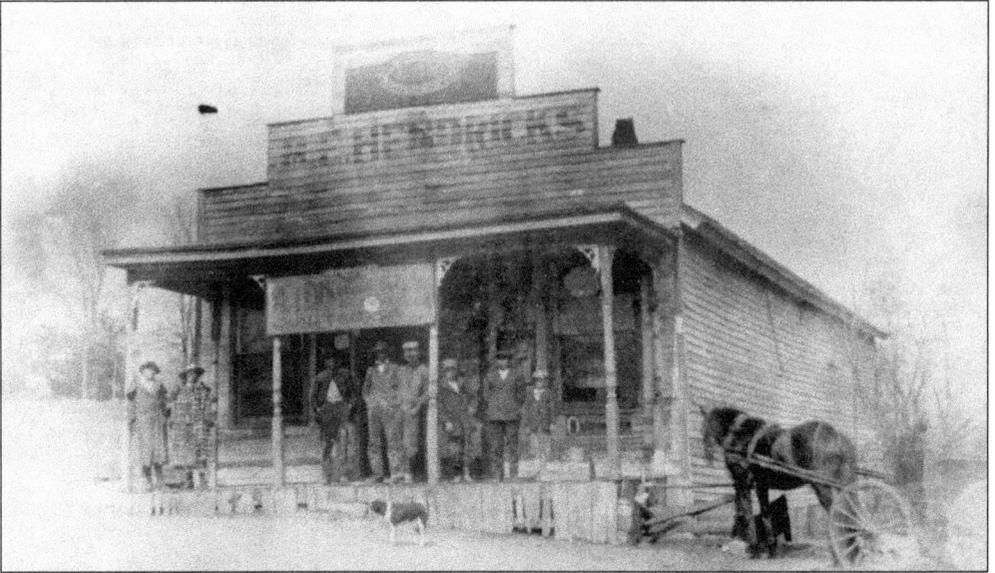

The first store in Rockcastle was Marshall and Bradley. It was in operation as early as 1836; the well-patronized store kept a general stock of goods. Baker and Standrod, a successful mercantile and commission business, was in operation until 1862. This early-20th-century photograph depicts M. E. Hendricks's store, a structure thought to have survived the burning of Rockcastle in 1908. In a series of raids on Rockcastle between August 1907 and January 1908, the Night Riders burned the hotel owned and operated by Johnson Hendrick, as well as three residences, a blacksmith shop, two stables, a warehouse, the post office, and two other businesses. Rockcastle, which had been a teeming, prosperous river town, never recovered from these attacks.

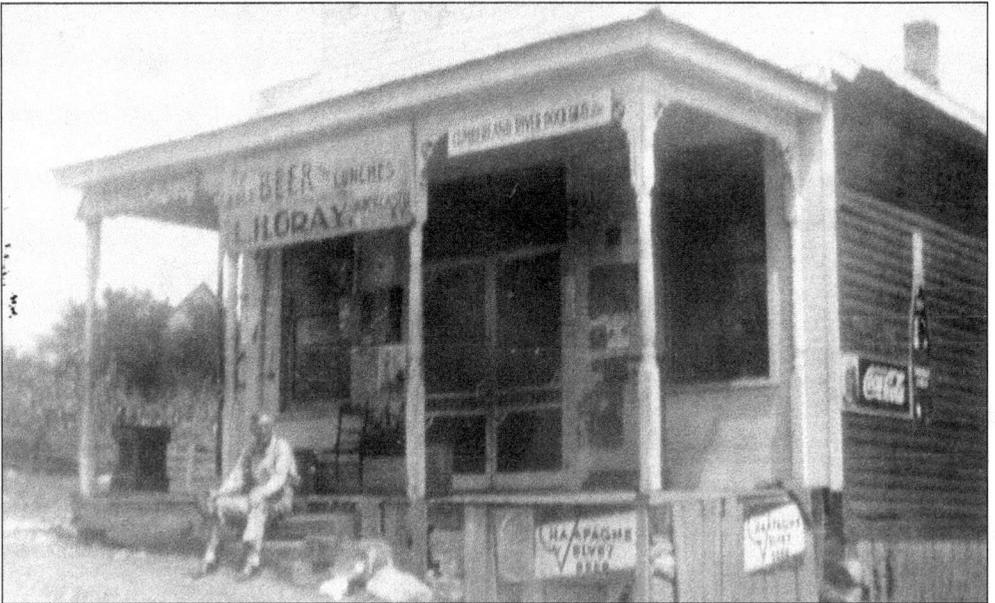

Lawns Hollis "Dock" Gray (1890–1947) of Rockcastle owned and operated a general merchandise store; he is pictured here around 1930, seated on the front steps. Gray provided the residents of Rockcastle and neighboring communities in Caldwell County with cold beverages, hot meals, and most any other item they might need for their home or farm. (Courtesy Frances Cunningham.)

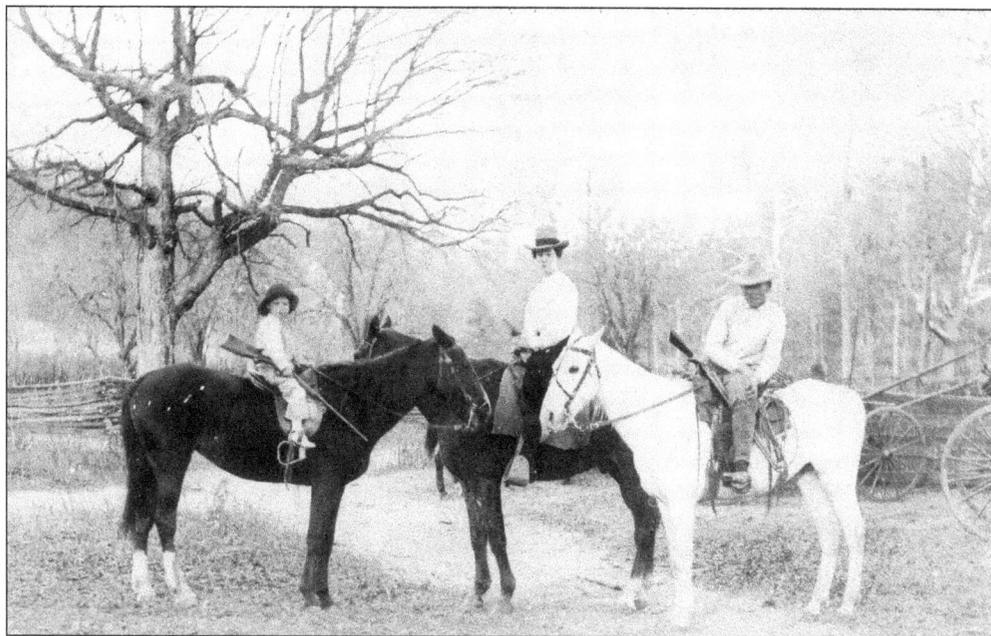

Mary Magdalene "Cotton" Cunningham (left) and her parents, Eudora "Dora" Mitchell Cunningham and Garland Cunningham, create a striking image on horseback in this c. 1924 photograph in the Trigg Furnace community near Rockcastle. Cotton and her father both carry shotguns, while Eudora totes a pistol. (Courtesy Lucille Witty.)

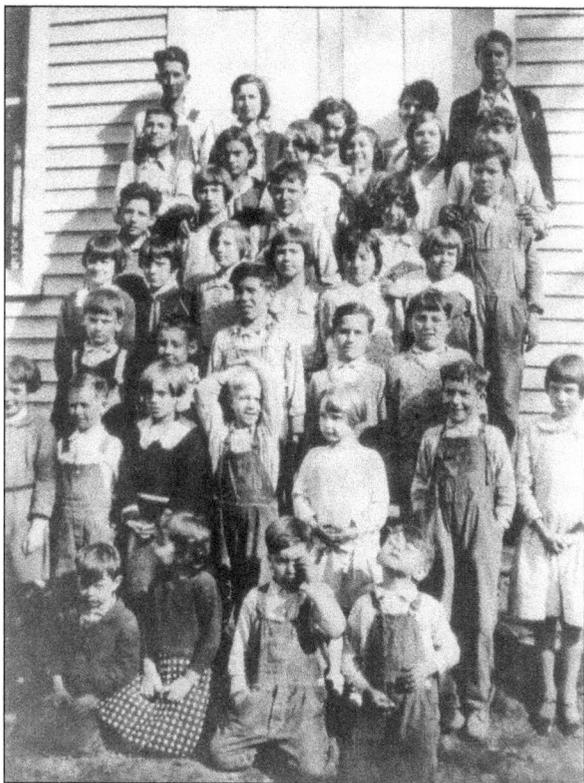

Nello Holland was the teacher at Rockcastle School in 1932. Holland's pupils, from left to right, are (first row) Calvin Hawkins, Virginia Gray, Joe Joyce, and Johnny Hawkins; (second row) Myrtle Colson, Malcolm Litchfield, Ethel Joiner, Ovid Boyd, Lola Burnham, Oscar Boyd, and Ernestine Boyd; (third row) Troy Cunningham, Gordon Gray, Guy Boyd, Herbert Allen, and Eura Joyce; (fourth row) Alice Litchfield, Naomi Litchfield, Mary Faughn, Kathryn Boyd, Frances Gray, and Clara Joyce; (fifth row) Wallis Gray, Louella Cunningham, Charles Butts, Camilla Williamson, and Hayden Cunningham; (sixth row) Browdas Allen, Hazel Henry, Dorothy Burnham, Nancy Sherbert, Fern Boyd, and Leonard Joyce; (seventh row) Errol Williamson, Emma Williamson, Rubelle Allen, Virginia Allen, and Robert Joyce. (Courtesy of Frances Cunningham.)

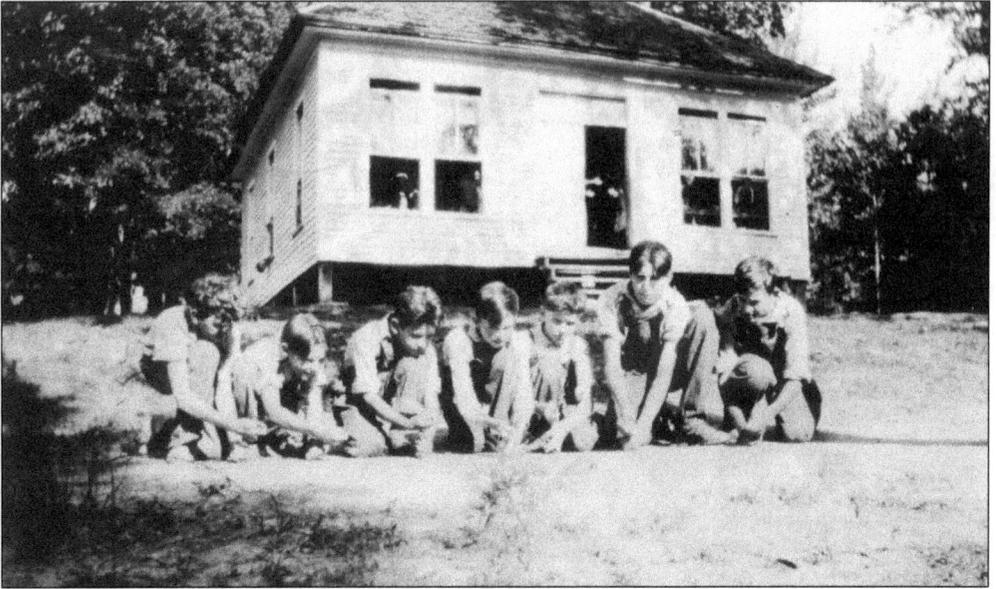

The 1932 Rockcastle School marble team is photographed in action near the front of the school. The team members are, from left to right, Leonard Joyce, Charles Butts, Wallis Gray, Guy King Boyd, Hayden Cunningham, Robert Joyce, and Browdas Allen. The building pictured remained in use until 1948, when the county schools were consolidated. At that time, it was converted into a residence by Browdas Allen. (Courtesy Frances Cunningham.)

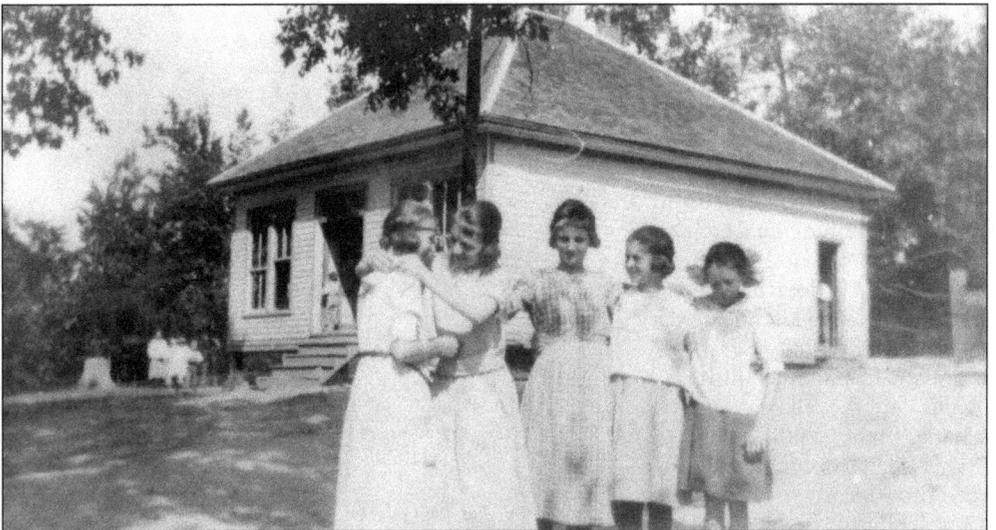

These Rockcastle schoolgirls are, from left to right, Charlotte Dunnigan, Lois Wallace, Mattie Johnson, Fannie Ellis Cunningham, and Bertie Dunnigan. Rockcastle School, like other one-room schools in the community, provided education to children from ages 5 to 18. The structure shown in this and the previous photograph is the second school, built in 1913. The original 1890 building was destroyed by fire. (Courtesy Frances Cunningham.)

Three

MAPLE GROVE, OAK GROVE, AND DONALDSON

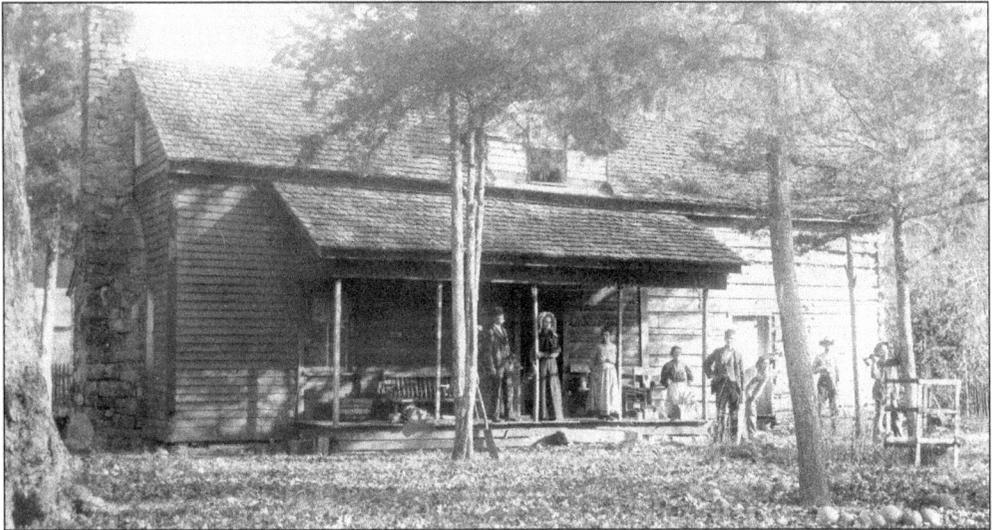

The log cabin at right is the original home built by Drury Bridges in 1804. The frame portion at left was added as the family grew. Bridges resided here until his death in 1840, and this 1907 photograph was made just before the home was torn down to make way for a larger modern frame house. The frame portion was demolished, but the cabin was relocated and used as a residence by Jack Bridges, who lived and worked on the farm. Jack was a descendant of the Bridges family's former slaves. Seen from left to right are Cullen Bridges (grandson of Drury), Virginia Thomas Bridges (his wife), Drucilla Bridges, Sarah Francis, John Bridges, Jesse Bridges, Flo Bridges, and Alvin Bridges.

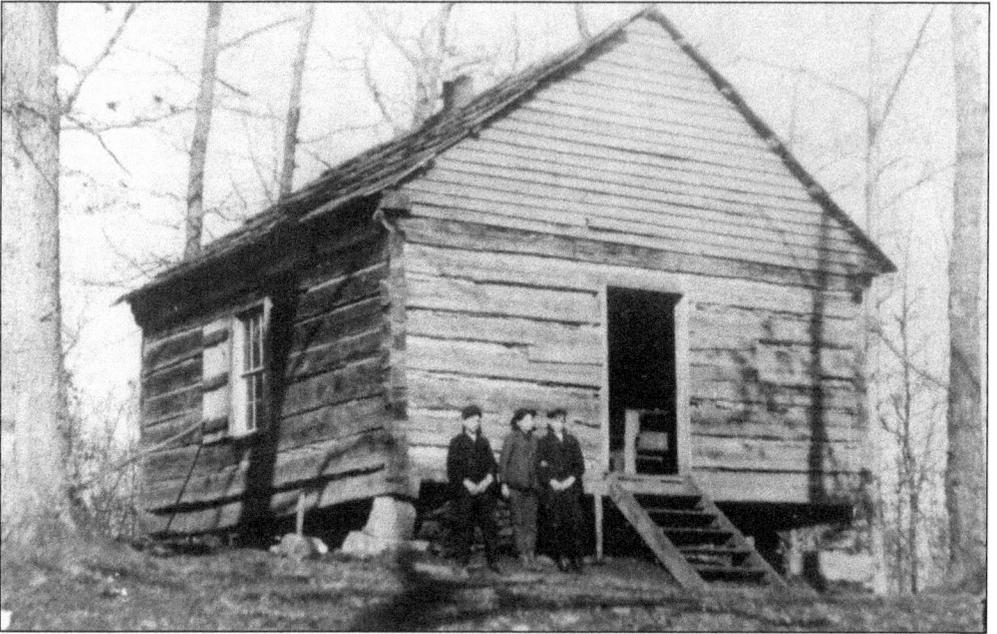

Maple Grove School was constructed in the early 1800s and was replaced by a concrete structure in 1913. Drury Bridges's great-grandsons, Ghent, Mark Dale, John, and Jesse Bridges, built the school utilizing a block-making apparatus they purchased from the Sears, Roebuck and Company catalog. Standing in front of the school are, from left to right, Peyton Thomas, Alvin Bridges, and Taylor Thomas.

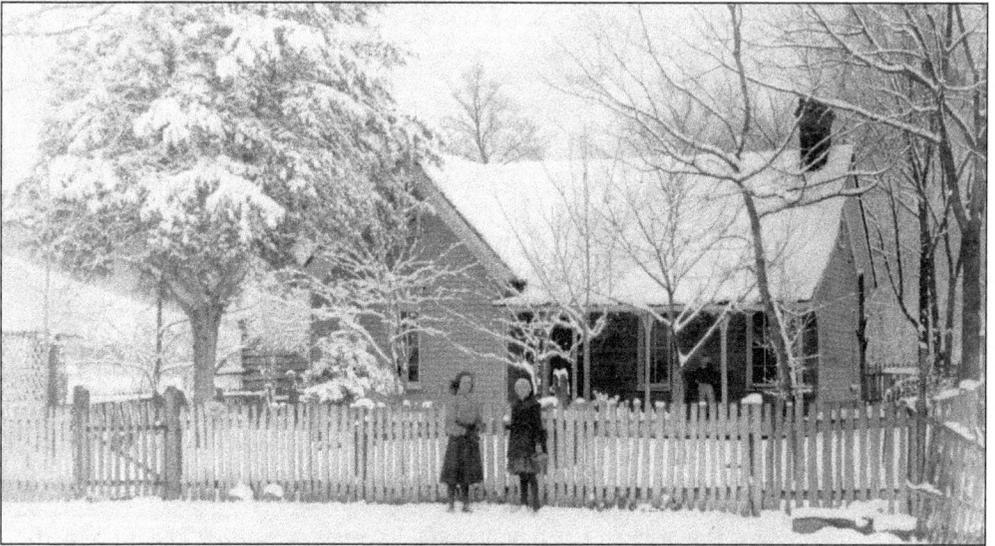

This c. 1906 winter wonderland features the home of the William A. "Ghent" Bridges family. Ghent and his wife, Nettie Cunningham Bridges, were both talented photographers, and the couple maintained a dark room in their home. Ghent was primarily a portrait photographer, while Nettie preferred landscape photography. The large representation of the Maple Grove community in the photographic archives of Trigg County is in large part a result of Ghent and Nettie's active photography careers. Lorene Bridges Hughes (left) and Flo Bridges stand along the fence in this snowy scene.

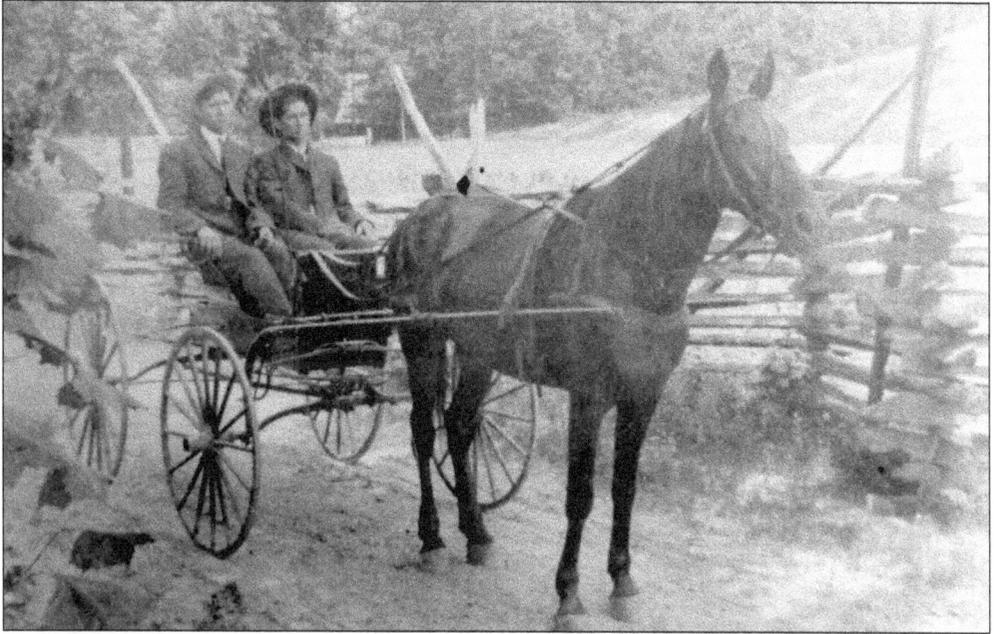

Garland Drew Bridges (left), son of Drew and Nannie Gresham Bridges, and Jesse Clyde Bridges, son of Cullen and Virginia T. Bridges, are seen here in a horse-drawn buggy in Maple Grove about 1910.

Cullen and Virginia Thomas Bridges had this frame house constructed on the site of the original Drury Bridges cabin alongside Beechy Fork Creek in 1910. Virginia died shortly after moving into the home, and Cullen lived there until his death in 1913. The last Bridges descendants to occupy the home were Jesse Clyde (1887–1963) and "Myrt" Davis Bridges (1890–1988). The home has remained unoccupied since 1988, and it now stands in ruin. Pictured around 1911 are, from left to right, Mollie Bridges, Cullen Bridges, Ora Bridges Thomas, Lorene Bridges, Ella Thomas, and Nell Bridges.

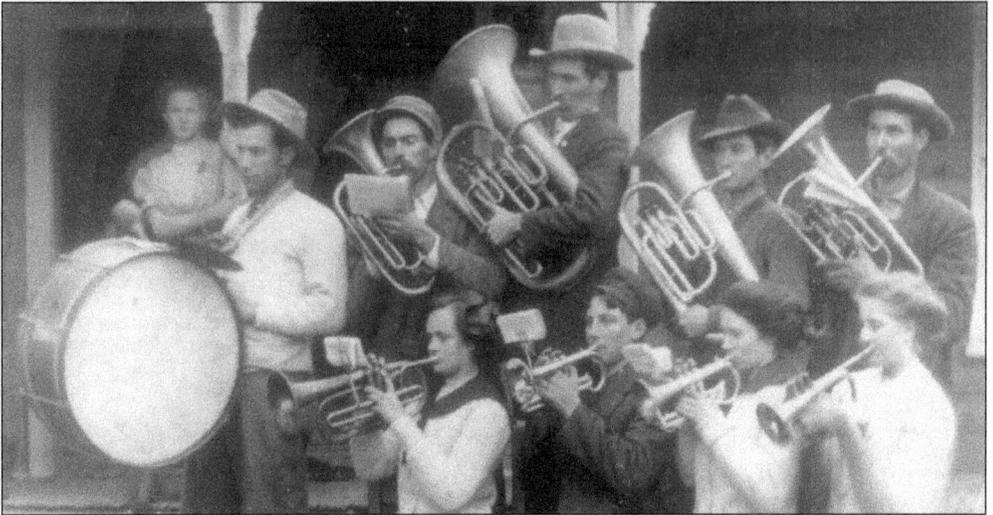

"I don't know how this band got started, but I am pretty sure it never had a recording contract!" said Edison H. Thomas. A listener was once asked how the band sounded, and the reply was, "Out of hearing would be better!" The Bridges Band consisted of, from left to right, (first row) Lorene Bridges, Alvin Bridges, Nellie Bridges, and bugler Nell Bridges Hardy; (second row) drummer Ben Grigsby and brothers Dale, Ghent, Jesse, and John Bridges. Standing on the porch to the left of the drummer is Lucy Bridges.

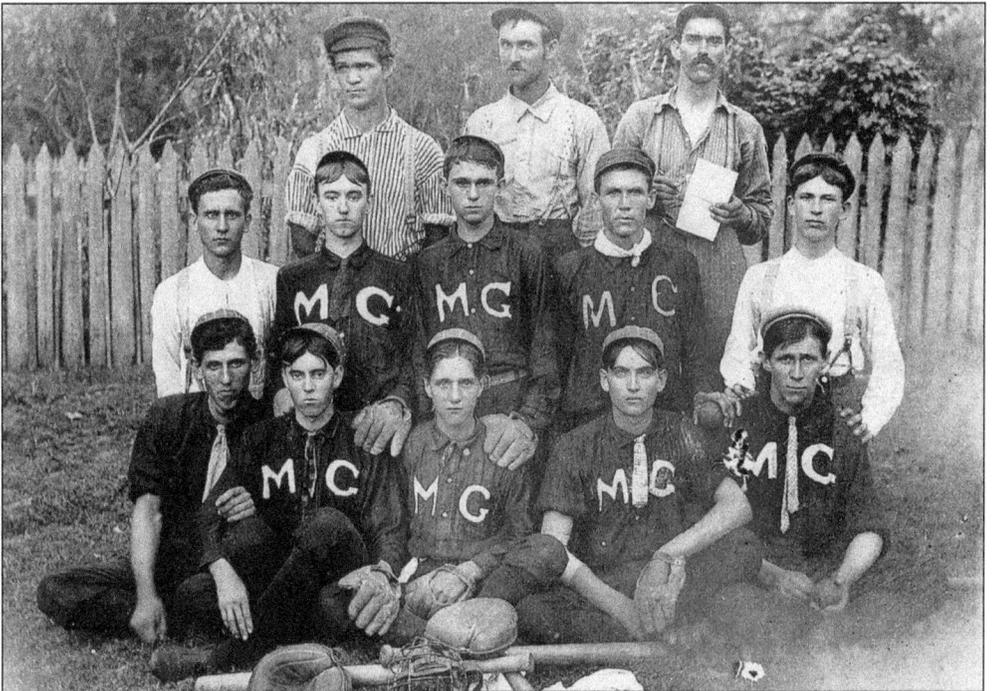

Although an industrious people, the citizens of Maple Grove could often be found gathered for a variety of social activities, including a summer game of baseball. The Maple Grove baseball team consisted of, from left to right, (first row) Cleve Cunningham, Willie Bridges, Vernon Coleman, Jesse Bridges, and Garland Bridges; (second row) Nay Herndon, Samuel Bridges, Trevor Battoe, Harry Lancaster, and Josh Light; (third row) John Saffer, John Bridges, and Dale Bridges.

In this c. 1907 scene, Jesse (left) and Alvin Bridges are "taking up" fruit trees to fill orders placed by customers throughout the region. Standing in the distance is Jesse's older brother and business partner Dale Bridges. The young boy standing at the right is Dale's son Percy.

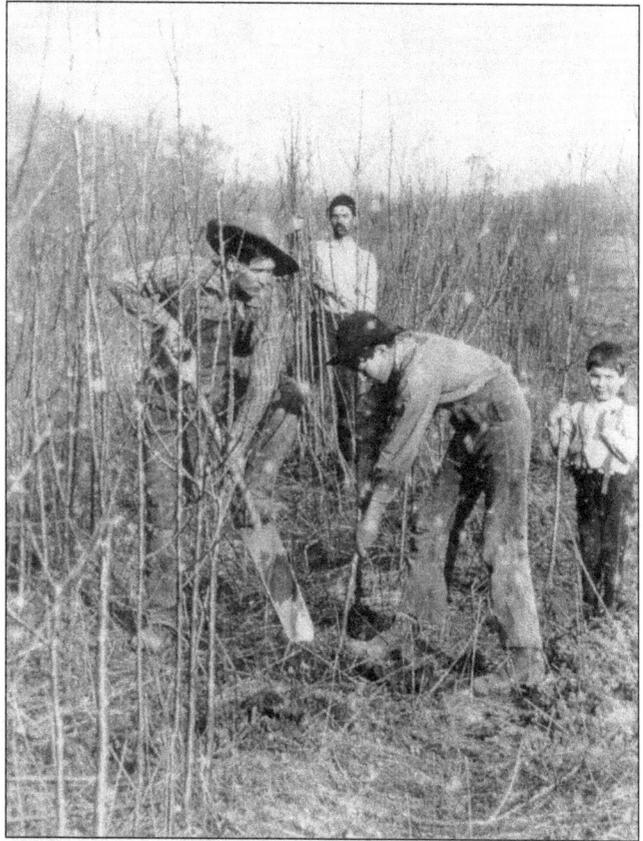

Maple Grove Nurseries

BRIDGES BROTHERS

Growers of and Dealers in

Apple, Peach and Ornamental Trees, Vines, Roses, Etc.

Nursery at

MAPLE GROVE,

KENTUCKY.

As early as June 1891, brothers Ghent, Dale, John, and Jesse Bridges operated a nursery at Maple Grove. Bridges Brothers Maple Grove Nurseries ceased operation around the start of World War I. Jesse Bridges is said to have made the final delivery of fruit trees by bicycle.

41

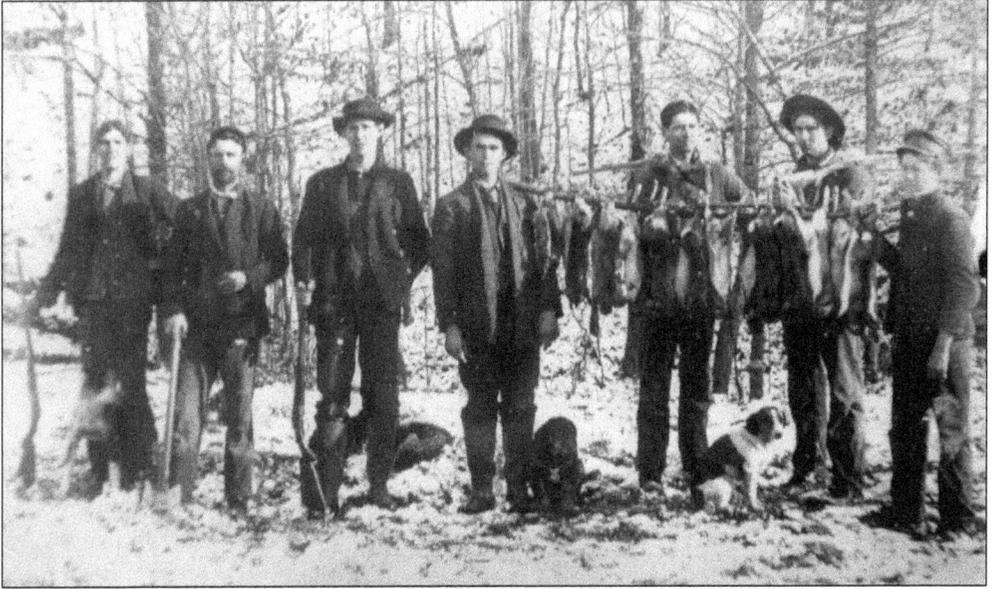

The abundant wildlife of the area provided both sustenance and entertainment for the residents of Maple Grove. This *c.* 1915 photograph serves as a testament to the marksmanship of the men of the community. Seen here from left to right are Willie Bridges, John Bridges, Garland Bridges, Trevor Battoe, Jesse Bridges, Samuel Bridges, and Vernon Bridges.

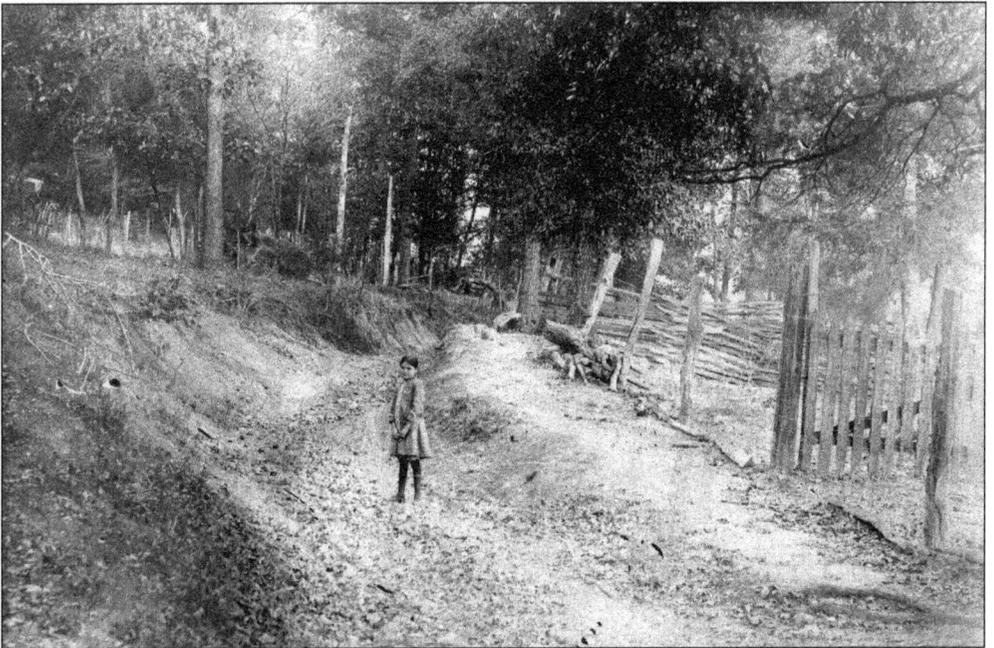

Ernestine Bridges stands in Beechy Fork Road around 1912. Many early roads throughout the county were barely more than rutted paths, barely passable with a buggy and more suitable for travel by horseback. It was not until the middle of the 20th century that the dirt roads were first graded and graveled, and even then, the road was crude at best. The earliest major road improvements were made in 1926 to the Jefferson Davis Highway from Cadiz to the Christian County line, just west of Gracey.

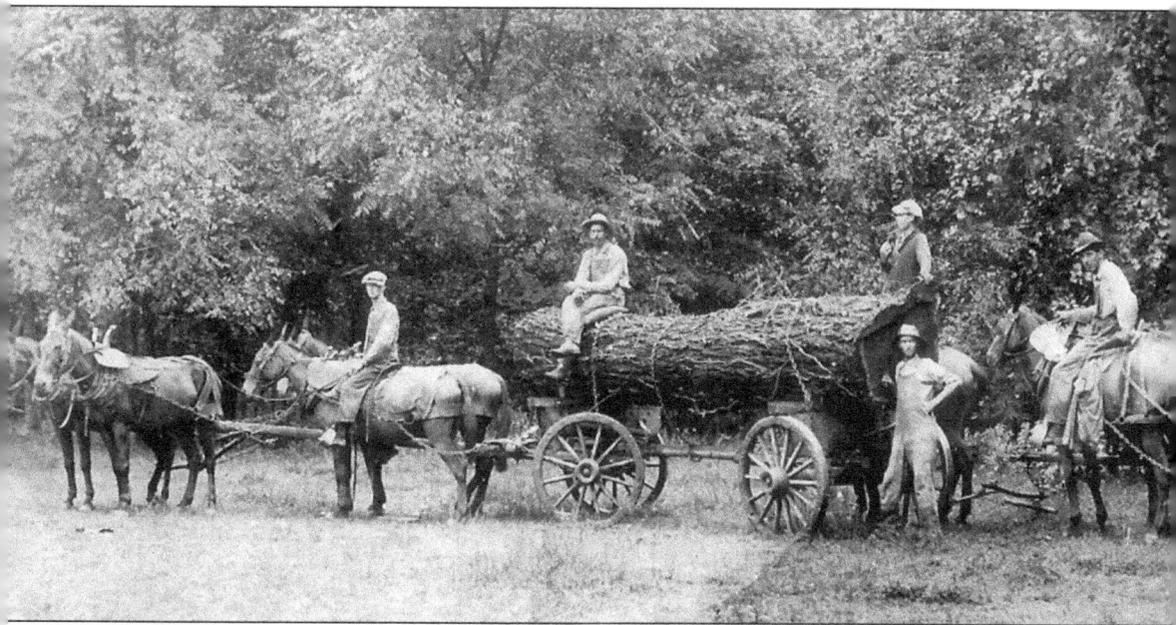

Logging was big business in late-19th- and early-20th-century Trigg County. Large stands of virgin timber were felled to clear land for farms and homes. The early timber industry was fed by a growing nation's expanding iron industry and railroad system. Logs like this one were commonplace; some were 6 feet or greater in diameter. Smaller trees provided cordwood for the iron furnaces of the area; thousands of acres around the furnaces were cleared in the late 1800s, rendered into charcoal, and consumed by the massive stone furnaces. From left to right, the loggers in this scene are Jesse Bridges, unidentified, Alvin Bridges, unidentified (on ground), and Ell Cunningham on horseback. (Courtesy Howell Finley.)

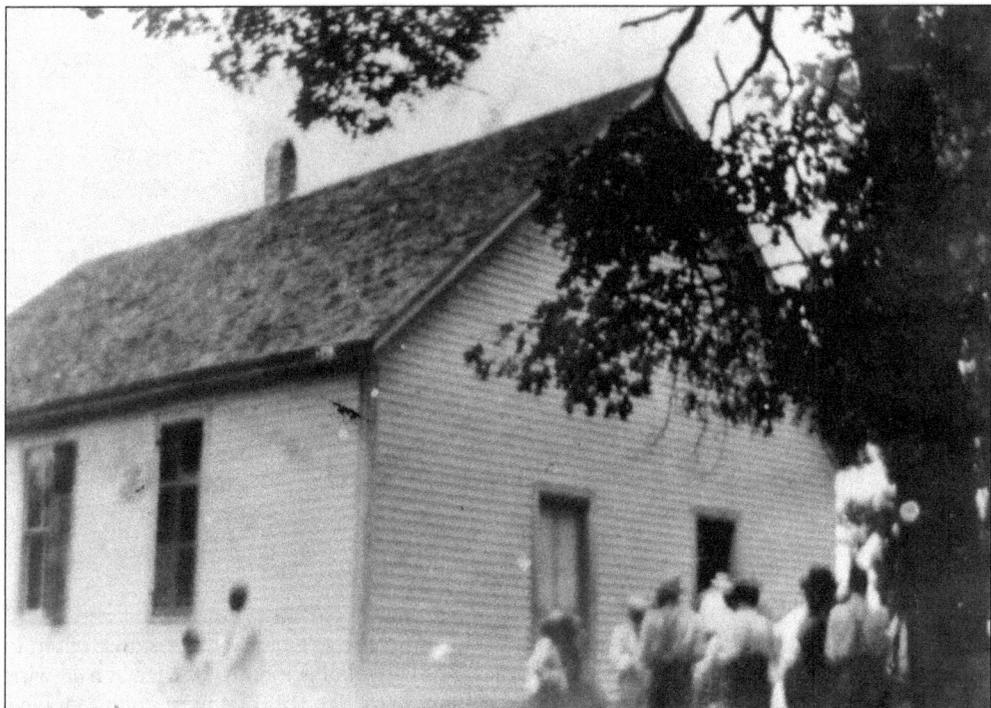

Stanley Thomas and Humphrey Lawrence donated land for the construction of Oak Grove Baptist Church, and it was completed in August 1875. A second church, shown here in 1909, was built on the foundation of the first in 1904. Amos Flood donated additional land for a parsonage, completed in 1959; new classrooms and offices were completed in 1964. The second church building was razed on September 1, 1973, and services have been held since that time in the concrete-and-redbrick building at the intersection of Oak Grove Church Road and Floyd Sumner Road. (Courtesy Betty Cunningham.)

Rev. John T. Cunningham (1859–1954) served as pastor of Oak Grove Baptist Church for 52 years (1890–1892 and 1902–1952), longer than any other to date. Cunningham served as pastor emeritus from 1952 until his death in 1954. In addition to being a Baptist minister, Cunningham also taught school for 15 years in Trigg County. (Courtesy Tom and Nell Vinson.)

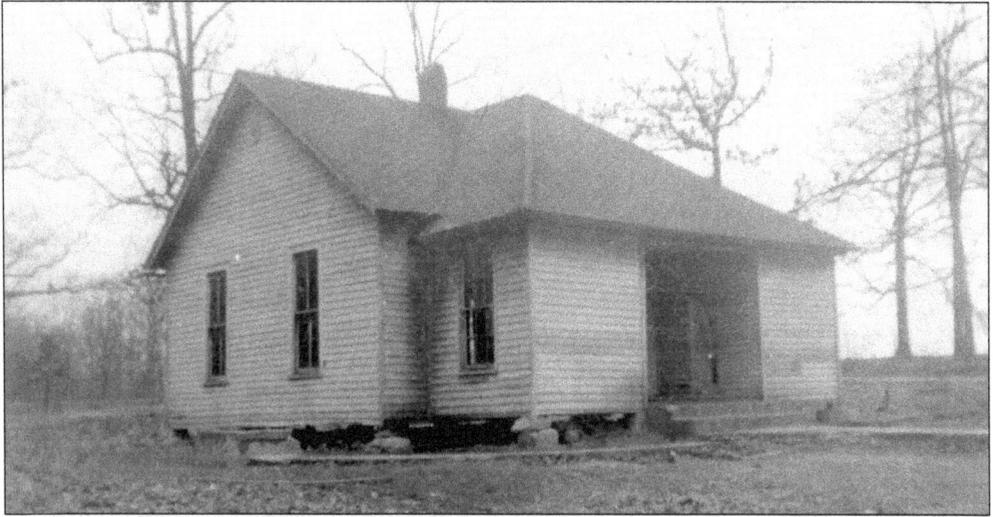

The original log Oak Grove School was replaced by this frame building in 1890. Both stood on land donated by Perry Thomas. Charles Pursley was contracted to build the 24-by-32-foot structure with a 10-foot ceiling and was paid $326.50 for labor and materials. The first teacher at the school was Ottawa Tart. Twenty-four teachers would succeed Tart at Oak Grove, ending with Anna Carr Williams in 1953, after which the school was consolidated into the county school in Cadiz. The coatrooms at the front of the building were added in 1920.

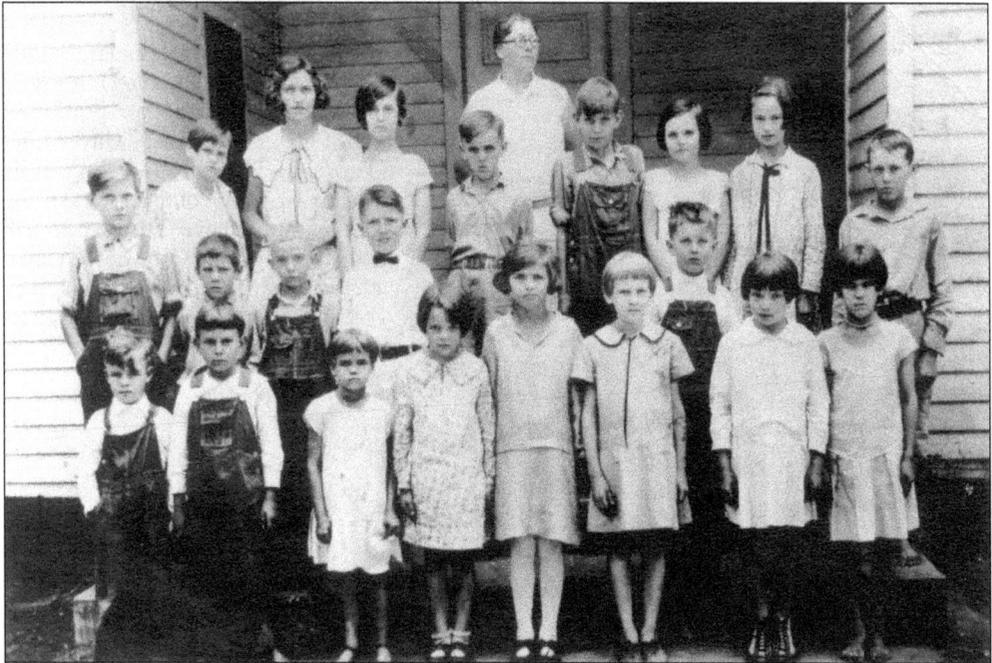

From left to right, the students in this 1928 Oak Grove School picture are (first row) Carey Davis, Alton Thomas, Mary Ann Rogers, Ruth Dixon, Norine Thomas, Agnes Sumner, Ernestine Meador, and Mary Sumner; (second row) Thomas Bridges, Lawrence Sumner, James Rogers, Douglas Thomas, Charles Thomas, and Thomas Sumner; (third row) Thelma Marquess, Mary Julia Thomas, Martha Sumner, George Sumner, Boyd Thomas, Marie Thomas, and Mallie Dixon. Teacher Lela Robey Green stands behind the third row of students. (Courtesy Joyce Banister.)

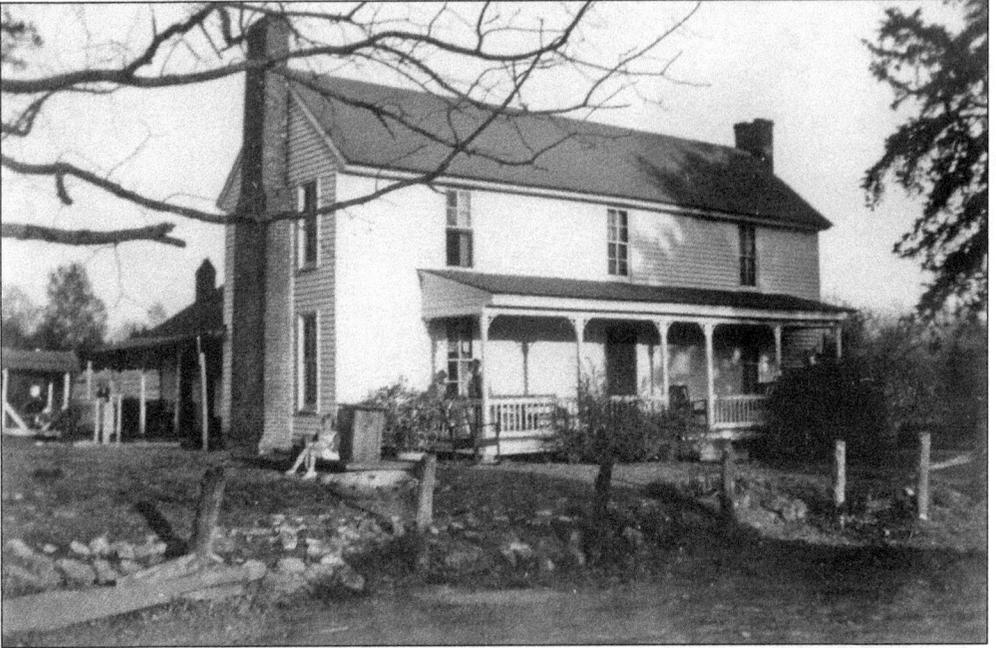

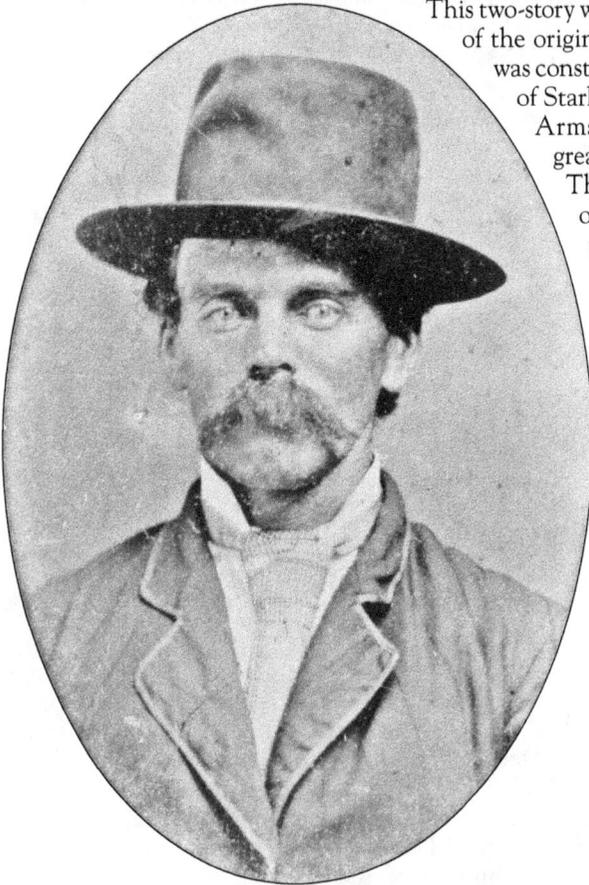

This two-story white frame house still stands on the site of the original Starkie Thomas cabin. This home was constructed around 1896 by the youngest son of Starkie and Mary Bridges Thomas, Starkie Armstead Thomas (1844–1907), a great-great grandfather of the author. Starkie A. Thomas (left) married Inez "Mitt" Miller on February 23, 1881, and the couple reared their family of daughters in the home featured above. The home is still owned and occupied by descendants of both James Thomas and Drury Bridges. A portion of the original home stood until 1934.

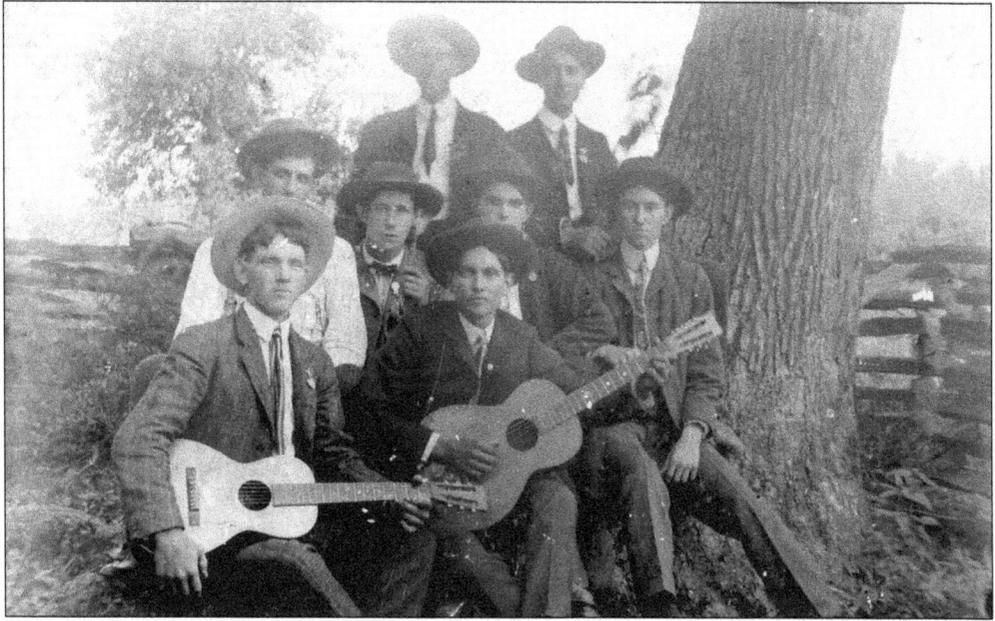

Six of the eight young men in this *c.* 1905 group were cousins. It was common practice in the era for families to gather on Sunday afternoon to visit with one another. It was not unusual for musical instruments such as fiddles, guitars, and banjos to be produced in order to add to the merriment of the occasion. From left to right are (first row) Burl Crisp and Jesse C. Bridges; (second row) Cleve Cunningham, Garland Bridges, Trevor Battoe, and Sam Bridges; (third row) D. Floyd Sumner and Vernon Coleman. (Photograph by D. W. Crawford.)

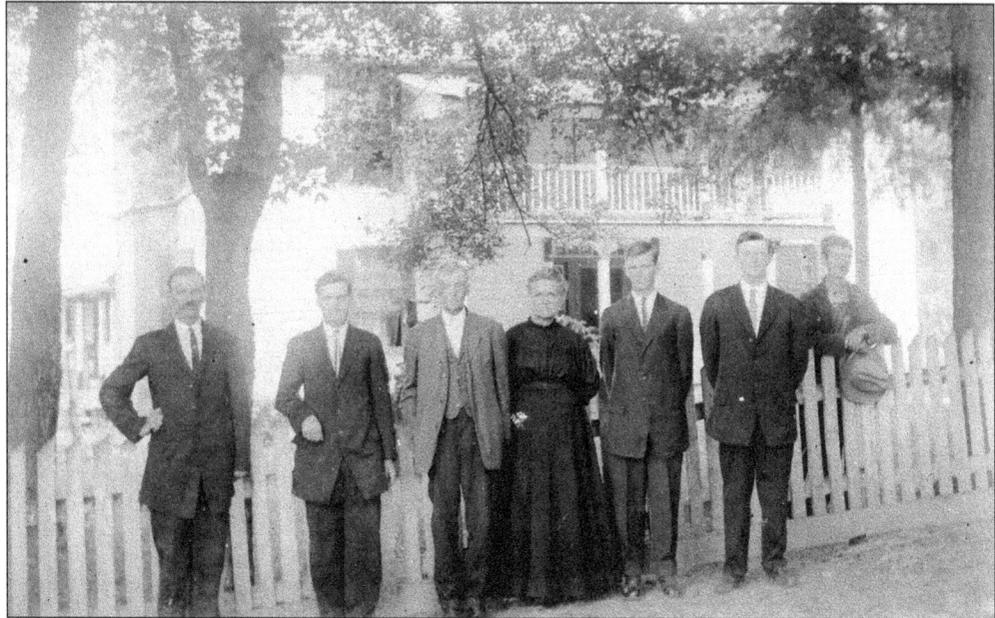

In this *c.* 1915 scene, the two-story white frame farmhouse stands behind the family of its occupants, Francis M. "Fant" Thomas, Mary Forrest Rogers Thomas, and four of their sons. Seen here from left to right are Haywood, Starkie, Fant, Forrest, James, and Alfred Thomas. The man behind the fence is unidentified. (Courtesy William Mize.)

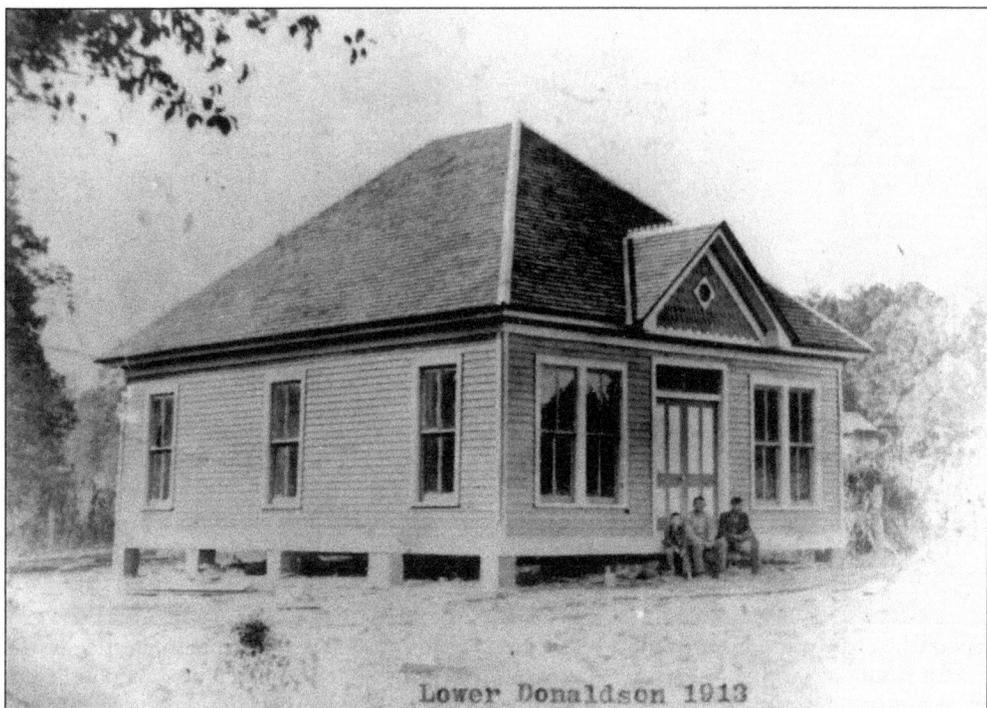

Lower Donaldson 1913

First known Dixon School, Lower Donaldson School was located 1.25 miles west of Donaldson Creek Church on land owned by the Dixon family. The school board purchased 2.5 acres of land in 1913 for $50, and John Bridges (left) built a new school to replace the former log structure, which had been destroyed by fire. The new frame building, shown here at its completion, remained in service for 49 years. In 1962, the land and building were sold to the Army Corps of Engineers for $800, and the building was razed to make way for the impoundment of Lake Barkley. (Above, courtesy Freda McAtee; left, courtesy Lucille Wilty.)

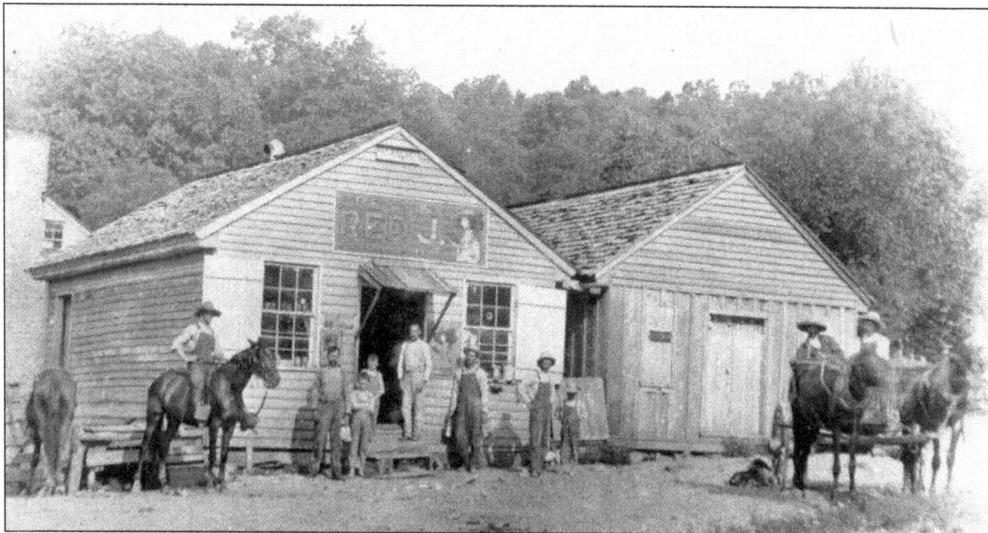

On the corner of Donaldson Creek Road and Maple Grove Road, Chilton Thomas operated this general merchandise store during the late 1800s and early 1900s. This c. 1913 scene includes the store and the adjoining post office (left). The post office was the location of the polling place for the Donaldson precinct for many years. Pictured from left to right are Garland Sumner (on horseback), Henry Dixon, his sons Blufford and Elmer, Chilton Thomas (standing in the doorway), John Bridges, Tommie Sumner, and Preston Sumner. The men in the wagon are Charlie Thomas and Edd C. Thomas. (Courtesy D. B. Redd family.)

The first school on Donaldson Creek dates to 1813, when several parents contracted with Ephraim Cowan to "teach reading, writing, and arithmetic." A log schoolhouse was in use by 1815, and it remained in use until 1910. The Bridges brothers constructed a concrete structure east of the log structure and adjacent to the present-day Peyton Thomas Cemetery. This building served the community until the 1940s, when Trigg County Schools began consolidation. This March 10, 1911, photograph features the new Upper Donaldson School with, left to right, Herbert Bridges, John T. Bridges, Mark Dale Bridges, and Cullen T. Bridges.

Cullen Thomas's 1812 cabin, photographed about 1970, stood on the south side of Donaldson Creek. The log portion of the home appears in this image covered with clapboarding. The cabin was disassembled and reconstructed near Montgomery in 1990 for use as the Trigg County Museum. Cullen Thomas was born in Bertie County, North Carolina, on August 21, 1791. He arrived on Donaldson Creek in what was then Christian County in 1806 with his father, James Thomas. (Courtesy Edison Thomas.)

Pictured shortly after its construction in 1915, this large frame house was located on upper Donaldson Creek. On the porch from left to right are Dallie B. Thomas; his daughters, Maude, Stella and Edna; his wife, Willie; and his mother, Avia Dunn Thomas. This home, one of the finest in the Donaldson Creek community, burned in the winter of 1928. (Courtesy Connie Baker.)

Four

WARRENTON AND BLUE SPRING

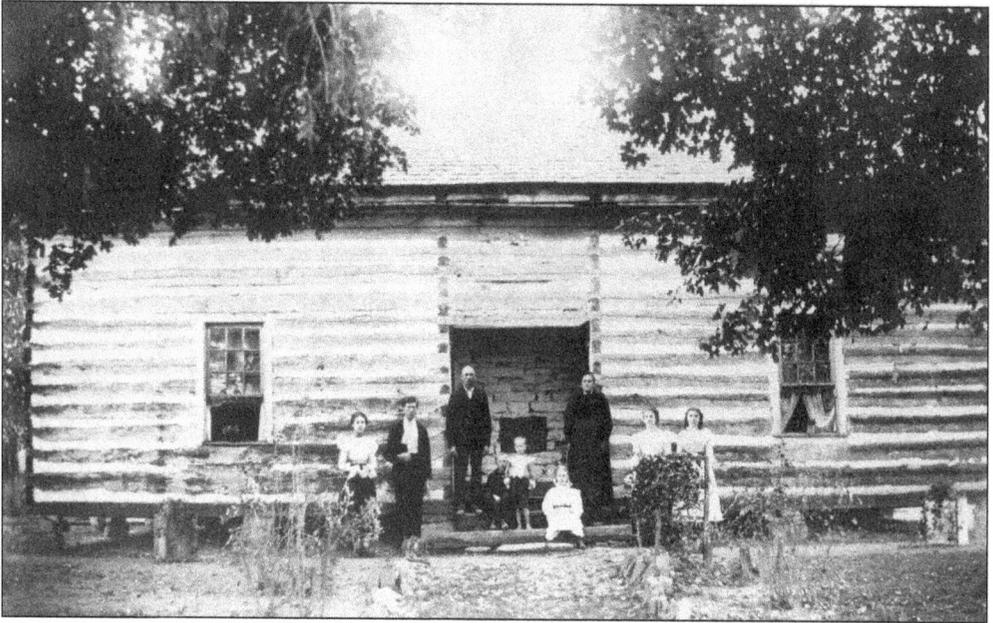

Edmund Pendleton Malone was a Virginia wagon maker who migrated to Trigg County, where he married Celena Ann Jefferson in 1844. Edmund and Celena's son, Edmund Pendleton Malone Jr., was born in Trigg County on February 18, 1855. He is pictured with his family in front of their double log cabin located on what is now Malone Road west of Cadiz in the Warrenton community. Shown from left to right are Malone family members Ethel, Schuyler, Edmund, Henry, Elliott, Janie, Bettie, Ida, and Annie, seen here around 1900. This home remained in the family until it was destroyed by fire on July 1, 2001. (Courtesy Freda McAtee.)

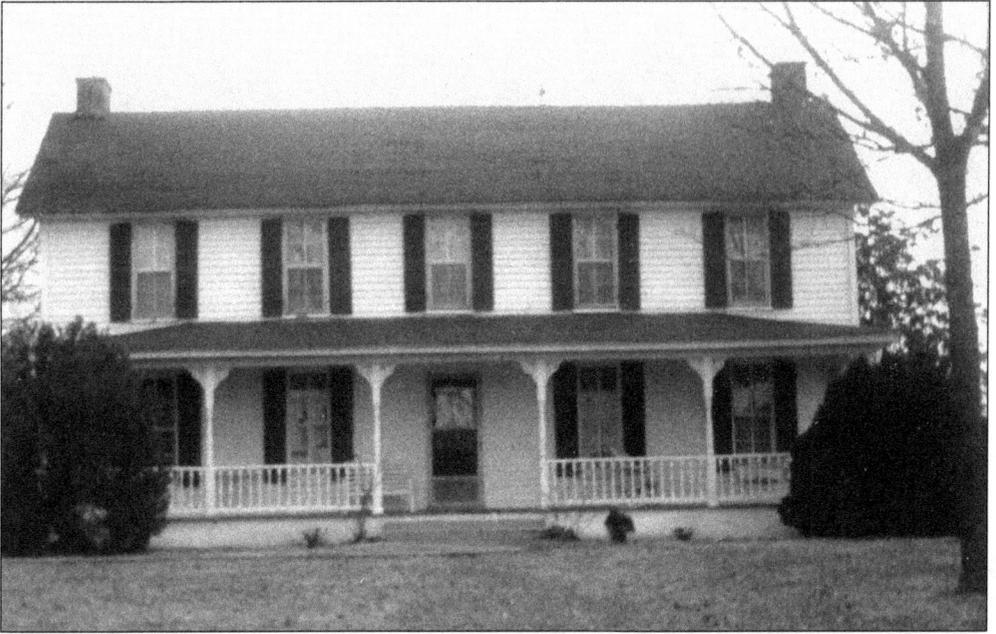

This two-story frame farmhouse was constructed around 1880 by Thomas Vinson. The house has remained in the Vinson family since it was built; it is presently the home of Shannon Perry. This structure stands on the "old Carson place," which was owned by Samuel Orr at the county's formation in 1820. It was at Orr's Warrenton home that the first court of Trigg County was held on May 15, 1820. The original house located on this site was a two-story brick structure that served both as a dwelling and a trading post; soldiers burned it during the Civil War. The chimneys of the present home are believed to have been constructed using bricks from the original structure. (Courtesy Tom Vinson.)

Pinkney B. Harrell (1835–1923) is pictured here with his horse and buggy near his Warrenton farm. Harrell served in the Confederate army under Capt. Alfred Thomas, also from Trigg County. Captured at Fort Donelson, Harrell was held prisoner at Camp Douglas, Illinois, for seven months, after which he was transported to Vicksburg and exchanged. The road in this c. 1920 photograph would later become U.S. Highway 68. (Courtesy Kim Fortner.)

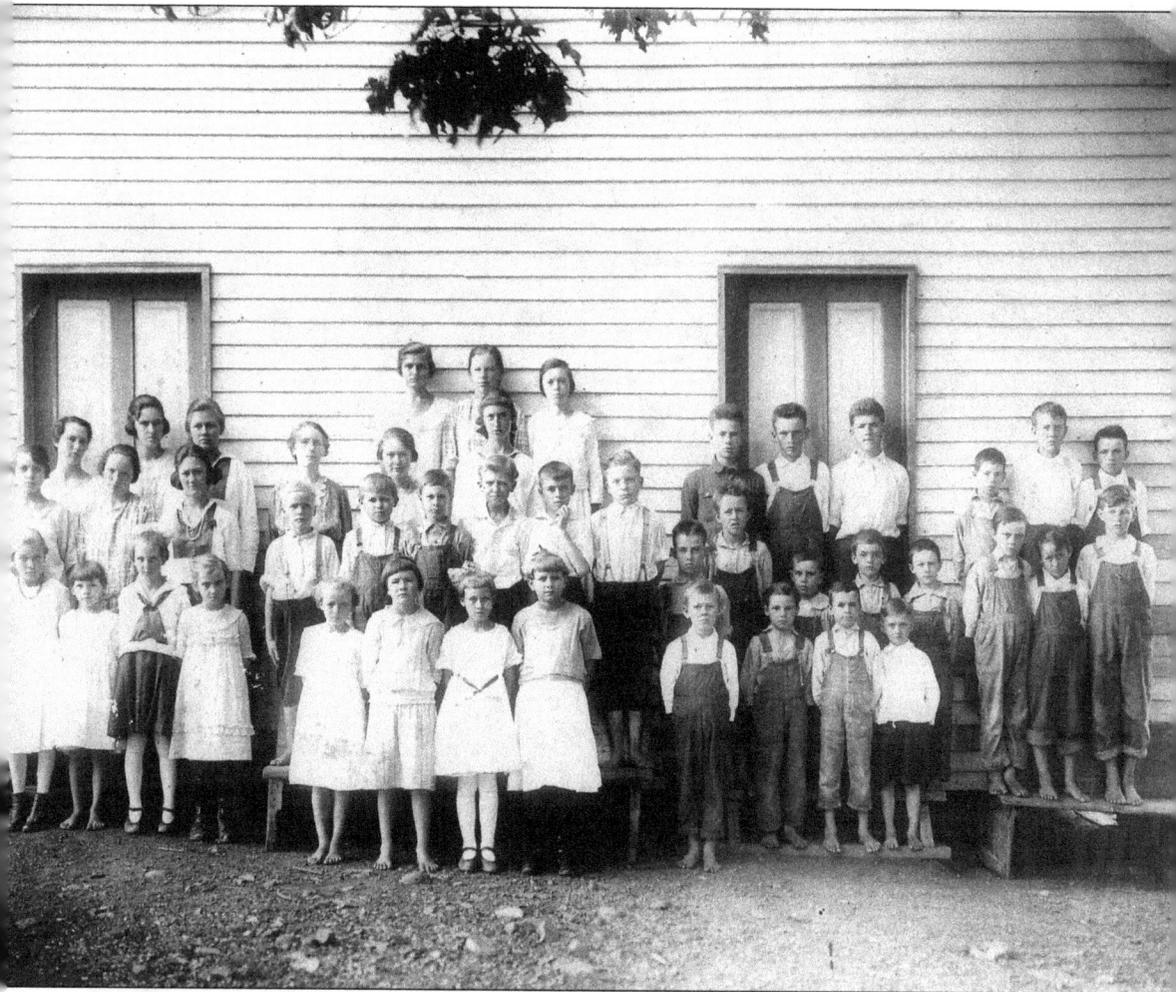

Established in 1889, Warrenton School stood 4 miles west of Cadiz alongside what is now Blue Spring Road. The original school building burned in early 1943, but another was erected in time for classes to resume in July. The first teacher was Rev. John T. Cunningham. Warrenton School remained in service until 1953. From left to right, the individuals in this *c.* 1920 photograph are (first row) Edna Hughes, Virginia Perry, Monico Guier, Mary Ann Stallons, Myra Flood, Elizabeth Radford, Ora Mae Stallons, Anna Sevens, Richard Hughes, Marlan Stallons, Jesse Grant, and Grundy Coleman; (second row) Nellie Perry, Helen Timmons, Mary Hughes, Denny Gresham, Garland Perry, Manuel Light, Bertram Hughes, Marcellus Miller, Lacy Gresham, Dennis Lawrence, Herbert Radford, Leslie Terrell, Herman Porter, Malcolm Light, Berthal Stallons, Charlie Flood, and Stanley Stevens; (third row) Commie Timmons, Eleanor Stallons, Elizabeth Hughes, teacher Maude Crute, Gertrude Hughes, Clara Miller, Clyde Lawrence, Johnny Stallons, Homer Radford, Edgar Terrell, William Flood, and Clarence Stallons; (fourth row) unidentified, Irene Timmons, and Gladys Perry. (Courtesy Florence Drennan.)

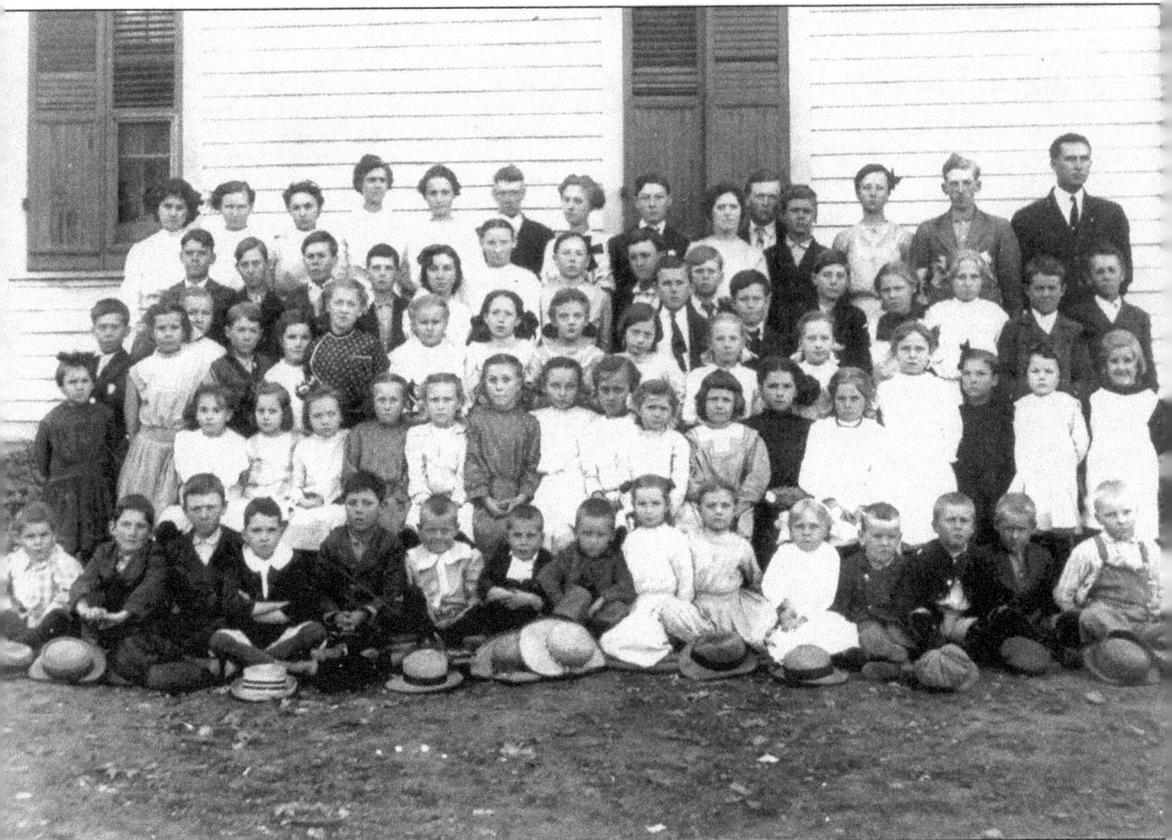

Located near the present site of Mount Pleasant Baptist Church, Blue Spring School was in service from prior to 1900 until 1959, when it was consolidated. This 1912 school photograph includes, from left to right, (first row) Hazel Noel, Beacham Curtis, Taylor Boyd, Shirley Braboy, Claude Finley, Robert Lancaster, Gordon Bridges, Clovis Noel, Kitty Hendricks, Lola Crisp, Edna Baker, Oscar Stallons, Rumsey Smith, Odell Noel, and Clinton Stallons; (second row) Ollie Hall, Ray Coyle, Mamie Boyd, Desda Keel, Myrtle Wallace, Etna Keel, Peachie Hendricks, Pansy Lancaster, Ruby Baker, Robbie Bridges, Julia Braboy, and Ophia Baker; (third row) Lucile Noel, Clovis Thomas, Lola Jo Bridges, Arminta Noel, Landis Cunningham, Jewel Cunningham, Lois Noel, Nella Noel, Agnes Coyle, Louise Crisp, Dorothy Coyle, Lizzie Baker, Sarah Guier, Coella Baker, Lanona Finley, Bertie F. Cunningham, and Orine Noel; (fourth row) Aubrey Lancaster, Delphus Coyle, Eli Thomas, Coy Braboy, Essie Mae Cunningham, Ethel Hendricks, Willie Dew, Othis Noel, Herman W Wallace, Relious Thomas, John Thomas, Delmar Coyle, Ann P. Smith, Mamie Baker, John Lancaster, and Goebel Wallace; (fifth row) Leah Noel, Ollie Hendricks, Nila Cunningham, Sophia Smith, Lillia Mae Braboy, Floyd Lancaster, Eva Baker, Forrest Guier, Argie Coyle, Andrew Wallace, Elliott Smith, Nannie Dew, Carlos Baker, and teacher Calvert Wallace. (Courtesy Betty Cunningham.)

The Frederick Guier home was located at the approximate site of the pro shop at the Boots Randolph Golf Course. The property was acquired by the Commonwealth of Kentucky around 1965 for inclusion in the Lake Barkley State Resort Park. The Blue Spring is a few yards from the former homesite and draws its name from the color of its deep, clear, icy blue water. (Above, courtesy Betty Cunningham.)

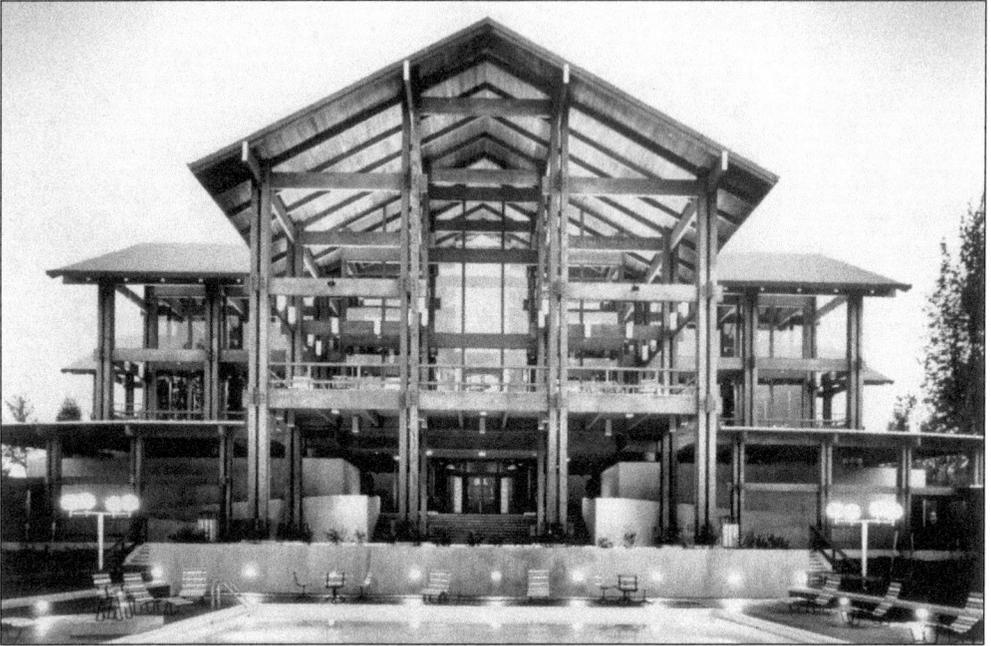

Lake Barkley State Resort Park was established in 1964, named for former U.S. vice president Alben W. Barkley, and contains approximately 3,200 acres of lakeshore land within the boundaries of Trigg County. The park opened on December 1, 1967, and has served the commonwealth as its flagship park since that time. The centerpiece for this recreational area is the massive frame lodge erected on a peninsula near the original mouth of Little River. Designed by the noted architect Edward Durell Stone and constructed by the Clark Construction Company of Owensboro, Kentucky, the 120 guest rooms provide accommodations for 300 people. Construction began in 1967, and the facility was dedicated on June 1, 1970. Constructed of western cedar, Douglas fir, and 3.5 acres of glass, the Barkley Lodge complex provides a lake view from the entire facility. (Both, courtesy William Turner.)

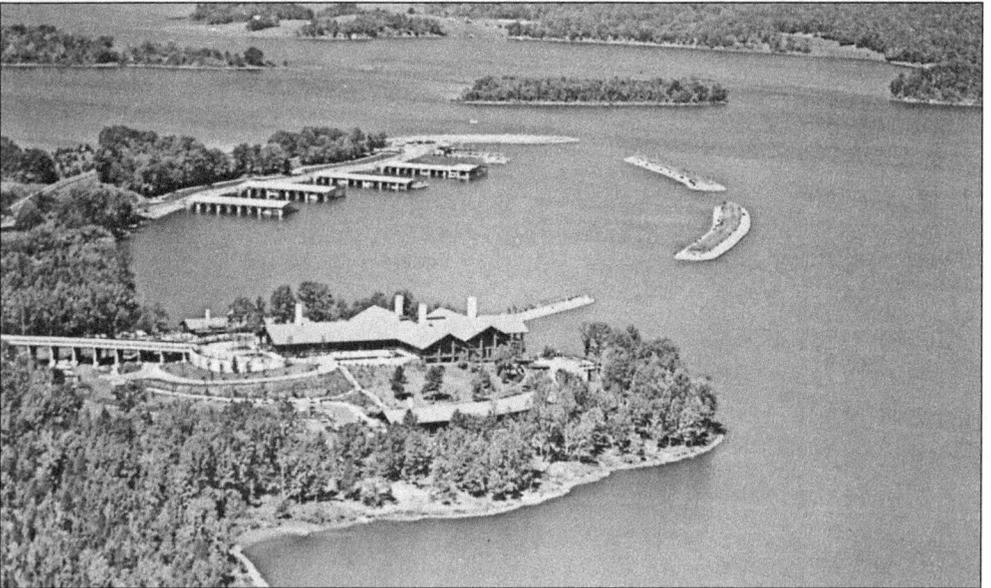

Five

ROARING SPRING
AND LINTON

One of the earliest and most popular natural landmarks in the area was this cave in the southeastern edge of the county. Its cool air and fresh water made it a gathering place for all ages. They assembled here for swimming, exploring, picnicking, and camping from the earliest days of Trigg County's recorded history. Tradition has always emphasized the sound of roaring water from deep within the cave, hence its name. (Courtesy Mary Lou Roark.)

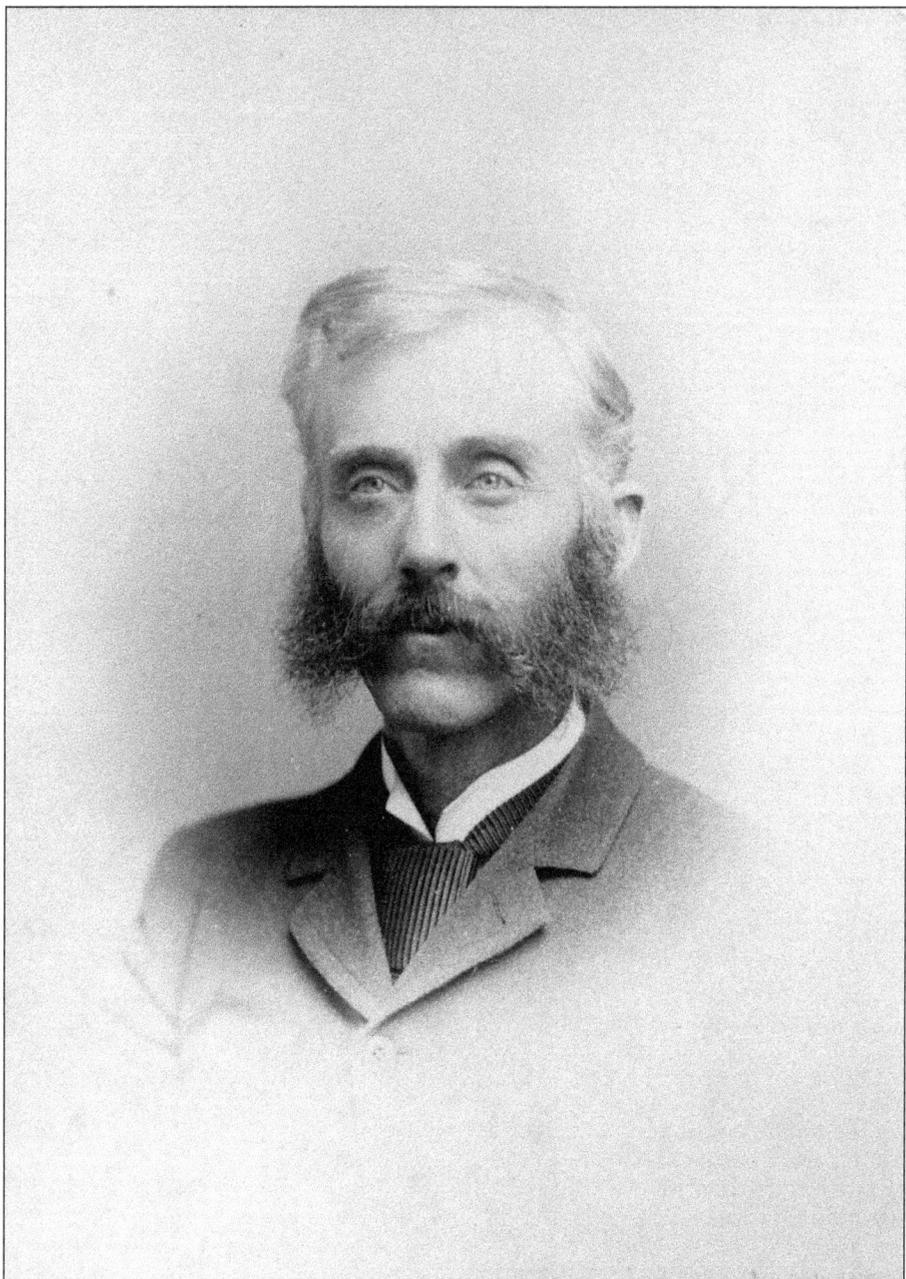

William W. Lewis was born on November 28, 1849, near Lafayette, Christian County, Kentucky. Lewis moved with his family to the Roaring Spring precinct in 1853. He was educated in the county schools of Trigg County and also attended the academy at Elkton, Todd County, for a short time. Lewis married George L. Dickinson in Christian County on February 25, 1885. As a farmer, he accumulated 200 acres. He was a member of the Christian Church at Roaring Spring, the Roaring Spring Lodge, No. 221, AF&AM, and was a Democrat. Lewis represented Trigg County in the 1890–1891 state constitutional convention held in Frankfort. The 1900 Federal Census of Trigg County lists him as a resident in the Roaring Spring voting precinct. (Photograph by H. G. Mattern, Courtesy Kentucky Historical Society.)

This two-story double log home with an open breezeway, later enclosed to create a central stairway, was built around 1820 by John P. Nance. The child at the extreme left is unidentified, but the other individuals are all members of the Dr. Henry Lewis John Hille family who settled in the Roaring Spring area around 1875. Seen here from left to right are Mable, Henry Lewis John, Katie, and Alberta Hille; Henry's wife, Camille Walters Hille; his sister Annie; and Grover and Henry Hille. (Courtesy Betty Hobson.)

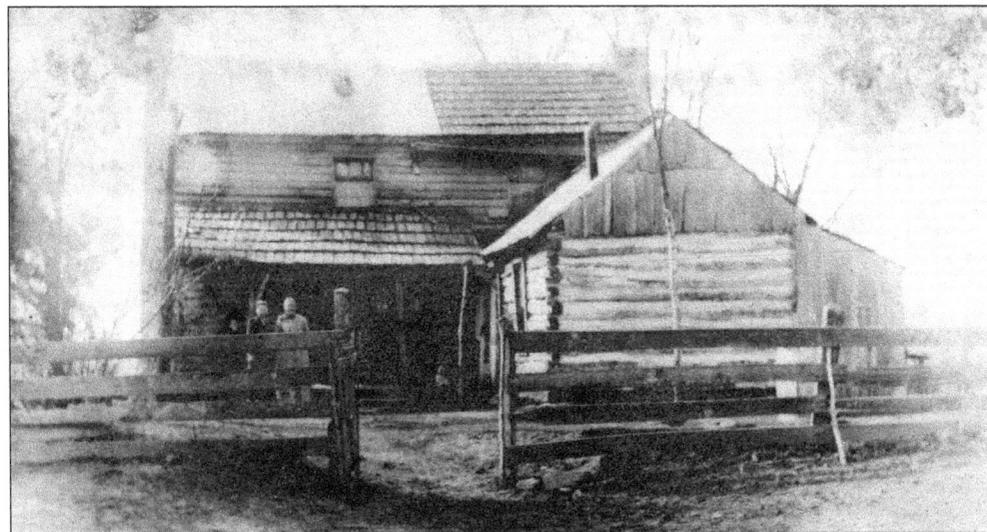

This Roaring Spring landmark stood about 5 miles from the spring in the Oakland community. The log structure with its wood shake roof reveals the architectural style of many Trigg County homes in the years leading up to the War Between the States. Several generations of the David Randolph family occupied this home through the late 19th and early 20th centuries. Standing on the front porch are Virginia Smith Randolph and her grandson James Tuggle. (Courtesy Mary Lou Roark.)

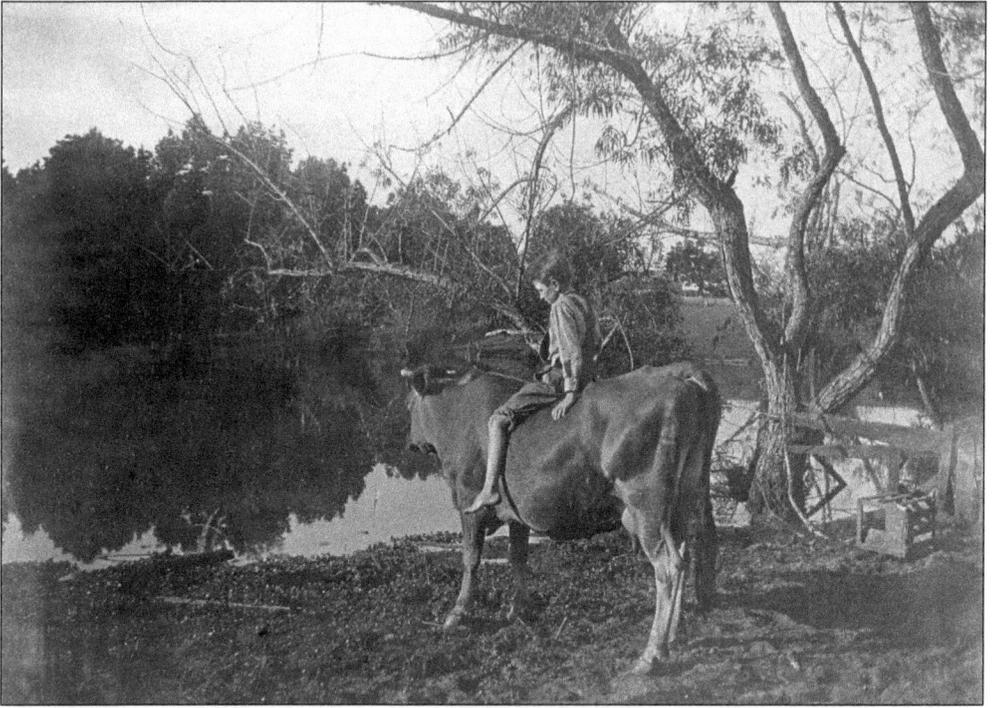

This comical image reveals Jimmie Tuggle riding the family cow on her way to the pond. Most rural families had a least one cow that was as much a member of the family as the modern dog or house cat. This snapshot was taken on the Tuggle-Randolph farm near Roaring Spring around 1910. (Courtesy Mary Lou Roark.)

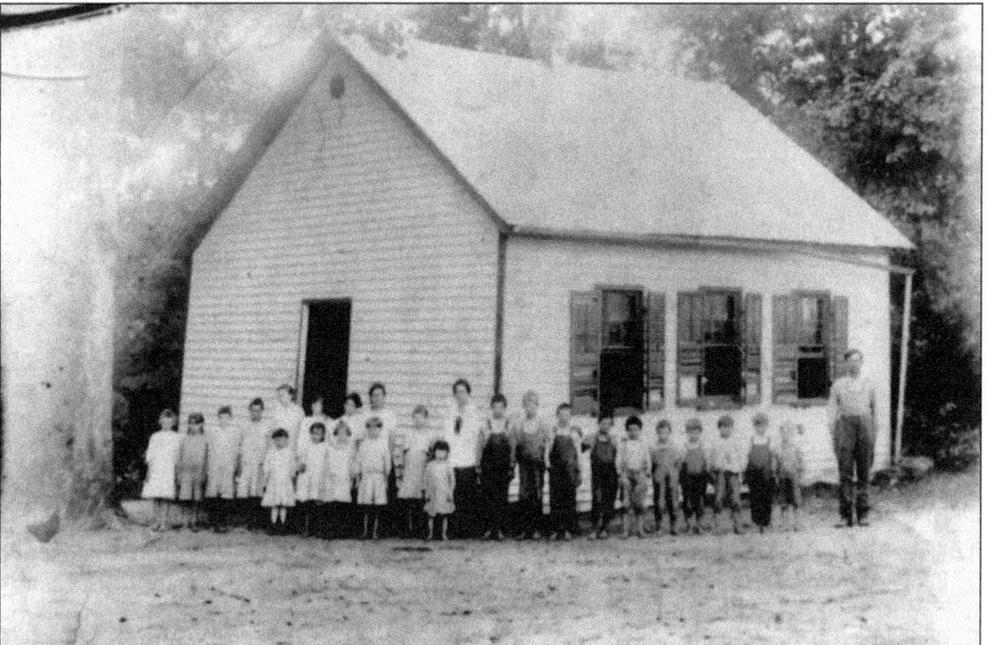

Delmont School was established around 1900 near the present site of Delmont Baptist Church. Teachers like Lorene Bridges, center, boarded with nearby families when school was in session.

Roaring Spring Christian Church began in a log schoolhouse at Buford's Spring on Casey Creek in 1833. The original name of the church was Lebanon Christian Church. A building was erected near Casey Creek and was in use until 1878. The church moved to its new building and assumed its new name in May 1878. The building near Roaring Spring burned during Sunday school services in February 1946. Church services were held at the Roaring Spring School until the new building, pictured above, was completed in 1948.

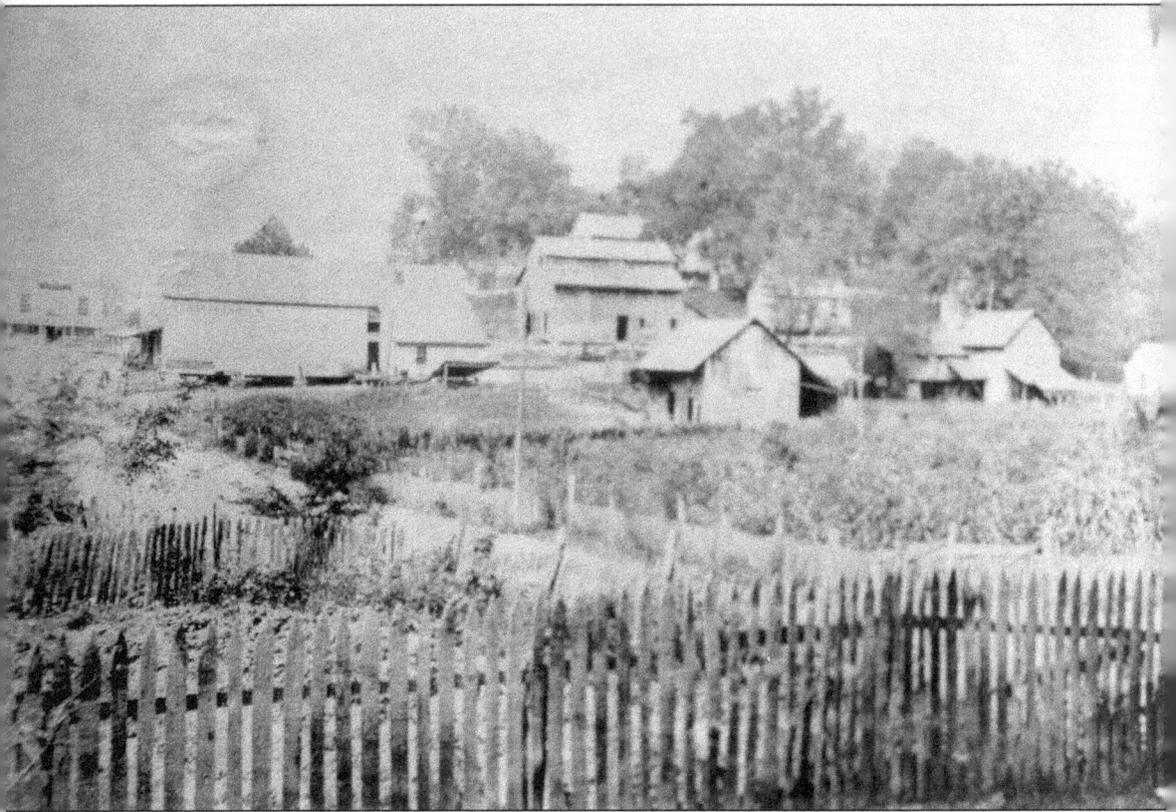

The Wester family migrated from North Carolina around 1798 and settled on Dry Creek near the Cumberland River in what is today Trigg County. Abel Olive, a brother-in-law of the Westers, arrived in the area around 1798. By 1800, several other families had settled, and Linton was established. The first general store was opened in 1830; in 1845, Stacker Furnace was built. The furnace only burned for a short time, and by 1856, operation of the furnace had ceased. In about 1858, S. A. Lindsay purchased the iron company's lands, laid out a 7-acre town, and offered lots for sale. (Courtesy Terry Lee McNichols.)

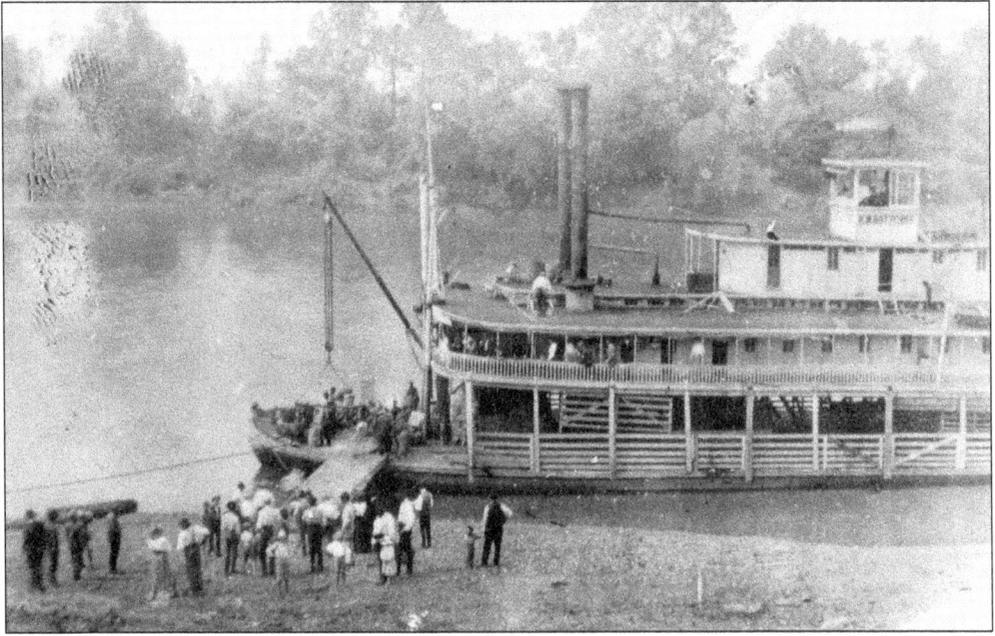

This scene reveals the excitement of a steamboat landing around 1895, before the rail and road improvements of the 20th century reduced river traffic. The boat here is tied at the east bank of the Cumberland River at Olive's Landing, later called Linetown, Shipsport, and—finally, in 1858—Linton. (Courtesy Terry Lee McNichols.)

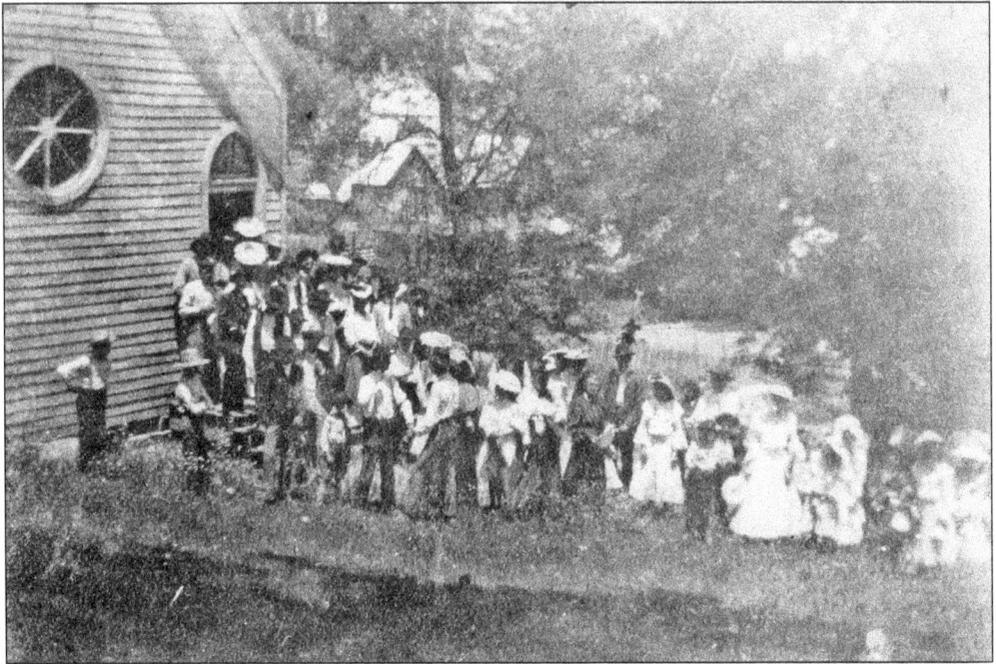

A large crowd, dressed in their finest attire, is featured in this c. 1900 photograph at the Linton Methodist Episcopal Church, South. Early services of this congregation were held in a local tobacco warehouse until a house of worship was erected in 1869. The structure was one of many demolished in preparation for the impoundment of Lake Barkley. (Courtesy Terry Lee McNichols.)

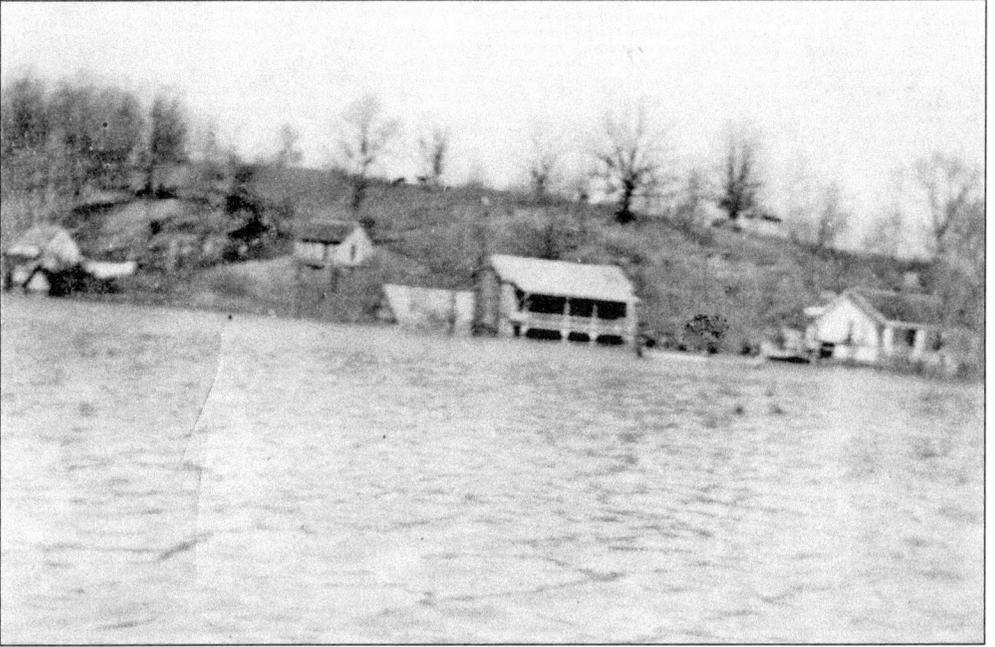

These images, captured during the 1937 flood, reflect the destructive power of the Cumberland River. While the river was the lifeblood of communities like Linton, Canton, and Rockcastle, their residents often suffered great tragedy and ruin; in addition to the 1937 flood, flooding paralyzed the region in 1917 and 1927. (Both, courtesy Terry Lee McNichols.)

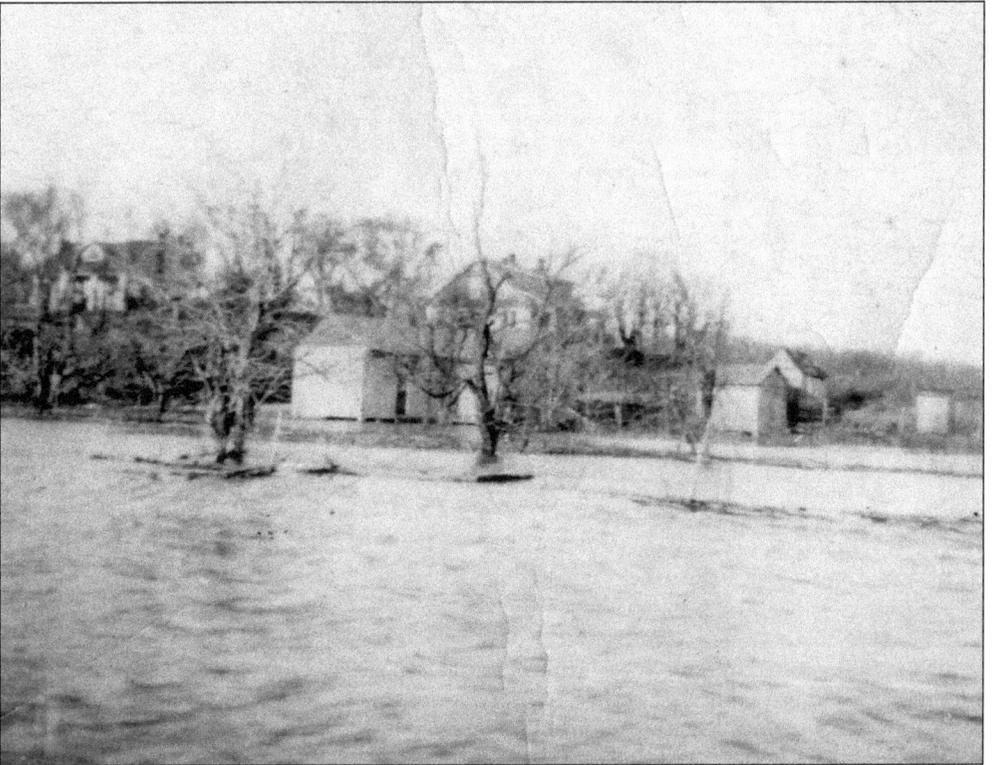

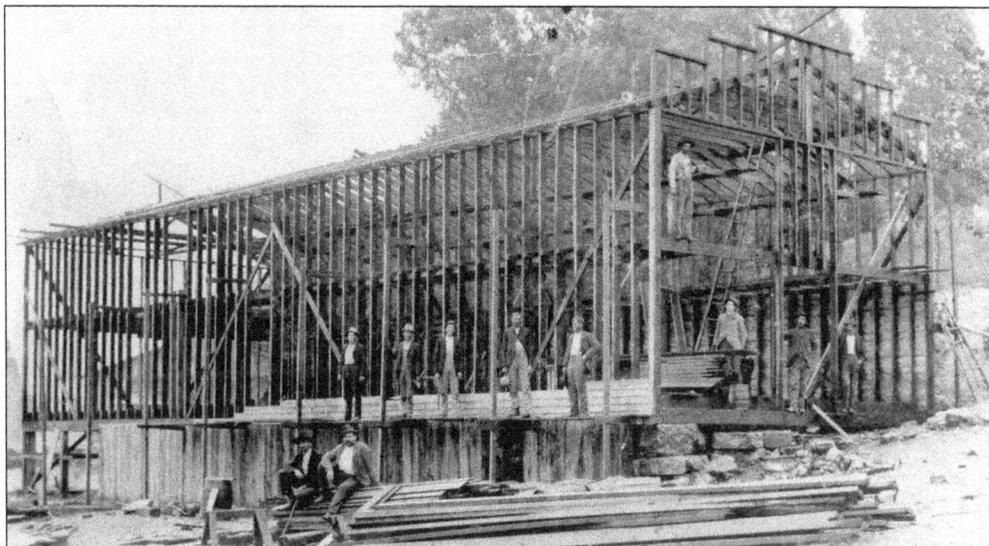

S. W. "Mr. Sam" McNichols, J. B. Bartee, and W. F. Sills organized the McNichols Mercantile Company in 1900. Between 1856—when operations ceased at Stacker Furnace—and the end of the iron furnace industry in the region around 1880, timber became the primary source of revenue in the rural village of Linton. The McNichols Mercantile Company led the community in harvesting timber and milling it into railroad ties. This was a profitable business in the late 1930s and early 1940s, as an average of approximately 41 million railroad ties were replaced annually in the United States. (Courtesy Terry Lee McNichols.)

This early 1920s bungalow, representative of many similar homes built throughout the county, was constructed on the Samuel Wilkinson McNichols home place in Linton. A rock retaining wall was built in front of the home about 1940 using the remains of Stacker Furnace. A portion of the wall remains, although much of it was destroyed when Highway 152 was widened and blacktopped in 1952. (Courtesy Terry Lee McNichols.)

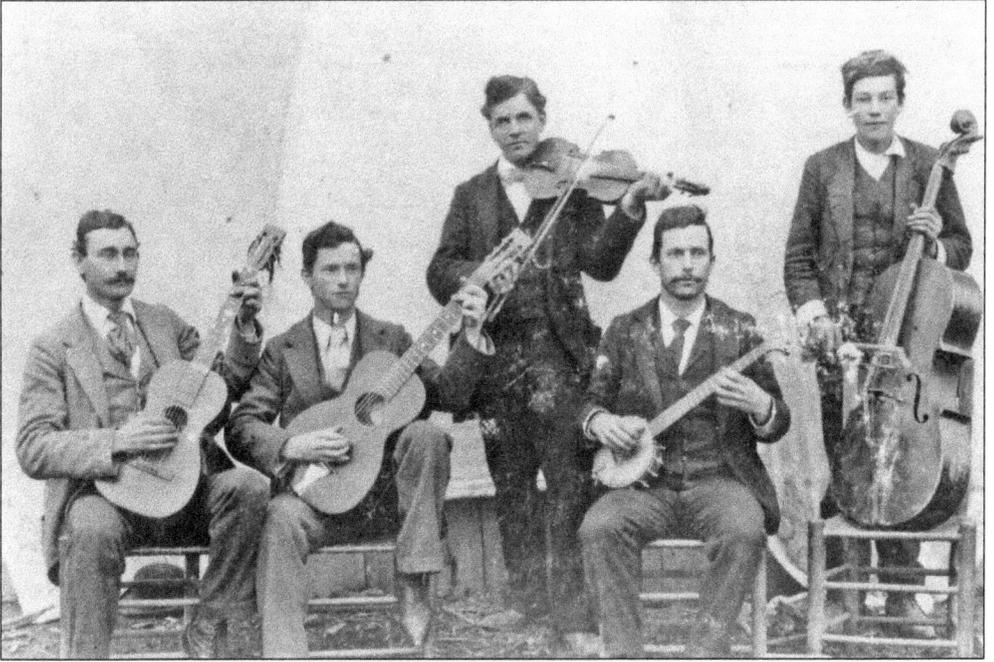

The Linton String Band is, from left to right, S. W. McNichols, Ed Spurlock, Cope Vinson, L. A. Tucker, and Joe Hunter. (Courtesy Terry Lee McNichols.)

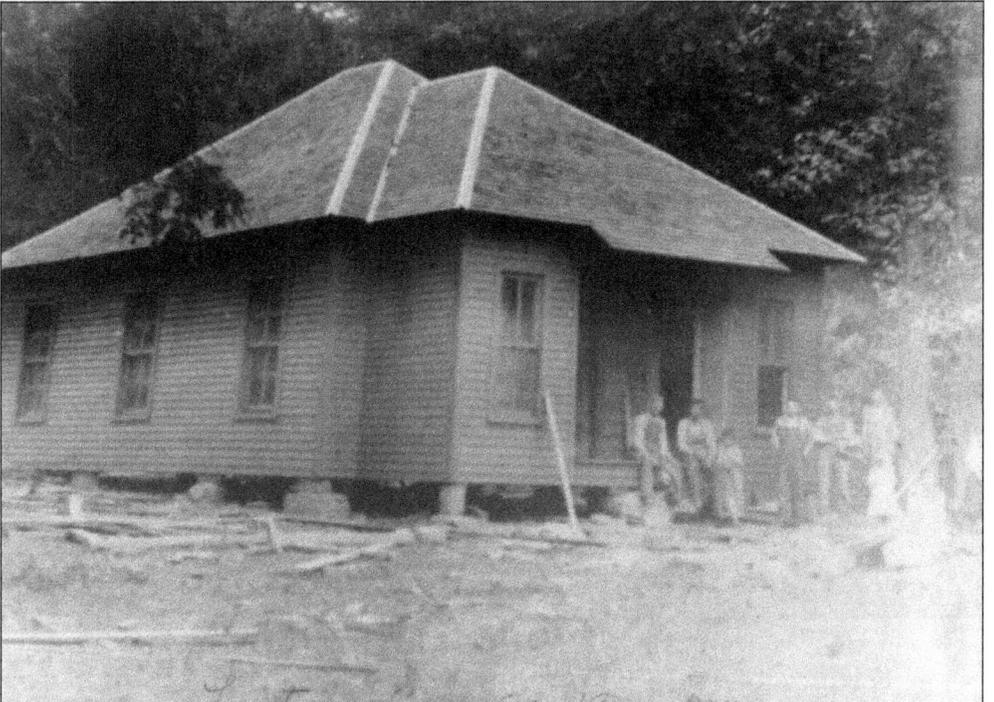

This structure was the second high school building constructed in Linton. Located at the bottom of Tine Allen Hill, the building was constructed in 1919.

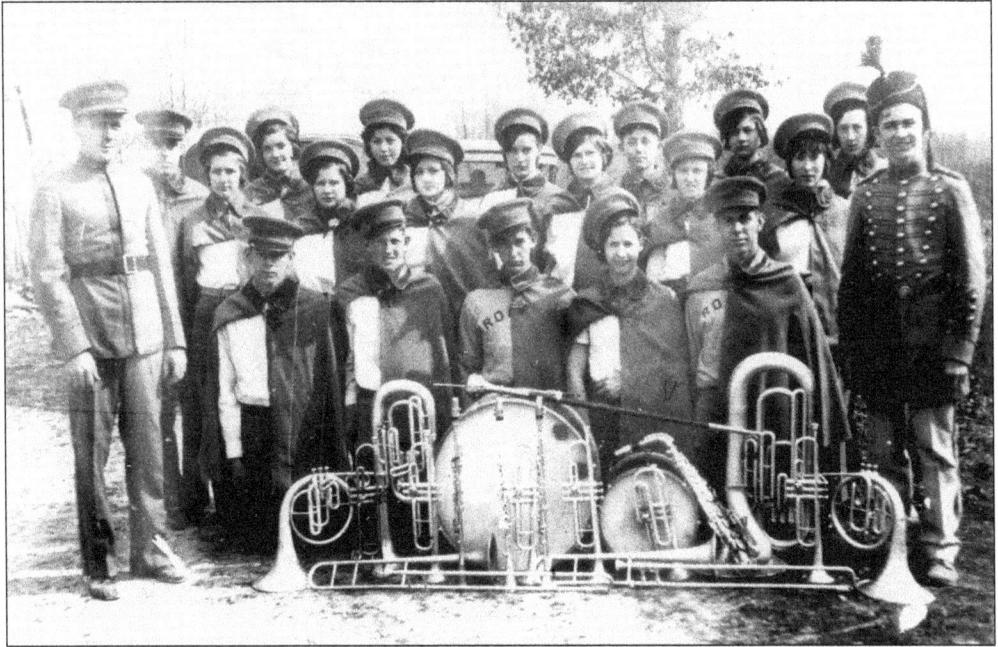

Rogers High School was located in the isolated Cumberland River town of Linton. The school's marching band, pictured around 1930, is thought to have been the first high school marching band organized in the county. Ardell Holmes was the first band director, and Junior Wolfe was the first drum major. In 1939 and 1940, upperclassmen were taken by bus to the high school in Cadiz, but in 1941, Rogers High School was consolidated into the county schools. (Courtesy Terry Lee McNichols.)

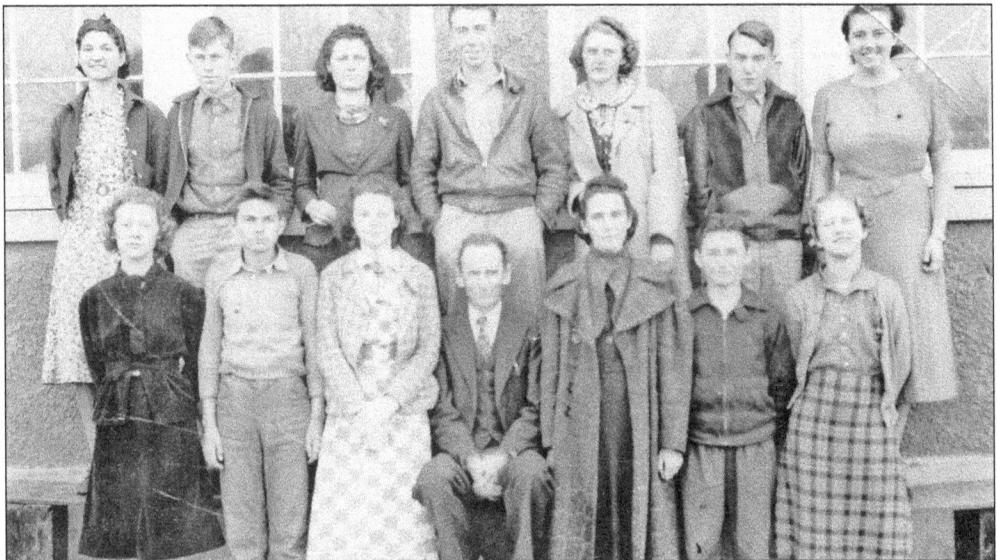

This 1938–1939 Rogers High School photograph features the sophomore class with its teachers and principal. From left to right are (first row) Mayme Cunningham, Robert Lee Gordon, Ruth Mae Dunn, Principal Charles Feltner (seated), Mrs. Norman Rose (teacher), Henry Wolfe, and Madolen Downs; (second row) Nellie Stallons, Clarence Hargrove, Anna Myrtle Futrell, Prentice Morris, Eunice Dunn, Robert Carr, and Alice Caldwell (teacher). (Courtesy Betty Hanberry.)

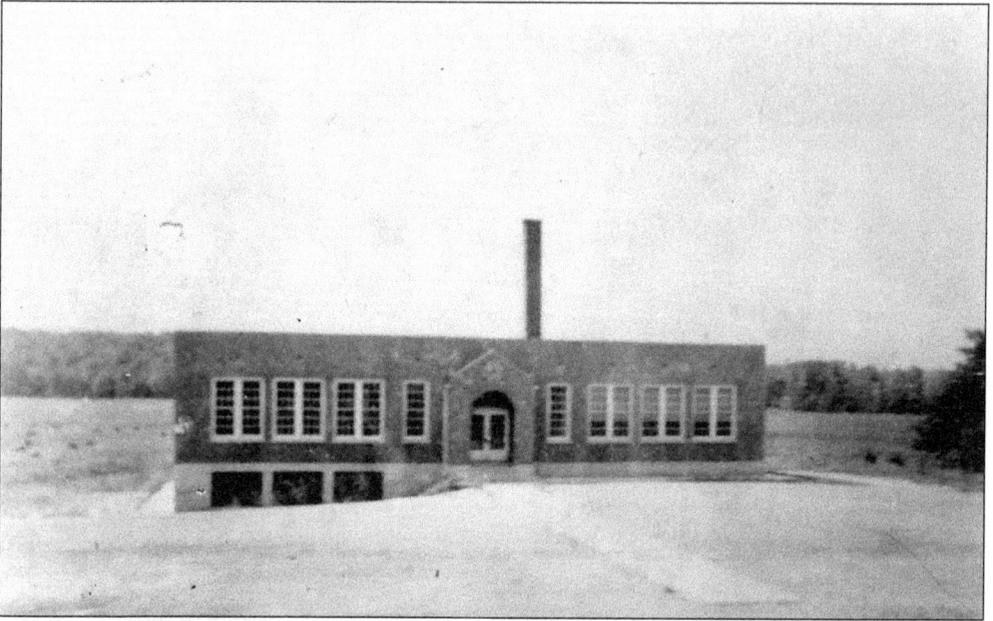

A product of the new deal, Linton Grade School is featured in this image in the era of its late-1930s construction. The Works Progress Administration used local labor to construct this and several other schools throughout Trigg County. This building remained in use until May 1960, when the Army Corps of Engineers acquired the building, and its students, teachers, and equipment were consolidated into the Trigg County Public Schools in Cadiz. (Courtesy Terry Lee McNichols.)

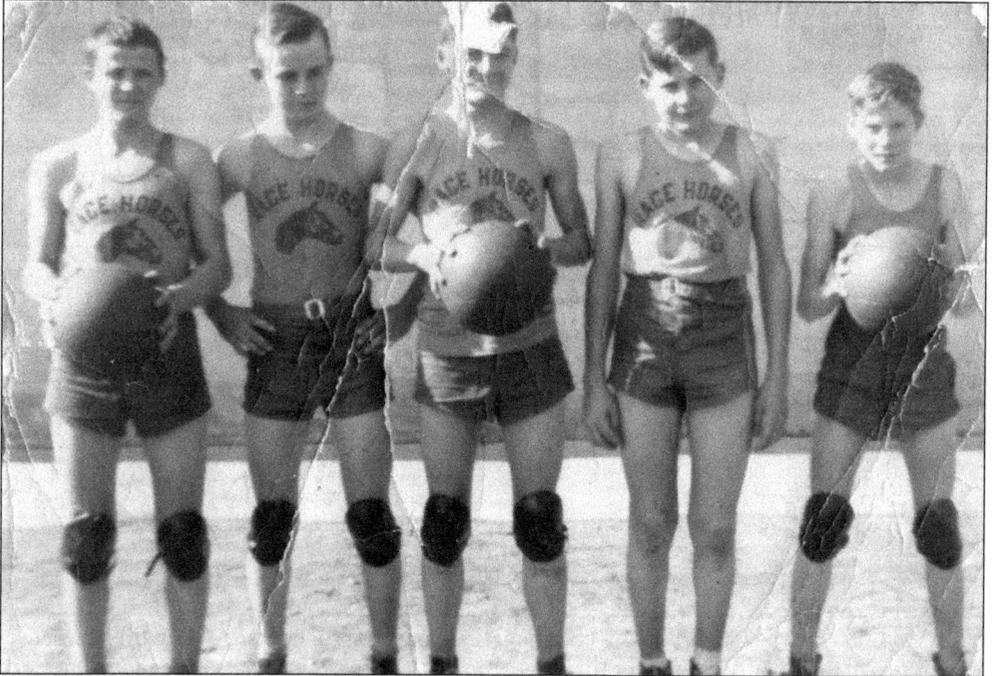

The Linton Race Horses played basketball for the Linton Grade School. This c. 1957 team includes Arrice Taylor, Donald Williams, Billy Wayne Taylor, Dorris Taylor, and Jimmy Dawson. (Courtesy Terry Lee McNichols.)

Six

CADIZ

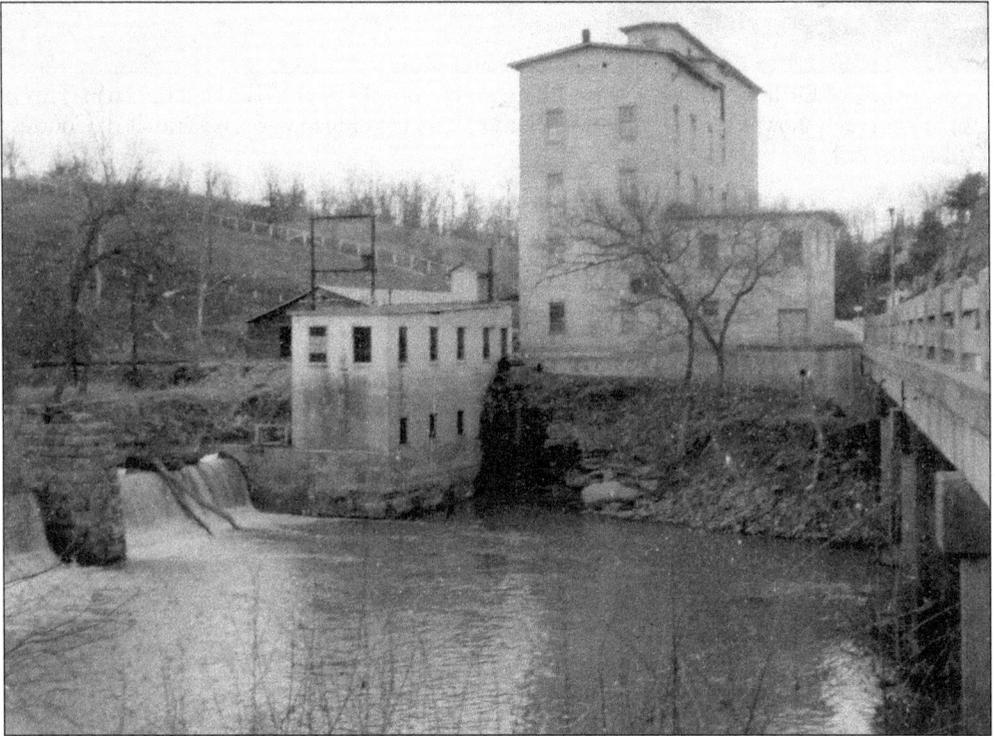

This view of the Cadiz Milling Company reveals the high water mark of the January 1937 flood. Percy White selected the site for the new mill in 1910; the powerhouse was completed in 1911 and the mill in 1913. The Cadiz Mill was among the first in Kentucky to utilize hydroelectric power. The flour mill was destroyed by fire in the fall of 1958. In 1959, the remaining structures on this site were purchased by the Army Corps of Engineers, and milling operations ceased in west Cadiz. A new modern feed mill was constructed 5 miles east of Cadiz in Montgomery. (Courtesy Stan White.)

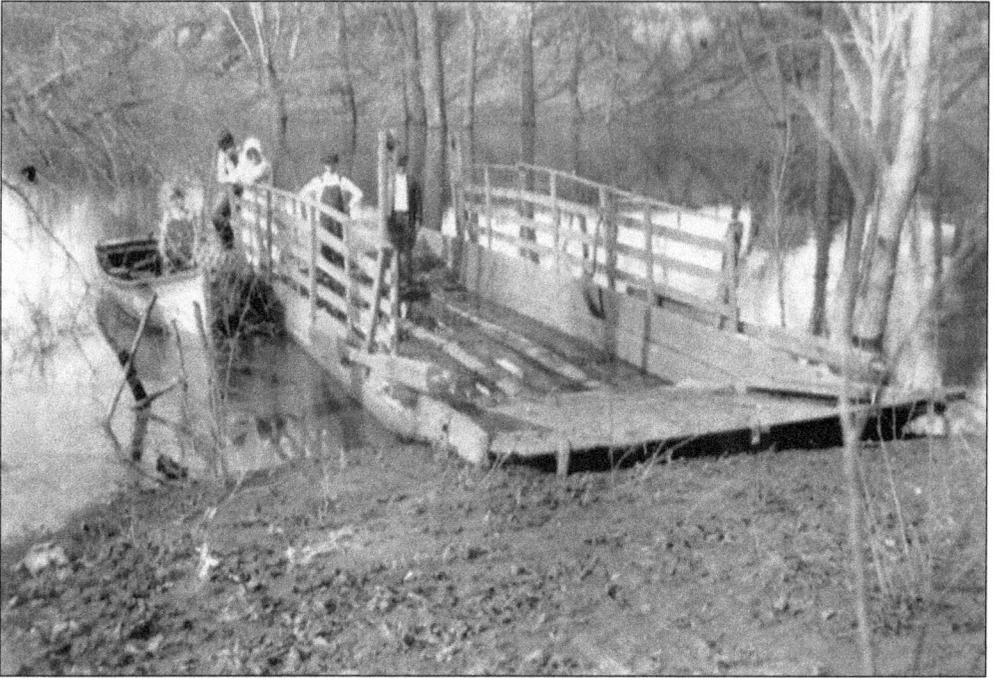

The crossing of Little River was a short affair, powered only by the oars of a rowboat. This *c.* 1910 photograph shows a typical early-20th-century ferry crossing in western Kentucky. (Courtesy Paul Fourshee.)

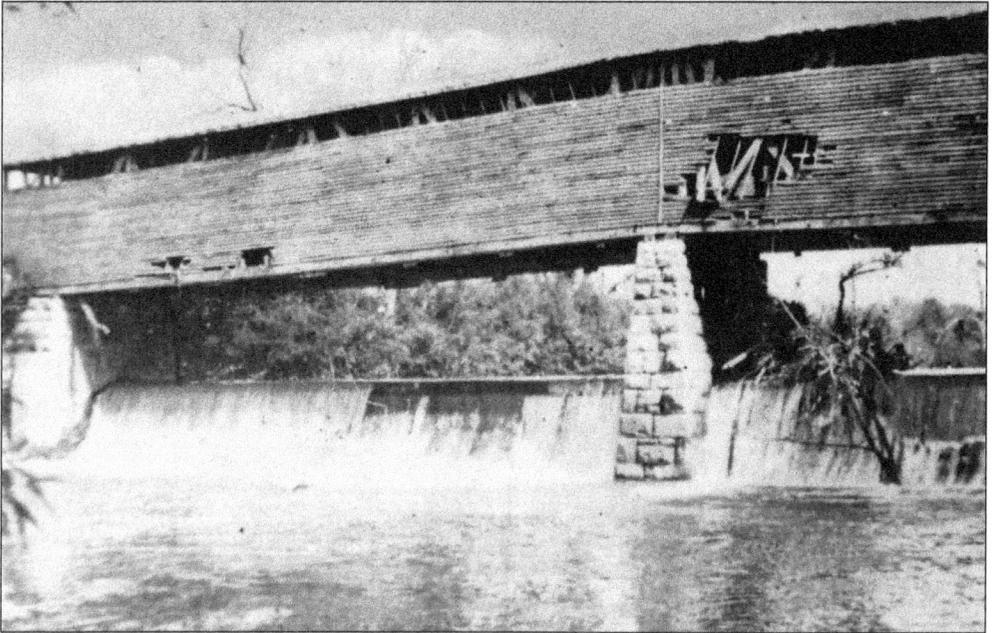

Located on the south side of Cadiz Milling Company over Little River, this hallowed landmark was one of three in Cadiz. The other two covered bridges spanned Little River on the Ollie James Highway in Street's Bottom and on the Rockcastle Road north of the Cadiz Mill.

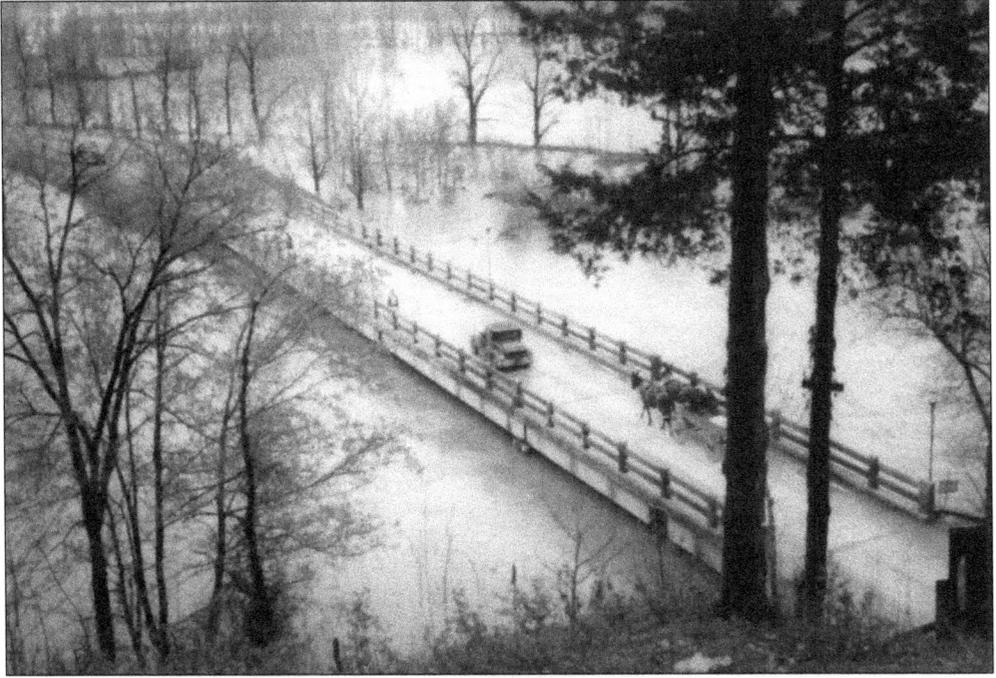

This winter scene, captured in the January 1937 flood, portrays the meeting of horsepower and motor power as these vehicles meet on the snow-covered bridge over Little River at the western edge of Cadiz. The vantage point from which this photograph was made is the approximate location of the American Legion clubhouse, which sat on Legion Hill until the building's destruction by fire on December 14, 1941. (Courtesy David and Barbara Shore.)

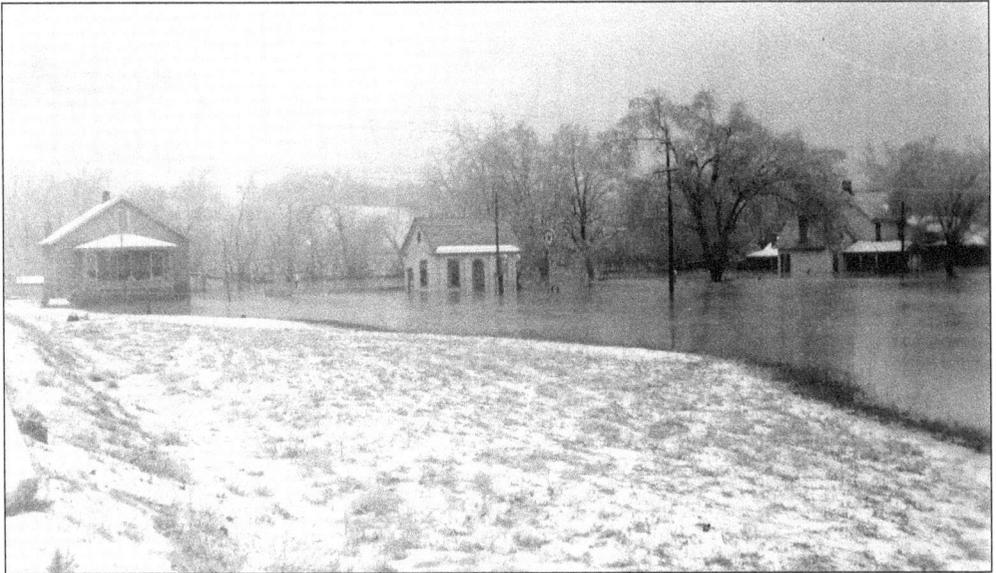

The concrete-block home of Gordon Cameron sits at the far left of this image. Progressing westward along U.S. Highway 68 is the Texaco service station and the Tiny Taverns Tourist Camp, and beyond this is the Minos Turner home. All of these structures were demolished in the 1960s in preparation for the impoundment of Lake Barkley. (Courtesy John L. Street Library.)

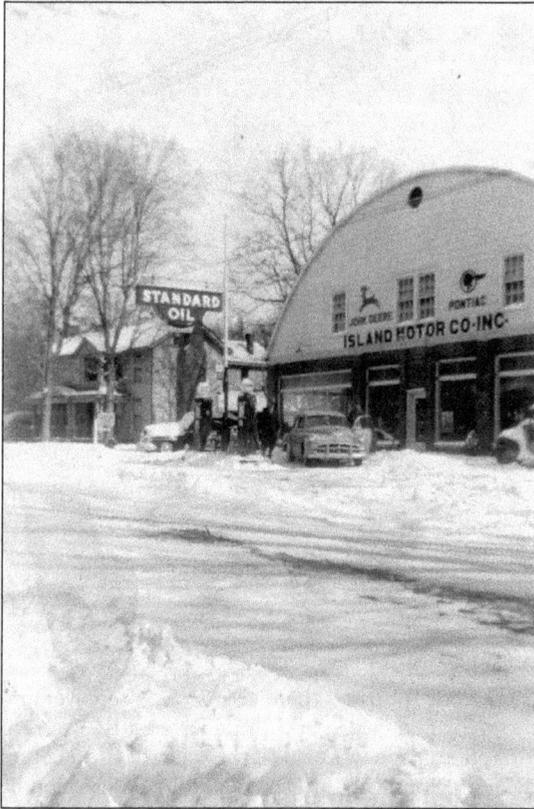

Chuck Thomas operated the Island Motor Company around 1943. He sold Standard Oil products, John Deere farm equipment, and Pontiac automobiles. The enterprise remained active until the early 1960s, when the Army Corps of Engineers acquired the property in preparation for the impoundment of Lake Barkley. The home of J. Minos and Anna Rawls Turner is shown in the left background. (Courtesy Joyce Banister.)

Tiny Taverns Tourist Camp

On U.S. 68

Clean Furnished Cabins, Shower Bath and Garage
Fishing, Boating, Swimming

Instant Service Station

Diamond and Shell **Gas** Tire Service Telephone.....**200**

JIM TURNER, Prop. Cadiz, Ky.

(Over)

A native of Cerulean Springs, J. Minos Turner—and his wife, Anna Rawls Turner—owned and operated Tiny Taverns Tourist Camp and sold Diamond, Shell, and later Gulf oil and gasoline. The Turner family operated the camp and service station from the late 1930s until 1946, when they sold it to James Marvel.

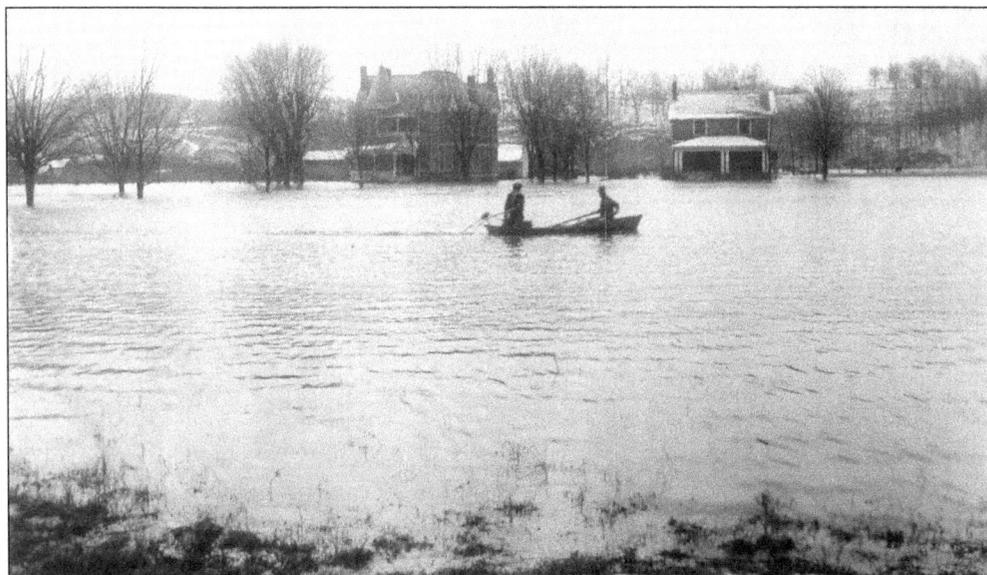

Two unidentified young men navigate the floodwaters of Little River in the front field of the Ben White farm west of Cadiz at the present site of the West Cadiz Park. Flooding was a common hazard for residents in this area, but never had the waters risen to this height prior to January 1937. The homes featured in the photograph above were owned by Ben White (left) and his father, Cleland. (Courtesy John L. Street Library.)

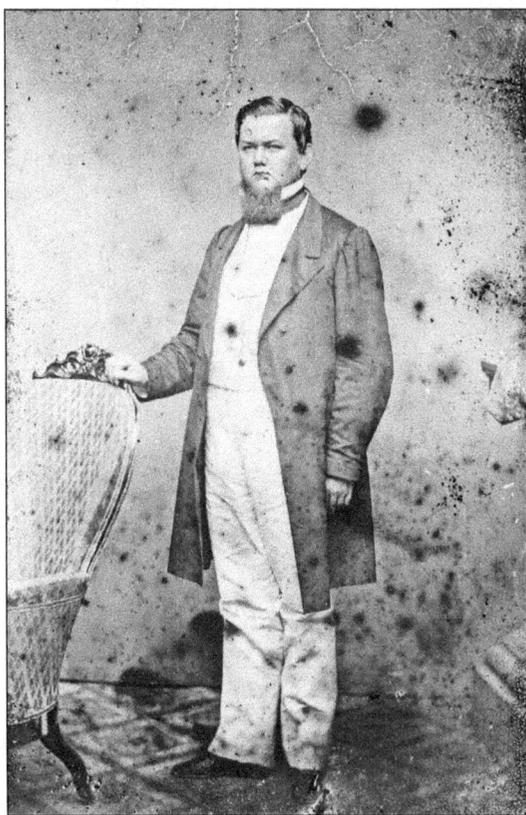

Cadiz resident Henry Cornelius Burnett (1825–1866), was a member of the U.S. House of Representatives from Kentucky's 1st Congressional District, and a Confederate senator. Burnett championed the Southern cause in Congress and worked within Kentucky to bolster the state's support for the Confederacy. His colleagues in Congress deemed Burnett's actions treasonable, and he was expelled from the House in 1861. Burnett died of cholera near Hopkinsville in 1866 and is buried in the Old Cadiz Cemetery. Burnett's widow, Mary, died in 1925, and was interred in East End Cemetery. Congressman Burnett's remains were moved to East End Cedmetery in September 1925, 59 years to the day from the date of his burial in the Old Cadiz Cemetery. The remains of the couple's infant son, Terry (1851), were also moved and buried in the family plot. (Courtesy Library of Congress.)

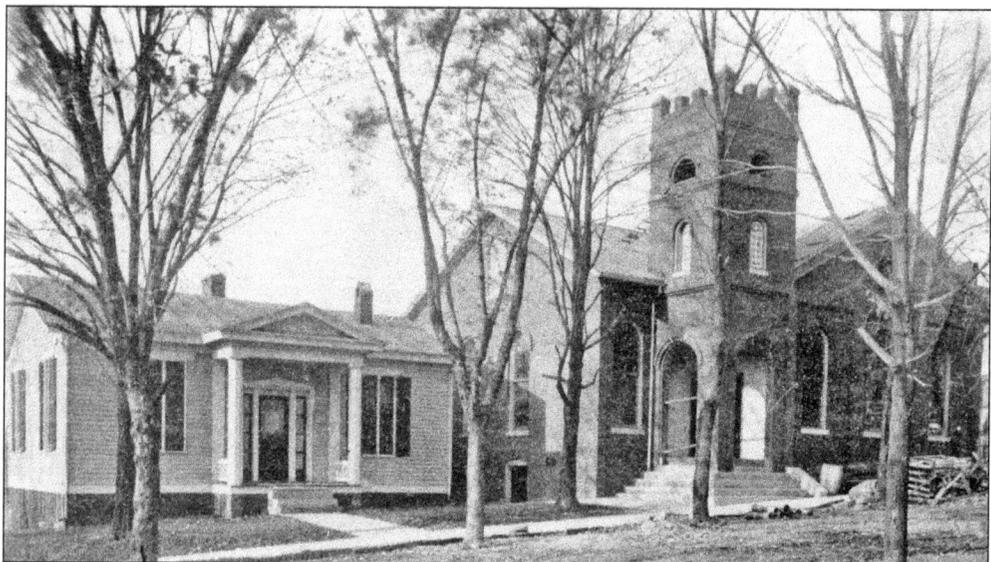

The Cadiz Methodist Episcopal Church South (right) was erected in 1870 and, along with its parsonage, was located on the north side of Main Street between Montgomery Street and Franklin Street. The Gothic tower seen in this photograph was not original but was added during one of multiple renovations made to the structure between 1906 and 1945. Services were moved to the county court house for several months beginning in May 1908, while the Woodruff Brothers renovated the structure. The congregation elected to relocate in the interest of additional parking space, and both of these buildings fell to the wrecking ball about 1958. (Courtesy William Turner.)

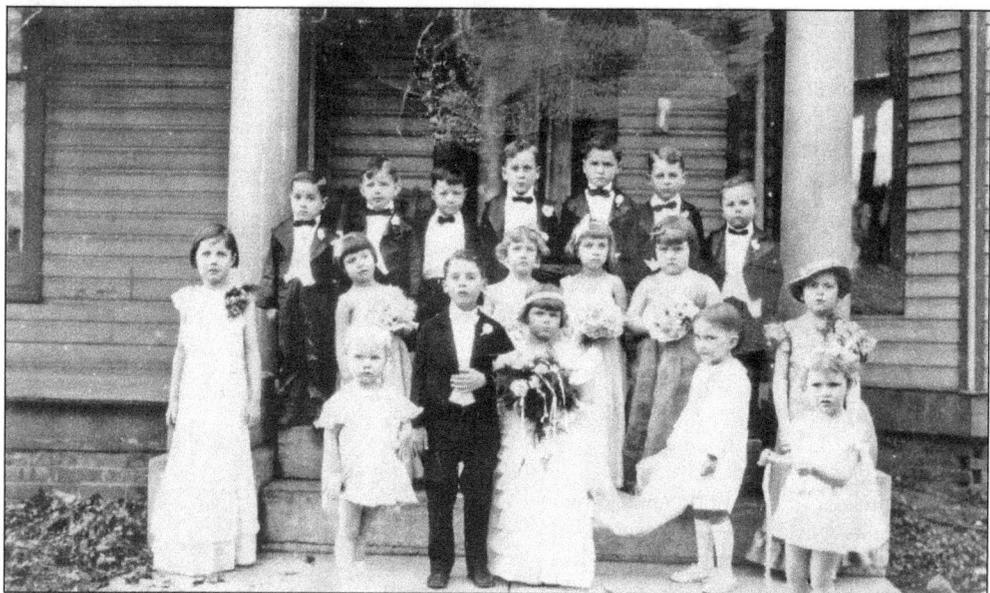

The Cadiz Methodist Episcopal Church sponsored this February 16, 1934, children's pageant and staged the program at the Trigg County Courthouse. Tom Thumb weddings were popular fund-raisers for schools and churches in the 1920s and 1930s. The groom and his bride (center) were Maurice Trusty and Patsye Futrell. Frances Thomas (far right in hat and gloves) sang "I Love You Truly." (Courtesy of Vicki Godwin.)

This two-story Greek Revival home was built around 1840. The house includes an entry portico, central doorway, and flanking three-part window. The two-story portico has four octagonal wood piers supporting it at each level, and it is topped by a pedimented gable. The house was deeded to Josiah Miller by Richard Poston in 1855 and conveyed to John Jefferson in 1870. The Jefferson family occupied the home until 1937, when W. Graham Egerton Sr. bought it from John Ernest Jefferson. The structure is presently under the care of the Cadiz Christian Church and Presbyterian Chapel, and it houses the church's offices. (Courtesy John L. Street Library.)

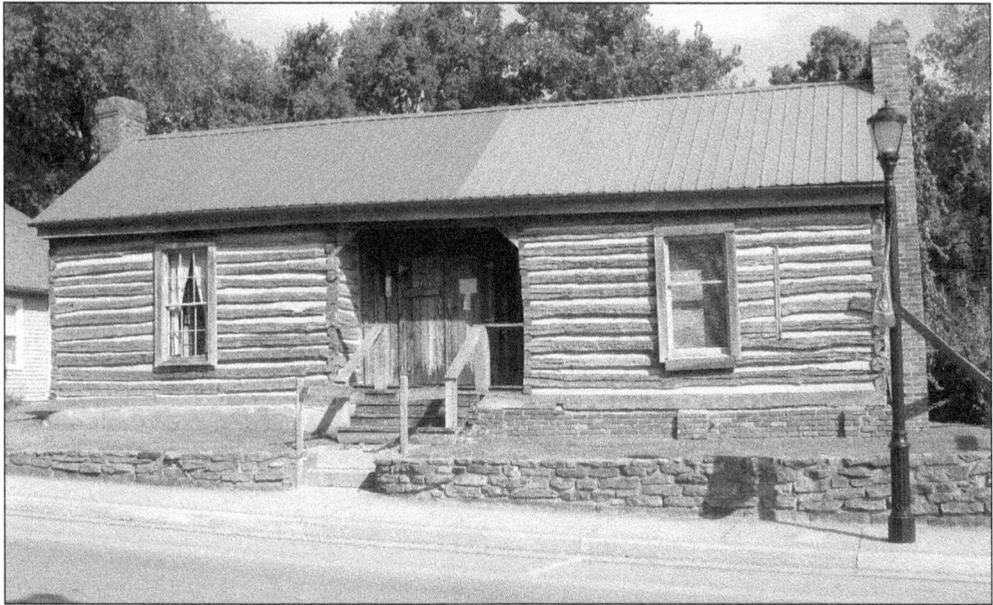

This house, believed to be the oldest in Cadiz, sits on lot No. 19 of the original town plat. First conveyed to John Caudle in 1821, the lot was sold to Alexander Baker in 1823. It was sold again to Josiah Miller in 1830. The deed described the property as "the same lot on which said J. H. Miller now lives." This was the first mention of a building being on the lot, and no evidence has been found to confirm that the present structure is the one mentioned in the 1830 deed. The home was the residence of Emma Rascoe until her death in 1972. The building was acquired by the Cadiz–Trigg County Chamber of Commerce in 1979 and served as the Downtown Tourist Center from 1979 until 2009; it is now owned by the City of Cadiz.

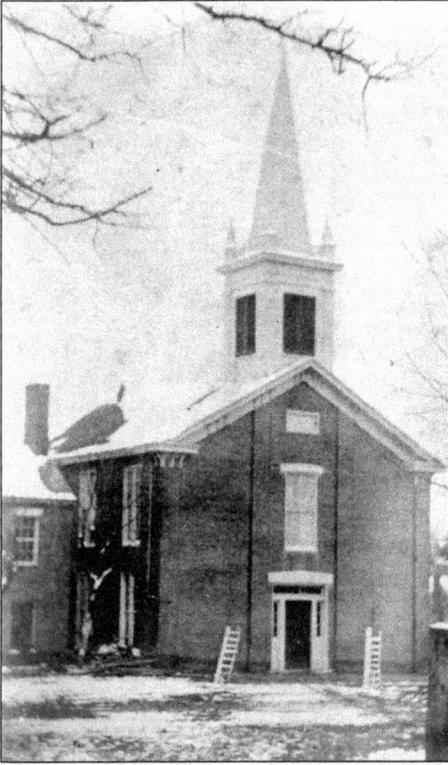

This 1854 structure is a rare local example of nonresidential Greek Revival architecture. The gabled end of the building fronts on Jefferson Street at the corner of Monroe Street and is divided into three sections by brick piers that rise to the roofline. The first floor of the facade has a central entrance with a double doorway topped with a transom and a triangular stone lintel. The second-floor central window has a nine-over-nine sash and a stone lintel. A wide fascia with brackets runs along the roofline. In this early image, the building retains its steeple, removed and relocated after the Cadiz Christian Church was built on Main Street in 1892. One of the oldest in Cadiz, this building was constructed in partnership between the Cadiz Christian Church and the local Masons, with the church using the first floor and the Masons using the second floor. The building has fallen into disrepair under the ownership of the Trigg County Fiscal Court which utilized the facility as a senior citizen center until 2010. The facility currently houses the Trigg County Museum, operatated by the Trigg County Historical Society. The Trigg County Fiscal Court used the facility as a senior citizen center until 2010. (Courtesy Joyce Banister.)

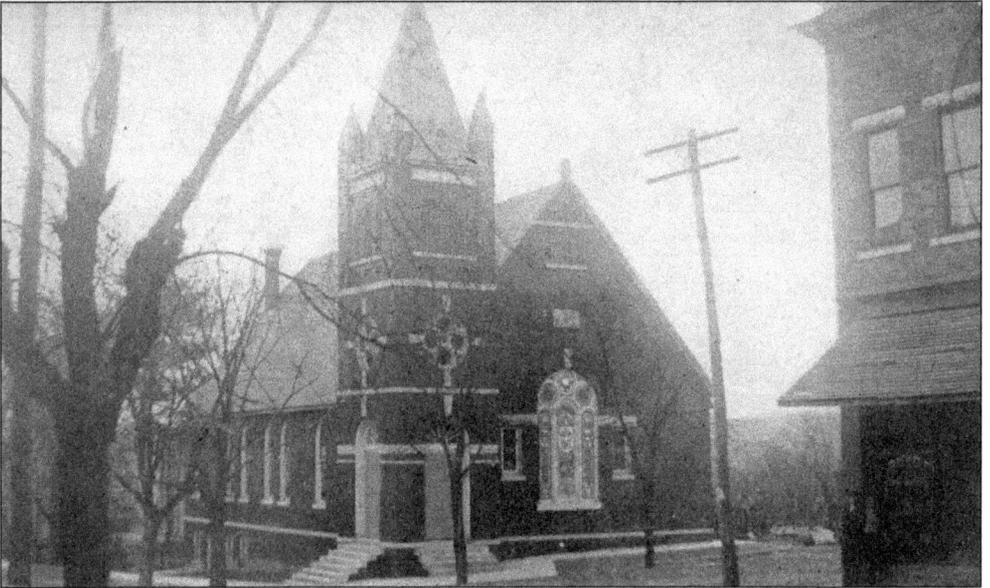

The Cadiz Christian Church was founded on August 1, 1842, and held services in several locations before erecting this Trigg County landmark in 1892. Built in the Romanesque style, the church has a southeast corner tower with south and east entrances, each topped with stained-glass fanlights and brick archways. The east and south sides of the tower also have circular rose windows containing stained-glass quatrefoils. Gothic-arched stained-glass windows run down the south and north sides of the sanctuary. (Courtesy William Turner.)

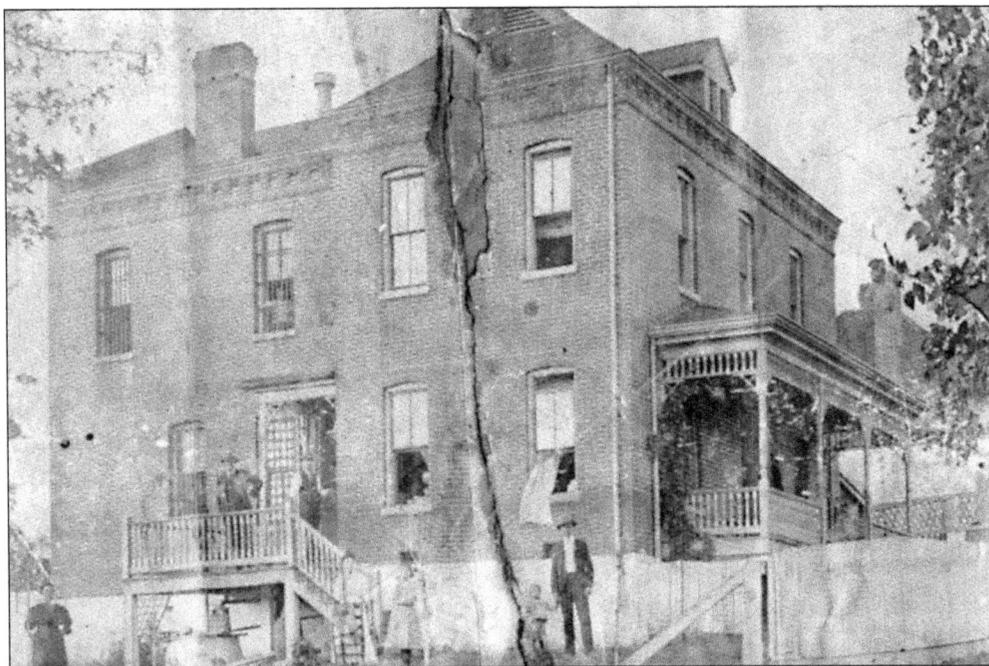

This rare c. 1902 photograph of the Trigg County Jail includes jailer William Timmons (left) and an unidentified assistant jailer, standing on the side porch, and Helen Timmons (left) and daughters Verdie and Gertrude. The man and boy at the front corner of the building are Ney Timmons and his son, Lewis. The first county jail was constructed in 1820, a log structure built on the present site of the Trigg County Courthouse Annex. The building shown here was the county's third jail, built in 1857 at a cost of $1,600. This building was located north of the courthouse on Lafayette Street and remained in use until it burned on March 1, 1975. (Courtesy Jack McSheery.)

Lurline Humphries (1898–1998) was the first woman in Kentucky to be elected sheriff. Humphries ran for sheriff in 1933 and was elected by the largest majority ever polled in the county at that time. She was elected again in 1952 to complete the term of W. C. Broadbent, who had died in office. As sheriff, Humphries always carried a .38 Smith and Wesson pistol, but she never had to use it. (Courtesy Paul Fourshee.)

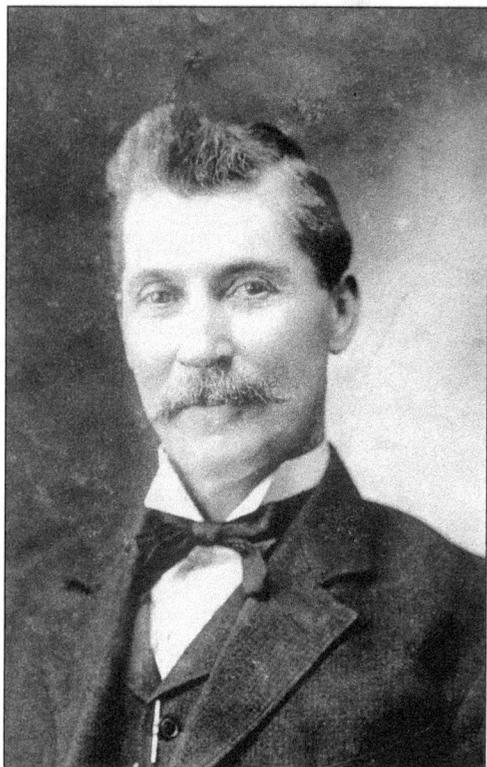

Willis Byron Woodruff (1859–1940), the son of a successful Hopkins County farmer and sawyer, moved to Cadiz in 1897. Upon relocating to Cadiz, Woodruff purchased 3 acres of land near the court square and established a modern planing mill and lumber business. In addition to Woodruff's work ethic, his numerous patented inventions propelled him to success in the lumber industry. (Courtesy Lee Woodruff.)

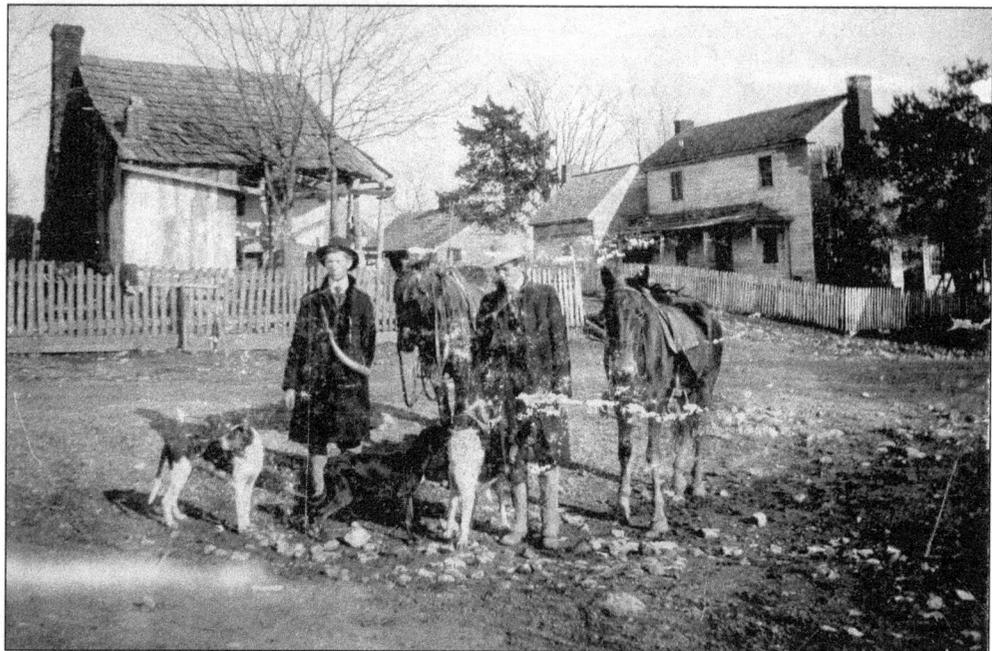

Spring Street is the probable location of this 1901 scene featuring Schulyer Malone (left) and James Ottawa Sumner. Some historians identify the location as being near the "Old Blue Corner;" a building that stood on the lot between Cadiz Antique Mall and the American Red Cross and housed the law office of J. John Jefferson. (Courtesy Tom and Nell Vinson.)

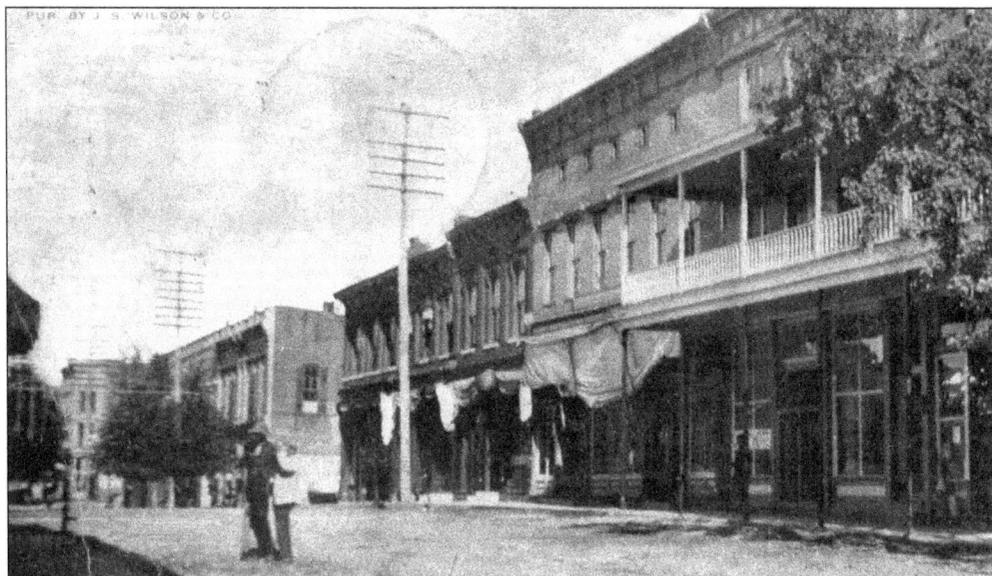

This 1908 postcard offers a view of the Cadiz Hotel, at extreme right with the upper porch, and other businesses extending to the east on the south side of Main Street. Most of the buildings in this scene burned on November 29, 1920. A portion of this block burned again on January 1, 1947, and was rebuilt a second time. Upon completion, business resumed until March 14, 1965, when a third fire completely destroyed the F. B. Wilkinson Company. The adjoining structures east and west of Wilkinson's were saved by the efforts of the Cadiz Fire Department with assistance from the Hopkinsville Fire Department. (Courtesy William Turner.)

The only significant Civil War event that took place in Cadiz occurred on December 13, 1864, when Capt. Cole of Confederate General Hylan B. Lyon's Brigade burned the court house, ostensibly to prevent the spread of small-pox, which had been introduced into the building by a detachment of Union soldiers who had camped there the night before. The Alex Poston Chapter, United Daughters of the Confederacy, placed this monument in honor of Trigg County's fallen Confederates in 1913. Dedicated on June 3, 1914, the monument is constructed of four marble Doric columns resting on a splayed base of limestone and supporting an arched lintel upon which five cannonballs rest. The four columns surround a basin on either side of the monument, one of only four memorial fountains in Kentucky erected as Civil War monuments. (Courtesy William Turner.)

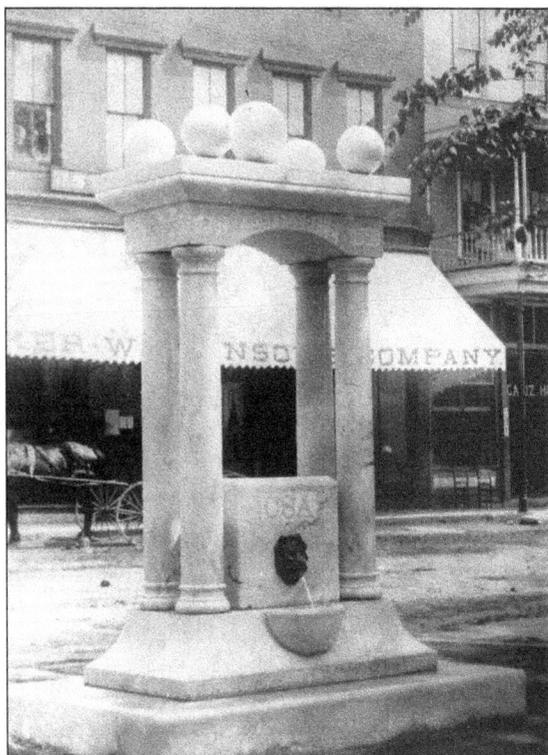

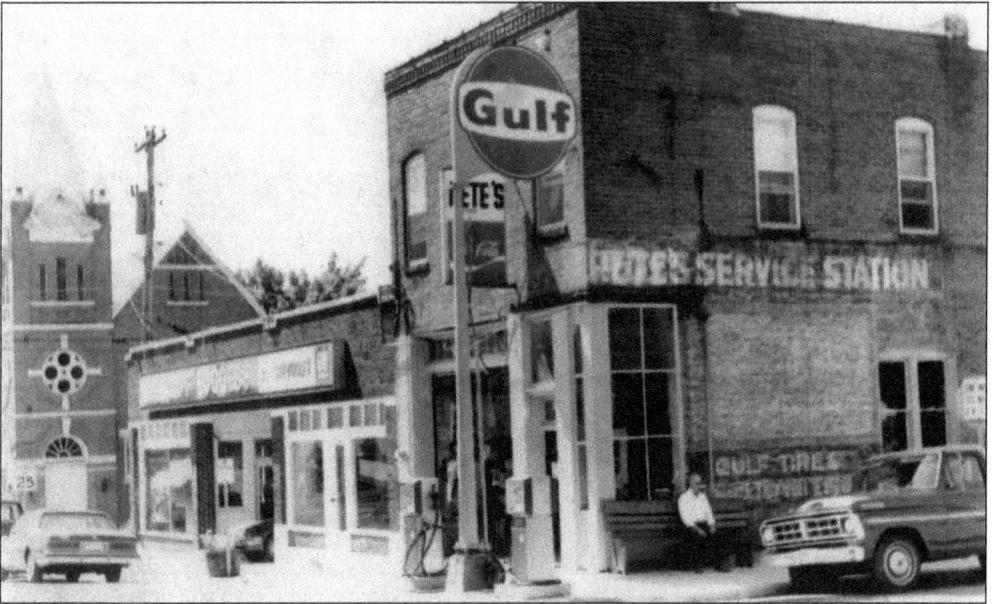

This scene features Pete's service station at right and the Wilbur F. Boggess Chevrolet dealership at left. These buildings were constructed following the 1920 fire that destroyed much of downtown. The White/Boggess building (left) was constructed as an automobile dealership; the facade was divided into three sections by brick piers with the central bay open to allow automobile access to the rear garage. The building wrapped in an ell shape around the service station and had an entrance on Madison Street. Although added to the National Register of Historic Places in 1988, both structures were razed in 2010 to make way for a municipal parking lot. (Courtesy David and Barbara Shore.)

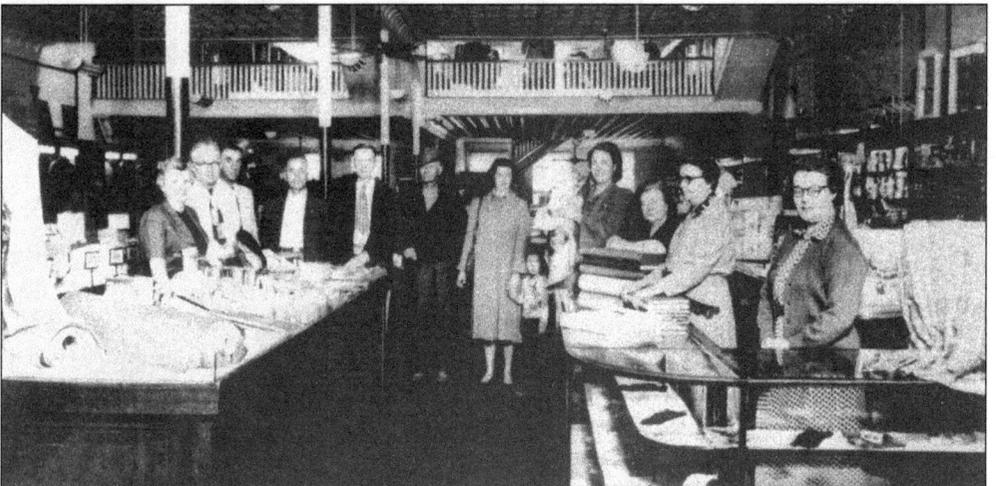

This photograph of the interior of F. B. Wilkinson Company depicts the style of mid-century department stores. Merchandise; women's, men's, and children's clothing; and gloves and hats were readily available to Trigg County shoppers from Wilkinson's Department Store between 1893 and 1993. Fire destroyed the building in 1965; it was rebuilt and remained in operation until 1993. Pictured are, from left to right, Undine Clark, Fred Major, Sam Baker, Jess Watkins, ? Hopson, unidentified, Alberta Rogers, Kenneth Rogers, Lorene Garner holding Roger Garner, Emma Rascoe, Marie Morris, and Frances Davis. (Courtesy Wallace Blakeley.)

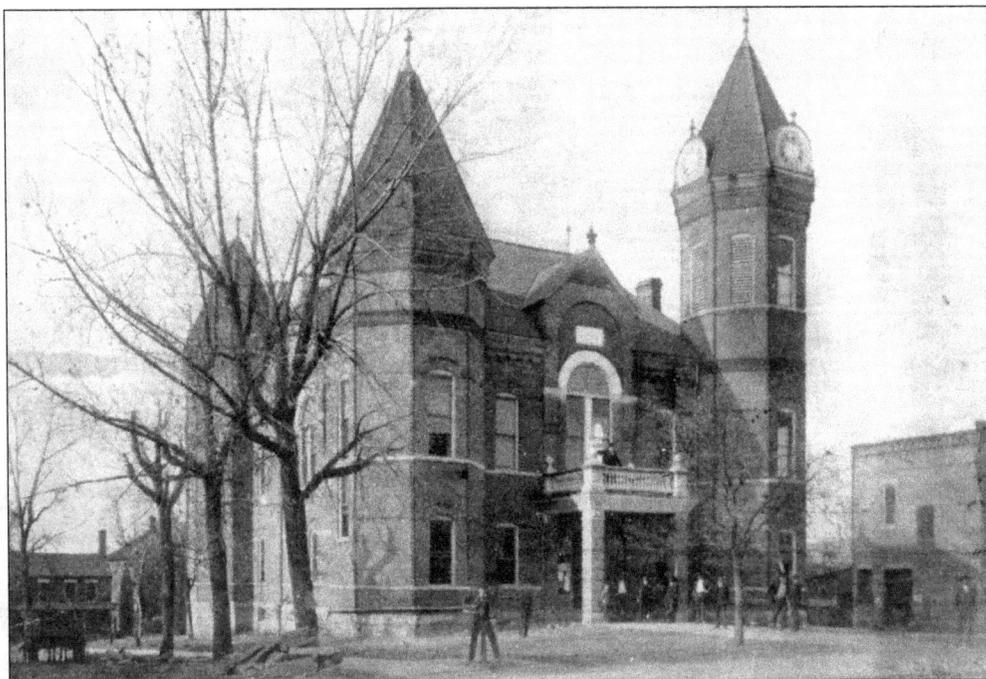

The fifth structure to house the Trigg County Court was constructed in 1895 following the destruction by fire of the previous dome-capped structure on January 13, 1892. Milburn and Son, architects of Kenova, West Virginia, drew plans for Trigg's new "temple of justice," and the contract for construction was awarded to Forbes and Brothers of Hopkinsville. The total cost of the new structure was $14,600.65. (Courtesy William Turner.)

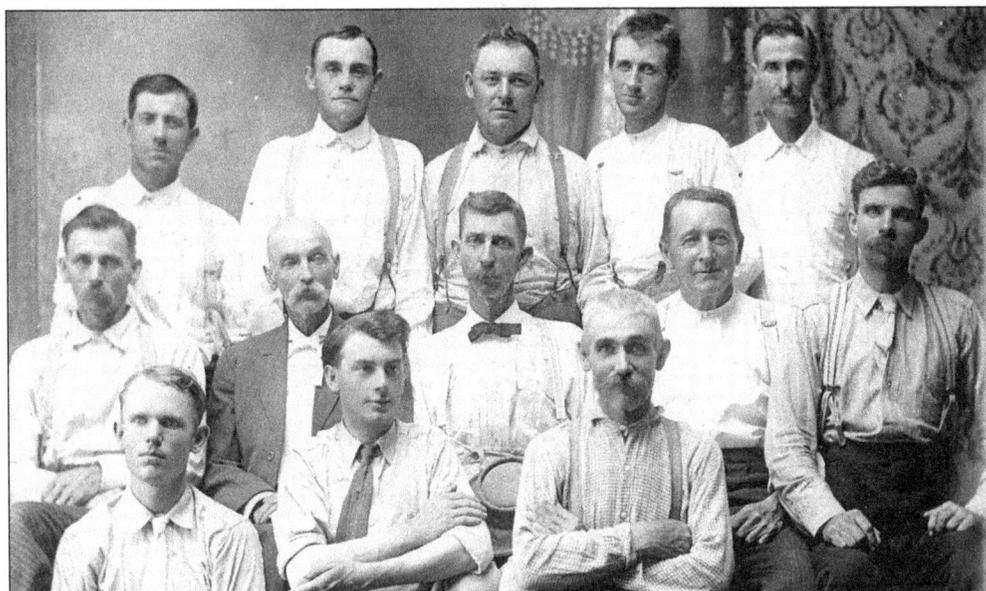

This rare photograph features a hung jury in an unidentified Trigg County case. From left to right, the men include (first row) Garland Cunningham, Charlie Humphries, and unidentified; (second row) ? Henderson, Bass White, George Austin, Tom Dorian, and Will Mize; (third row) Dick Crisp, Na Williams, Pat Ryan, Quint Noel, and Tom Curlin. (Courtesy William Mize.)

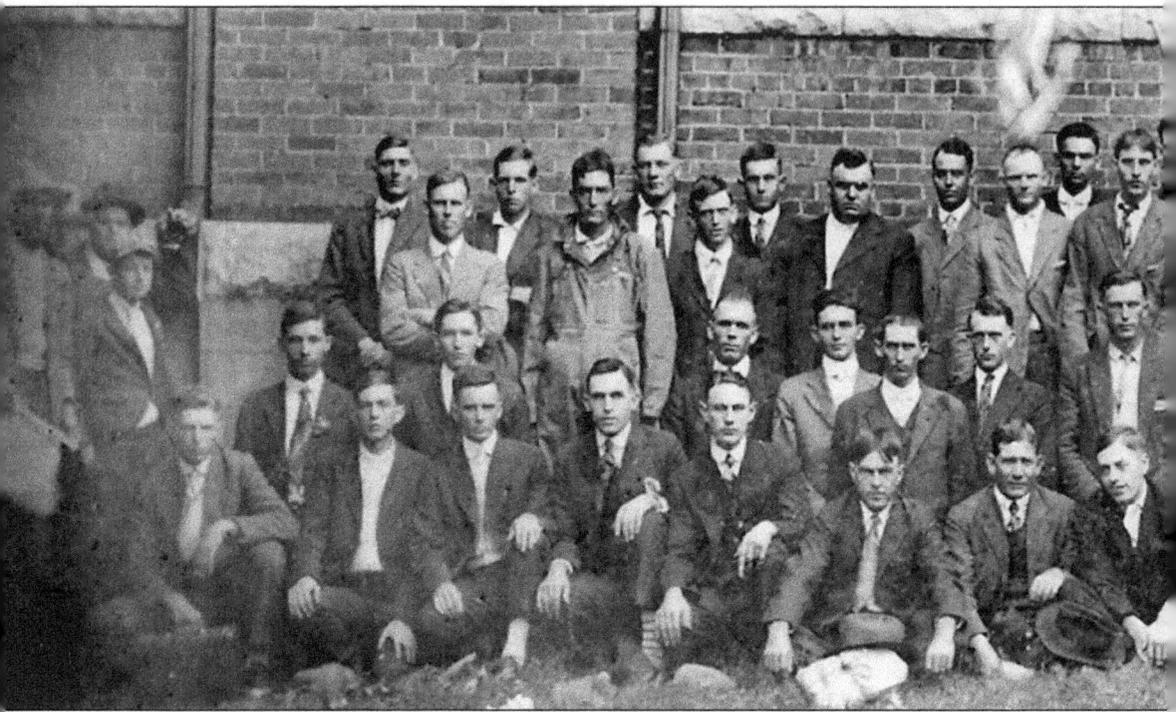

The 64 Trigg County men in this October 3, 1917, photograph were among the first from the community drafted during World War I. From left to right, the men are (first row) Mosco Guier, Gentry Cothran, Alf Thomas, Adolphus Faughn, Luke Franklin, Prentice Mitchell, Parks Nichols, Sam Hargrove, Ulysses Fox, John Sumner, Henry Bryson, John Boren, Arthur Carpenter, Barnett Wyatt, Burbon McCain, Thurman Green, Shelly Jones, and Luther Turner; (second row) Hugh Overby, Thomas Walker, Joe Nichols, Lucian Murphy, Burnett Finley, Tandy Futrell, Boone Sanders, Jack P'Pool, Joe Hopper Cunningham, Frank Bruce, Luther Thomas, Hill Wills, Robert Taylor, and Henry Barefield; (third row) Barney Mashburn, Herman P'Pool, Mike Cunningham,

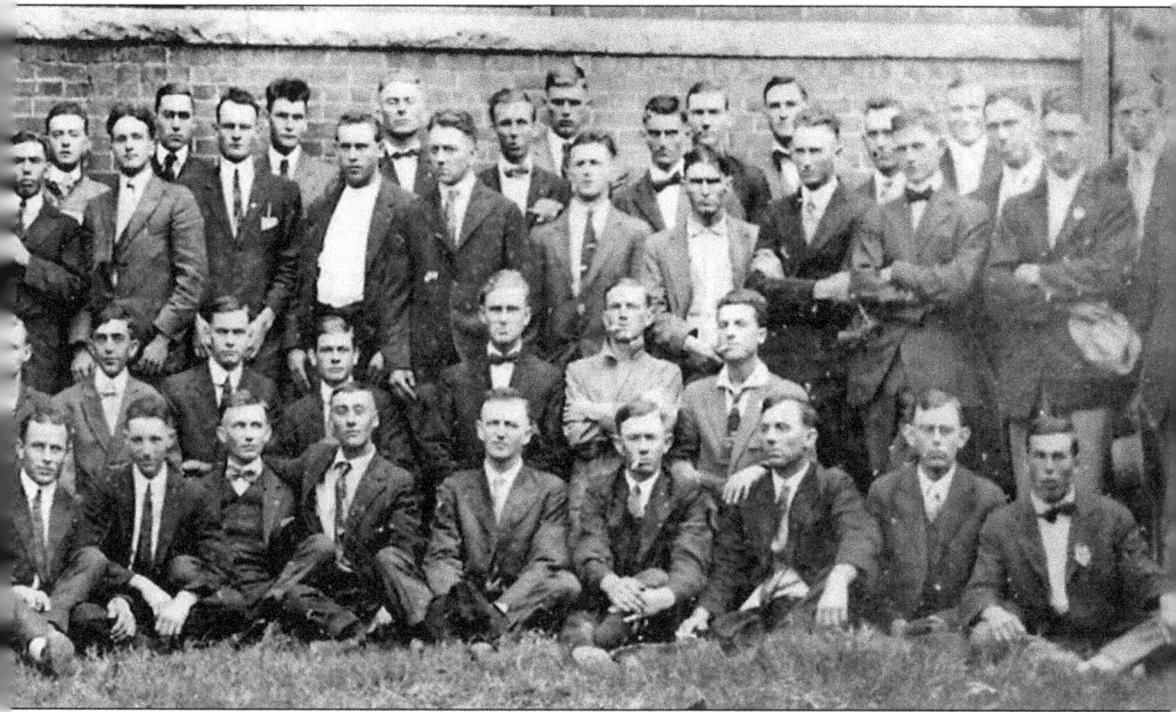

Lucian Carr, Homer Henderson, Daniel Meredith, Allen Wallis, flag-bearer Robert Mitchell, Homer Randolph, Wesley Tomme, Schuyler Gray, Karie Glenn, Taylor Underhill, Emmett Ledford, Ed Boone, John Jefferson, Alvin Goodwin, and Mike Lane; (fourth row) Henry Futrell, Albert Cassity, King Dyer, Thomas Rogers, James Campbell, Rufus Turner, Paul Knight, Erie Littlejohn, Lewis Mann, Otis P'Pool, John L. Street, Alfred Joyce, Homer Reddick, Robert Wilson, Joseph Boren, Claude Poindexter, Ovid McCawley, Claud Lane, Claud Bourne, and Drew Standrod. (Courtesy Edison H. Thomas.)

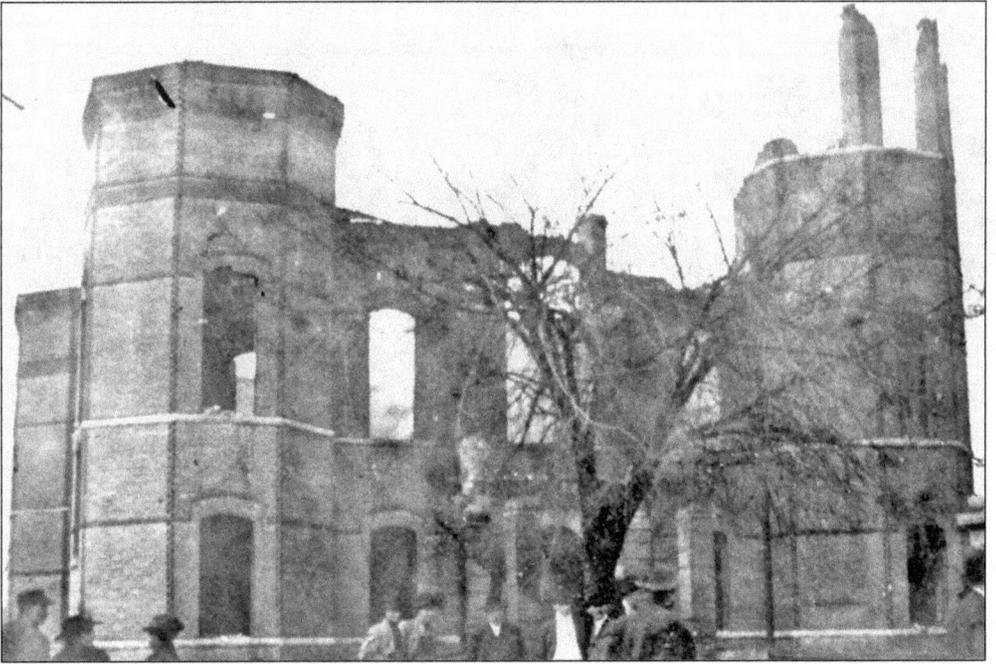

The headline of the December 2, 1920, *Cadiz Record* exclaimed "Cadiz Swept By Fire Monday: Most Destructive Conflagration in Town's History . . . Court House and Two Blocks of Business Houses Go Up In Smoke." The ruins of the courthouse are featured in these November 29, 1920, photographs. The clock in the southwest tower tolled four o'clock in the afternoon as it fell into the inferno. (Both, courtesy William Turner.)

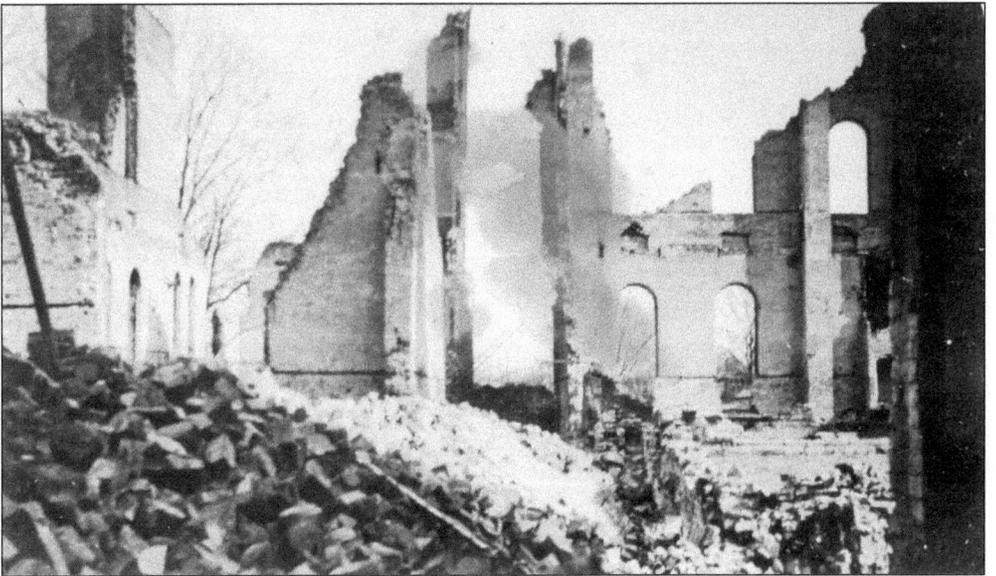

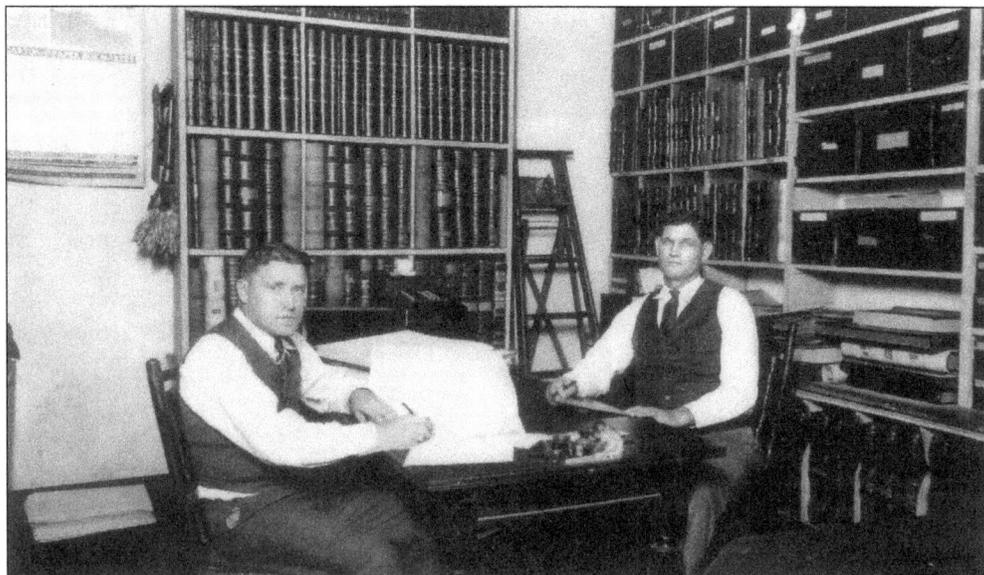

This *c.* 1926 photograph was taken inside the Trigg County court clerk's main vault. The county's records can be seen lining the shelves behind (left) "Dee" Bruce, county court clerk from 1926 to 1933, and Lemuel J. Banister Sr., deputy county court clerk. Although Trigg County's houses of justice have been plagued by fire through the history of the county, the court records have remained largely intact. (Courtesy Lem Banister Jr.)

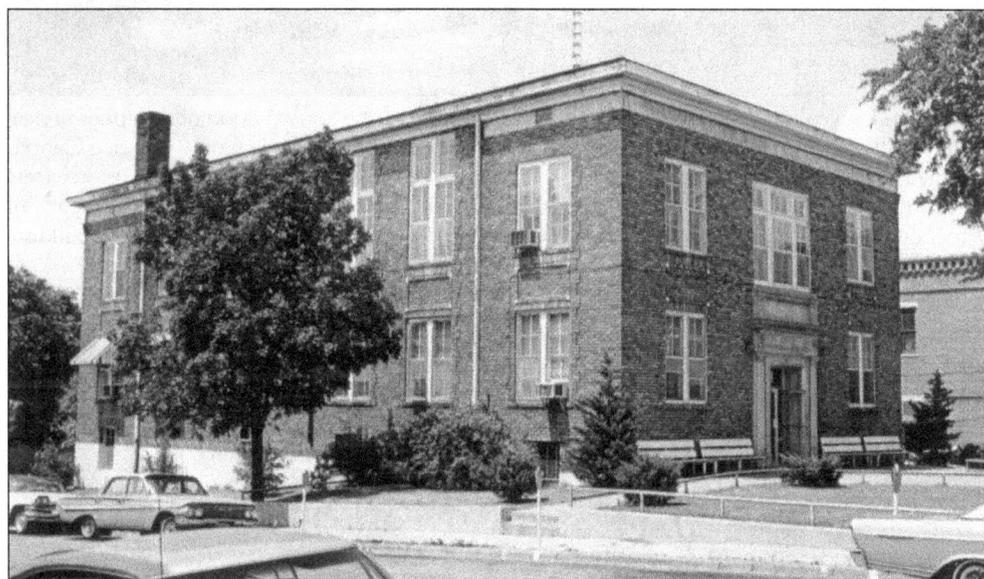

The sixth structure to house the Trigg County Court was constructed in 1921 and 1922 at a cost of $10,000. The simple yellow-brick two-story building was designed in the Classical Revival style by Chattanooga architect R. W. Hunt. Ornamentation on the building was concentrated on the central entranceway on the Main Street facade. A stone pair of pilasters holding a decorative lintel highlighted the entrance. A cornice supporting a false balcony topped the entrance. The second floor had a central three-part window and flanking double windows with four-over-four sashes. By the end of the 20th century, this courthouse had outlived its usefulness, and it was demolished in 2007 for the construction of a new justice center.

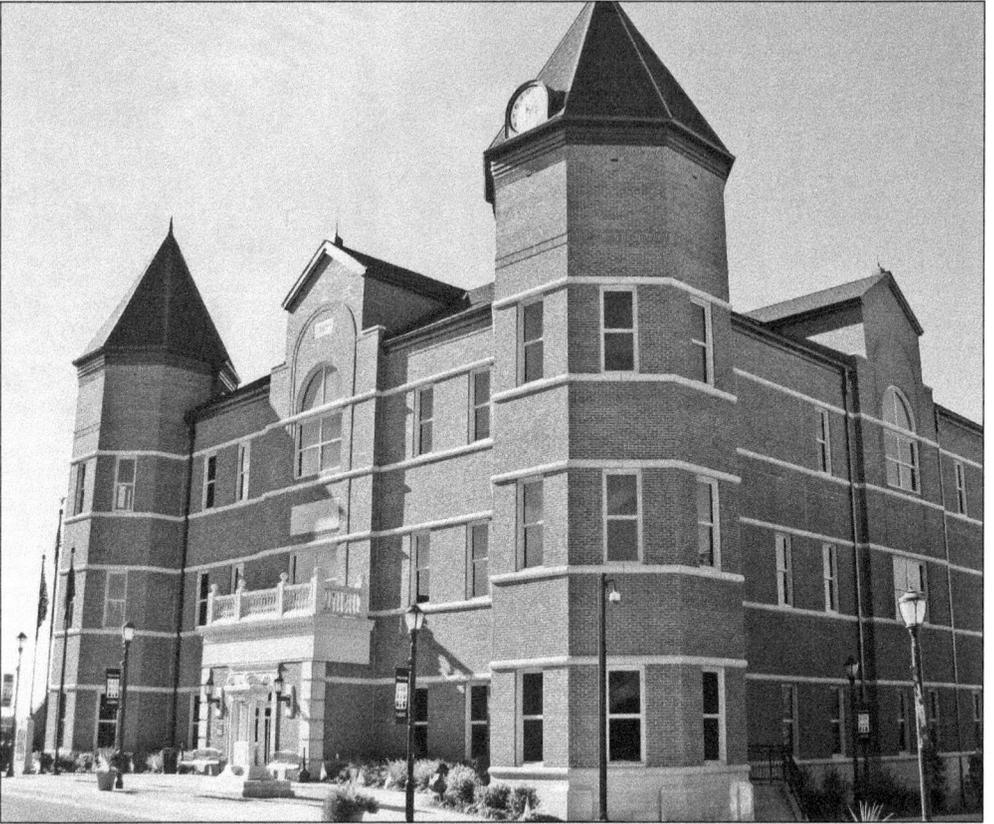

The Commonwealth of Kentucky assisted in the funding of the construction of a number of new county halls of justice in the first decade of the 21st century. The Trigg County Justice Center, designed by the architectural firm of CMW, Inc., of Lexington, Kentucky, was built at a cost in excess of $12 million. Ground was broken on November 26, 2007, and Codell Construction Company of Winchester, Kentucky, managed the project. Construction was completed in 2009, and the building was dedicated on October 28, 2009. The third-floor district courtroom is featured below.

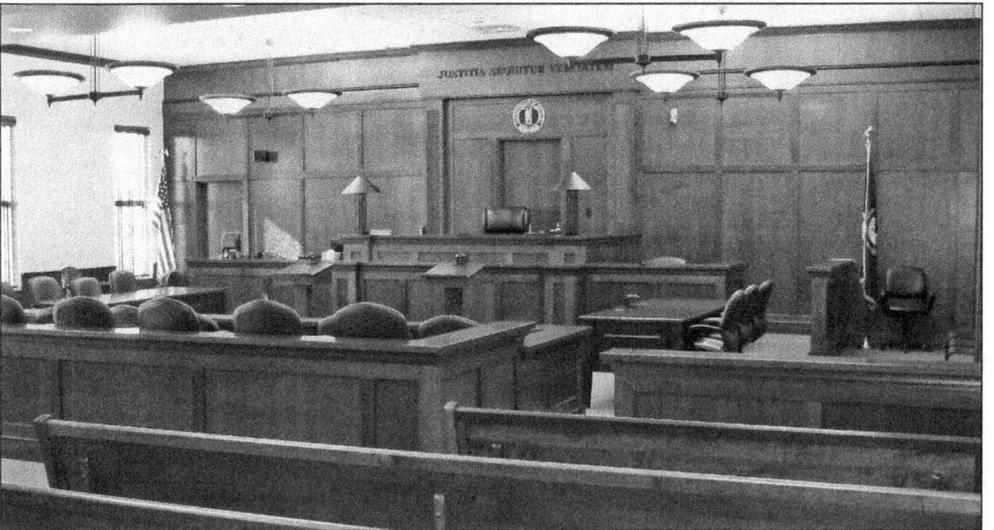

In this scene, D. L. Grinter and John S. Crenshaw are applying lettering to the front window of Trigg County Farmers Bank around 1917. The bank was established on January 14, 1890, and remained in operation until August 31, 1998, when it was sold to National City Bank, later Integra Bank. In 2010, the former Trigg County Farmers Bank was sold to Jackson Financial Corporation, which owns Mayfield, Kentucky, based FNB Bank, Inc. (Courtesy FNB Bank.)

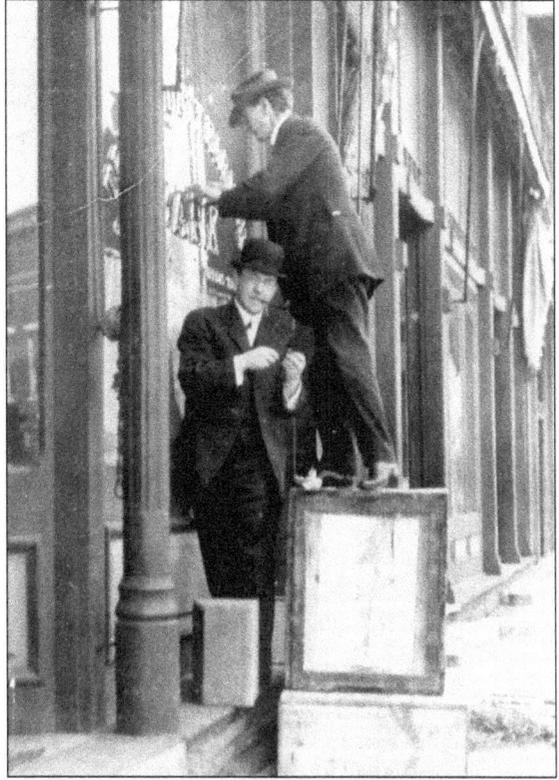

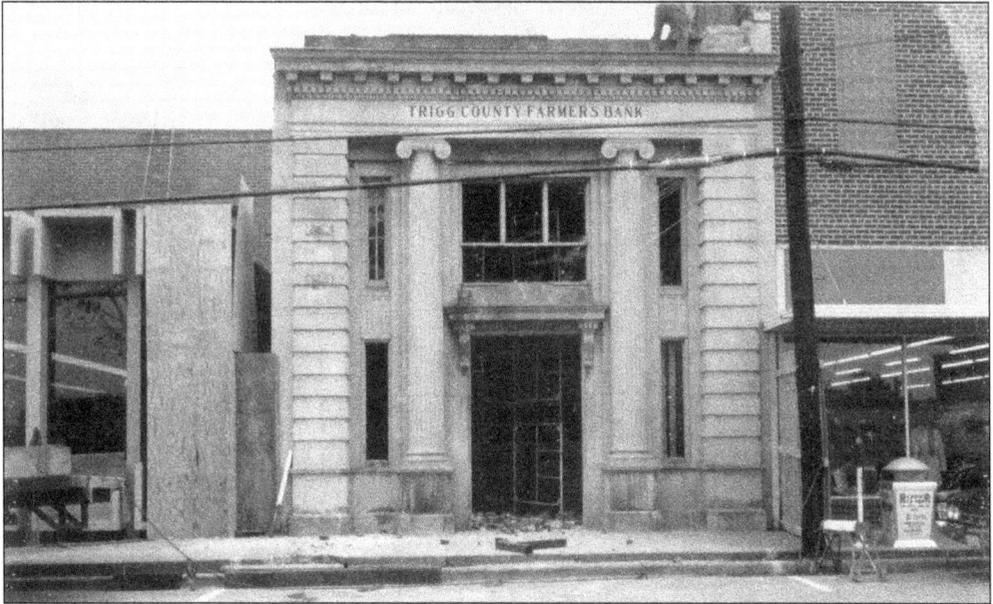

The classic facade of the Trigg County Farmers Bank appears in this image as it was about to be removed in 1971. The structure stood on Main Street next to F. B. Wilkinson's Department Store and across from the Trigg County Courthouse. The stone facade with its Ionic columns presented a handsome addition to the streetscape; its removal and the demolition of the building to its east were a tragic loss to the historic appeal of downtown Cadiz. (Courtesy FNB Bank.)

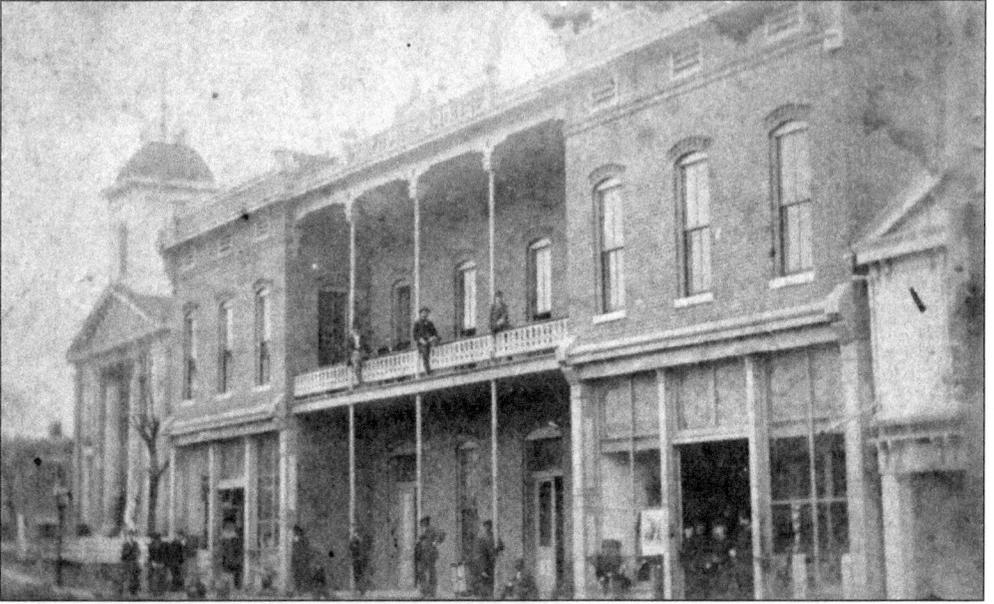

The reverse of this photograph is a business card for the Cadiz House, which is featured in the image. The advertisement touts the facility as "The Finest Hotel in Southern Kentucky." Proprietor S. Barnes goes on to state, "The above Hotel is just completed and ready for Guests, everything new and in elegant style. I have leased the above Hotel for five years, and am prepared to entertain Guests in the best style, and at reasonable prices. I have a Livery and Feed Stable connected with the Hotel, and will furnish Cabs, Hacks, Buggies, and Saddle Stock at all times at low rates. Sample Rooms for Commercial men. Call and see me." Visible at the extreme left is the 1884–1892 Trigg County Courthouse. (Photograph by J. E. Griffen.)

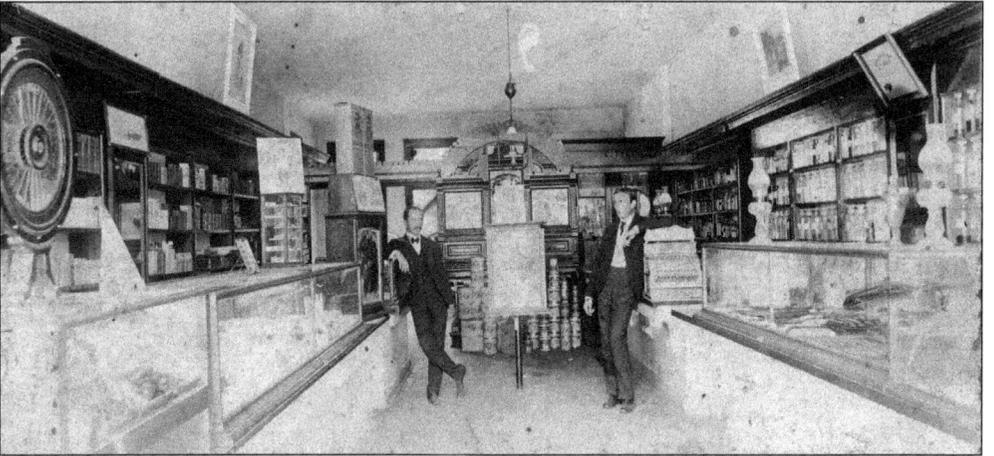

This early-20th-century photograph of an apothecary in downtown Cadiz is typical of such establishments in the late 1800s and early 1900s. Apothecaries formulated and dispensed materia medica to physicians, surgeons, and patients—a role now filled by a pharmacist. Apothecaries generally operated through retail shops such as this one in Cadiz, which in addition to ingredients for medicines sold tobacco and patent medicines. Beginning with its construction in 1905, the building at 48, 50, and 52 Main Street housed a drugstore. The building was constructed for the George L. Smith Drug Store and was the home of Blane's Drug Store until 1943. (Courtesy Lucy Helen Miller.)

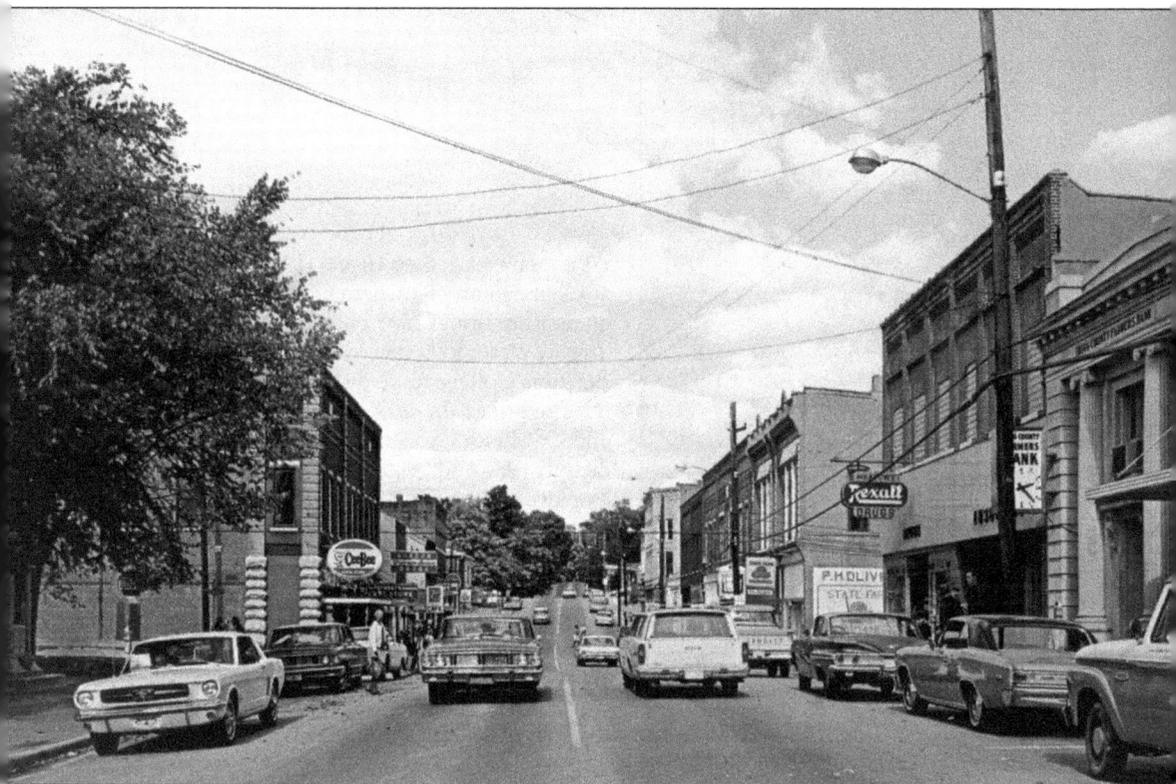

This 1965 postcard features the busy business section of downtown Cadiz looking east on Main Street from the courthouse. Cee Bee Food Store, Street's Department Store, Meadows Rexall Drugs, and Trigg County Farmers Bank all represent businesses no longer a part of the Cadiz–Trigg County business community. (Courtesy William Turner.)

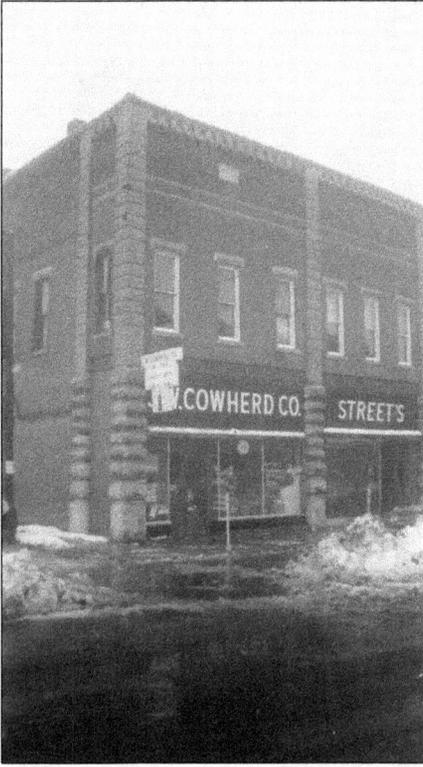

As a teenager, James Tuggle (1903–1990) worked at Chappell and Cowherd Grocery Store. Upon graduation from Cadiz High School in 1923, Tuggle, pictured below, attended Bowling Green Business College to study bookkeeping. He returned to Cadiz as bookkeeper for Chappell and Cowherd. Grocers Chappell and Cowherd died in 1927 and 1945 respectively. Former employees James Tuggle, W. H. Rawls, and Julian Roberts purchased the business and operated it until the mid-1960s, when they sold the business to Washer and Hughes, who operated the store as an Economy Cee Bee Food Store and eventually relocated the operation to lower West Main Street. Throughout its existence, J. W. Cowherd Company was one of the largest shippers of salt-cured country ham out of Trigg County. (Both, courtesy Mary Lou Roark.)

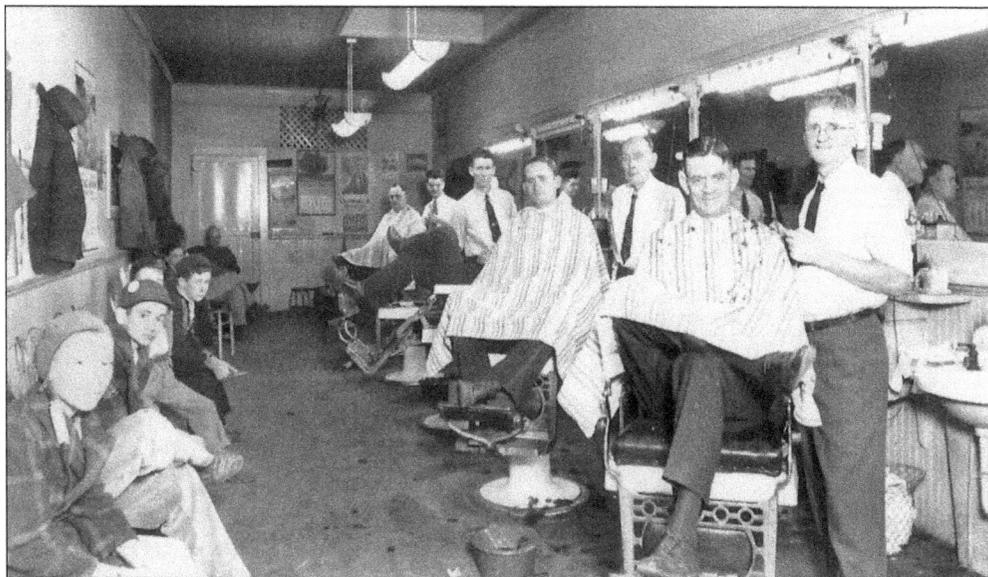

This *c.* 1945 photograph represents the classic style of the American barbershop of its era. From left to right, the barbers are Lexie Bush, "Ollie" Cunningham, Luther Adams, and "Avery" Francis. The boys sitting in the chairs at the left are Charles Crisp, R. W. Cunningham, Aaron Morrison, and J. B. Boren. The shop owner at the time was Arthur Worsham. He owned the business until 1965, when he sold it to Francis, Bush, and Cunningham. The three men had worked at the Cadiz Barbershop since 1924, 1926, and 1929, respectively. They sold the operation to Harold Knight and Ronald Capps in 1968. (Courtesy James Cunningham.)

Beginning about 1954, Joe B. Clement operated an apothecary in the front of the Futrell Clinic on the north side of Main Street in downtown Cadiz. In the early 1960s, Clement acquired the former Glenn's Dry Goods Store west of the clinic and established Clement's Pharmacy. He was affiliated with the national retailer Walgreen's for nearly 20 years. The pharmacy remained at this location until Clement's sons constructed their present facility in east Cadiz following their father's death on September 21, 1985. (Courtesy Rick and Bobby Clement.)

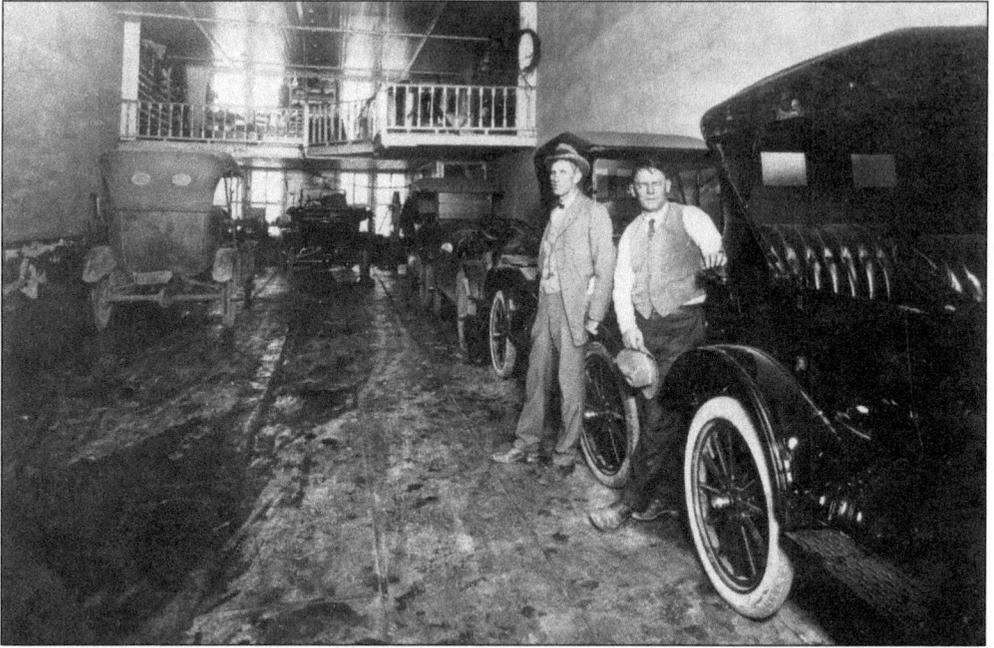

This *c.* 1923 scene features the interior of the Garland-Tom Ford Motor Company dealership located in downtown Cadiz. T. O. "Tom" Turner and Garland Cunningham were partners in this 1920s endeavor. The automobiles seen here in the showroom were among those available for purchase. (Courtesy William Turner.)

The Fuqua family of Canton and Cadiz attended to the necessary business of preparing the dead for burial. In this *c.* 1915 photograph, Terry Hart Fuqua is shown leaning at right. The two men at left are unidentified but are probably Rob Shaw and Jeff Mitchell. Shaw and Fuqua were business partners from 1910 to 1920, and Mitchell was an employee until Fuqua's death in 1946. Fuqua died along with his ambulance driver, patient, and two others when the ambulance stalled in flooded Dyer's Creek on Rockcastle Road. The only survivor, Haydon Cunningham, waded out to seek help; while he was gone, water covered the exhaust pipe, allowing carbon monoxide gas to fill the ambulance, poisoning its occupants. (Courtesy Dr. Terry Fuqua.)

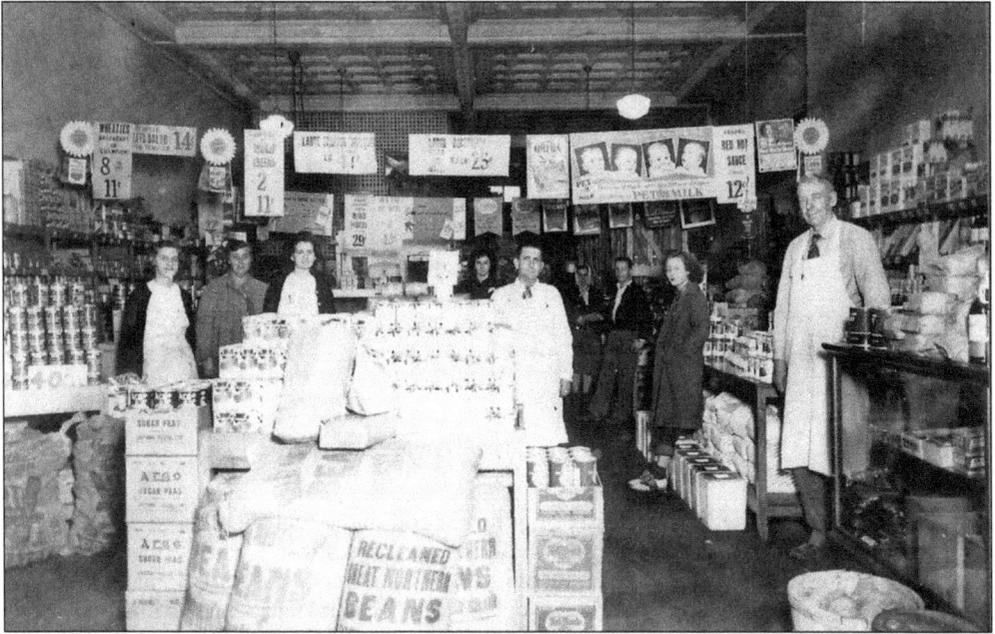

Located on the south side of Main Street at the heart of downtown Cadiz, the Red Front Store was owned and operated by Thelma and Peck Stewart. It was one of several dry goods or general merchandise stores located in the business district. From left to right, this January 30, 1947, scene includes Thelma Stewart, unidentified, Ruth Broadbent, Garvie Gray, Peck Stewart, ? Oliver, ? Luffman, ? Darnell, and W. H. Faulkner. (Courtesy Anna Powell.)

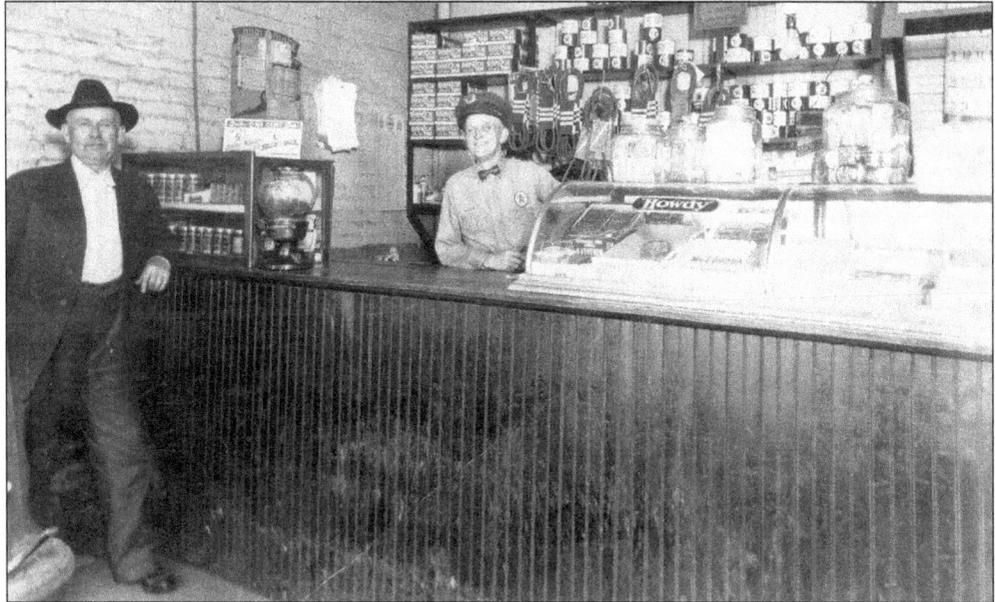

Earl Clark is seen here standing behind the counter of Clark Brothers' Grocery wearing his Texaco uniform. Patron Wesley Light leans against the counter to pose for the photographer. Clark Brothers' anchored the east end of the center row of business houses in the 1940s and 1950s. Texaco gasoline was available from a pair of pumps located on Main Street in front of the store, directly across from the present location of city hall. (Courtesy Kim Fortner.)

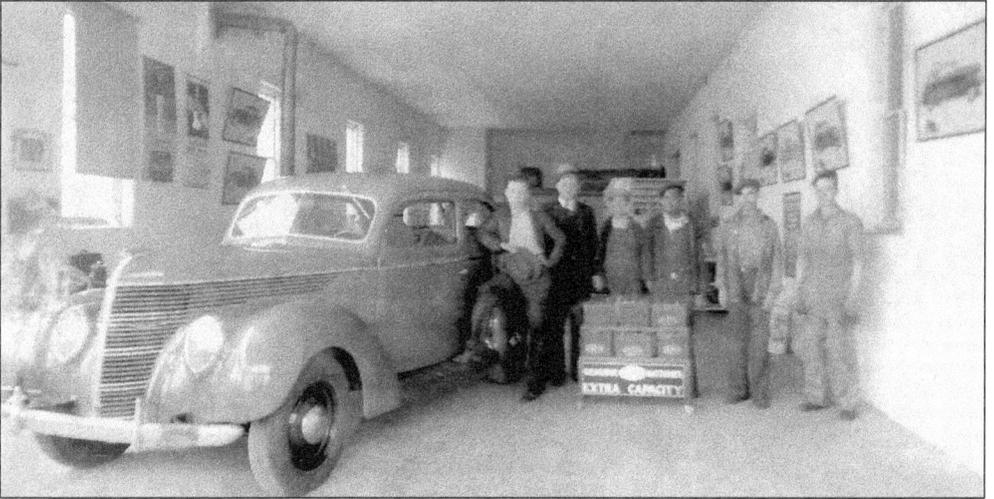

Luther Thomas, second from the left wearing the hat and suit, established a Ford dealership on the northwest corner of Main Street and Marion Street in downtown Cadiz in November 1936. Thomas is pictured here inside the showroom standing beside a 1937 Ford along with several unidentified employees. Thomas would later purchase the old Cadiz High School gymnasium across Main Street from the spot pictured here and move the automobile dealership to that location, leaving the tractor dealership at the original site. Thomas was a Ford dealer until January 1, 1953. (Courtesy Dan Thomas.)

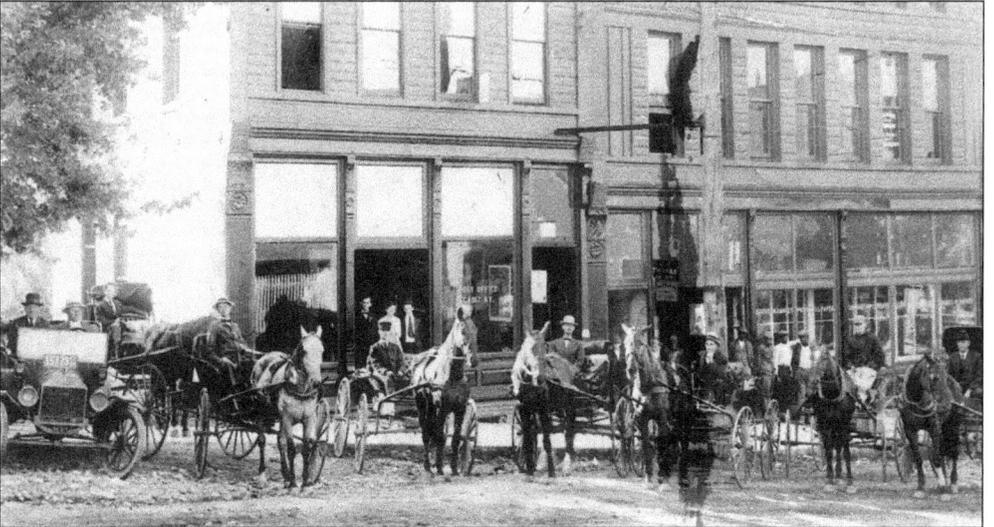

Lined up in front of the Cadiz post office, these letter carriers were about to set off to points throughout the county delivering mail. The post office operated in the 1912 addition to the Cadiz Hardware building from 1912 to 1941. The building that housed Cadiz Hardware (right) was acquired by the White family, which owned and operated the business for many years. Cadiz Hardware was located in a c. 1903 building that dominated the downtown street scene. The main three-story building had a cast-iron storefront on the first floor and a decorative sheet-metal front on the second and third floors. The main entrance to the first floor was located at the corner of Main and Marion Streets. The larger Cadiz Hardware building collapsed around 1990, crushing the smaller addition. Both structures were removed, and an outdoor stage now sits on the site. (Courtesy Joyce Banister.)

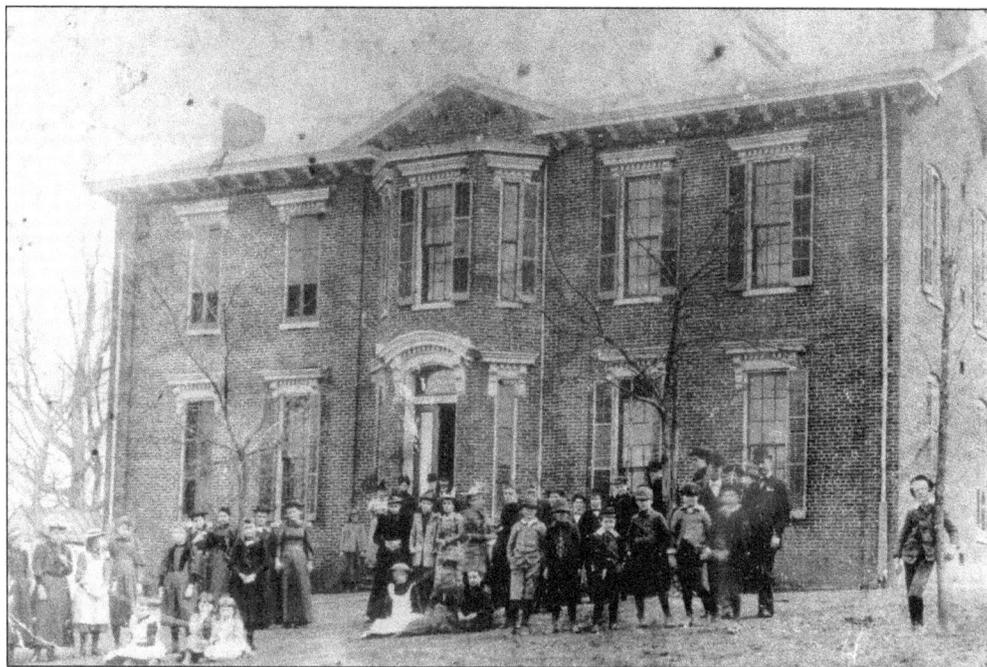

Cadiz High School was organized in 1873, with John C. Dabney as principal. The building was located on Main Street, just west of what would later become site of the Cadiz Baptist Church. The school curriculum provided a course for college-bound students as well as a teacher's preparatory course for those wanting to teach grades one through eight. (Courtesy Barbara Shore.)

This three-story brick building was constructed on the site of the previous Cadiz High School in 1911. In addition to Cadiz residents, students from outside the city limits were accepted on a tuition basis. After Cadiz High School consolidated with Trigg County High School in 1938, this structure remained in use for several years as a grammar school.

The Cadiz High School baseball team was the runner-up in the state tournament in 1929. Pictured here from left to right are (first row) Paul Magraw, Herbert Radford, Lawrence Larkins, T. Lacy Jones, Edward White, and Thomas Watkins; (second row) Smith Broadbent Jr., George Ryan, Lonnie Watkins, Ted Bush, Edward Henderson, Jack Vinson, and coach Lester Solomon. (Courtesy the *Cadiz Record*.)

The Works Progress Administration constructed this gymnasium on Main Street adjacent to the Cadiz High School about 1934. The building and adjoining lots, now owned by the Cadiz Baptist Church, were acquired by Luther T. Thomas in 1947 for use as the Cadiz Motor Company. Thomas constructed a glass showroom, now enclosed, onto the front edifice of the building. (Courtesy Dan Thomas.)

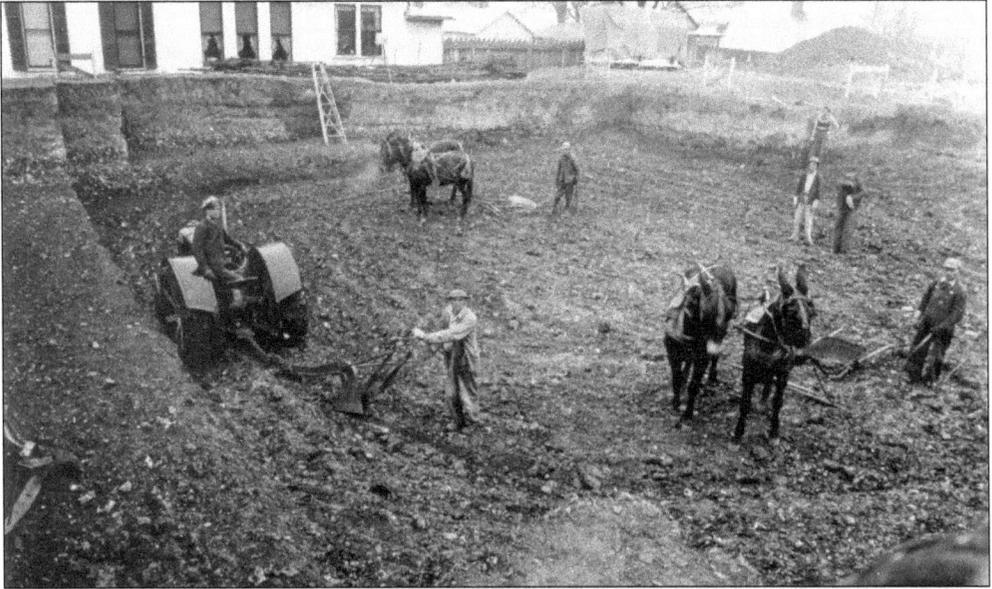

This February 1941 photograph was made while the basement level of the post office was being excavated. In the lower right of the photograph, Homer Cunningham is working a team of mules with a pond scrapper. In the upper center, A. L. "Bill" Davis is also managing a team of mules and scrapper. At left is Sonny Davis, operating the tractor. The others in the photograph are unidentified. The building in the upper left was the home of F. B. and Nellie Wilkinson. (Courtesy Joyce Banister.)

Constructed in 1941, the Cadiz Post Office was built in the Classical Revival style. The one-story redbrick building with a basement and a rear loading dock opened on December 29, 1941. The classical details are concentrated around the central arched doorway with its Doric columns and archway. A classical fascia with dentil molding runs across the front and sides of the building, and the hipped roof is topped with a four-sided cupola. Until its conversion into a museum, the interior retained its original wood entrance vestibule, brass mailboxes, and aggregate flooring. The building was dedicated as the Janice Mason Art Museum in 2000. (Courtesy David and Barbara Shore.)

Established in 1917, Dunbar School was near the present location of Bloomfield Baptist Church on Highway 139 north of Cadiz. The white frame building was approximately a 20-foot square with pine floors and several large windows. Trigg County Schools were segregated, as nearly all American schools were at the time. Grades 1 through 12 were taught at the school from 1923 to 1941, with as many as 200 children in attendance. In 1941, high school–aged Trigg County African American students began attending Dotson High in Princeton by order of the state supervisor of schools. Many of the county's African American schools were consolidated in 1948 and again in 1956, and crowding became unbearable. In 1957, the school was closed, and its students were transferred to McUpton School. African American students attended McUpton until 1962, when all U.S. schools were integrated. (Courtesy Hilda Crump.)

Times were hard and jobs were scarce. A federal program, the Civilian Conservation Corps, provided a great opportunity for employment and an increase in community revenue. Camp Trigg County No. 599 was an 8-acre tract located on the north side of what is now Lafayette Street from Line Street to the west corner of East End Cemetery. The camp was relocated to Princeton in 1939. (Courtesy Jimmy Woody.)

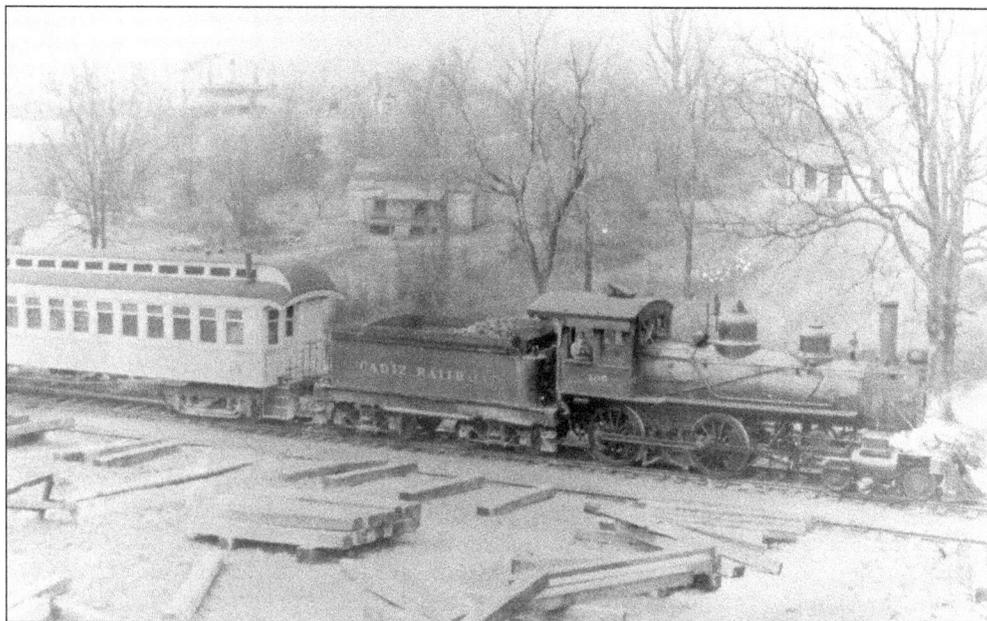

On March 9, 1901, the Cadiz Railroad Company was formally incorporated with William Cleland White as its president. The company sold 1,000 shares of stock for $25 per share, and most were purchased by Trigg Countians. Construction began on April 22, 1901, with mule-drawn scrappers and graders. Engine No. 10, an 1892 Baldwin, made its first run on the Cadiz Railroad in early March 1902. The Cadiz Railroad remained in operation until 1989. The scene above, east of the Cadiz depot, features Engine No. 109, its tender, and passenger coach No. 26. The image at right features Engine No. 633. (Both, courtesy Stan White.)

George C. Atkinson of Earlington, Kentucky had this bungalow constructed on Main Street in Cadiz as a wedding gift to his daughter Margaret who married John L. Street, Sr., October 12, 1916. The 1.5-story house is dominated by its front porch. The main floor has irregularly placed eight-over-one windows, and the upper floor has a front dormer window, a porthole window, and a double six-over-one window. This example of bungalow architecture is a charming contrast to the surrounding Queen Anne architecture. At the time of its construction, the home was noted as being the most "modern" home in Cadiz. (Courtesy John L. Street Library.)

Addie Baker Crump, the nurse for young John L. Street Jr., is pictured here with her daughter on July 12, 1937. The custom of hiring a nurse to attend a small child was a common practice among upper-class families in that era. (Courtesy John L. Street Library.)

Elizabeth Grinter, John L. Street, Mary Grinter, and Edward Street are seated from left to right on a retaining wall along Main Street, watching the world go by. (Courtesy John L. Street Library.)

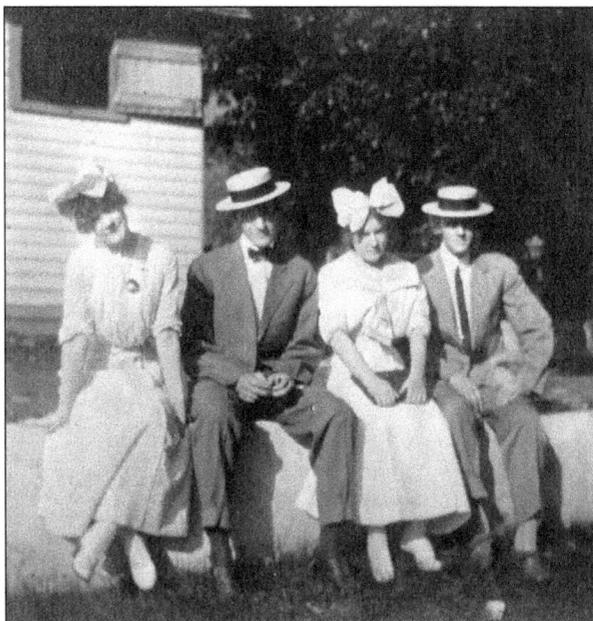

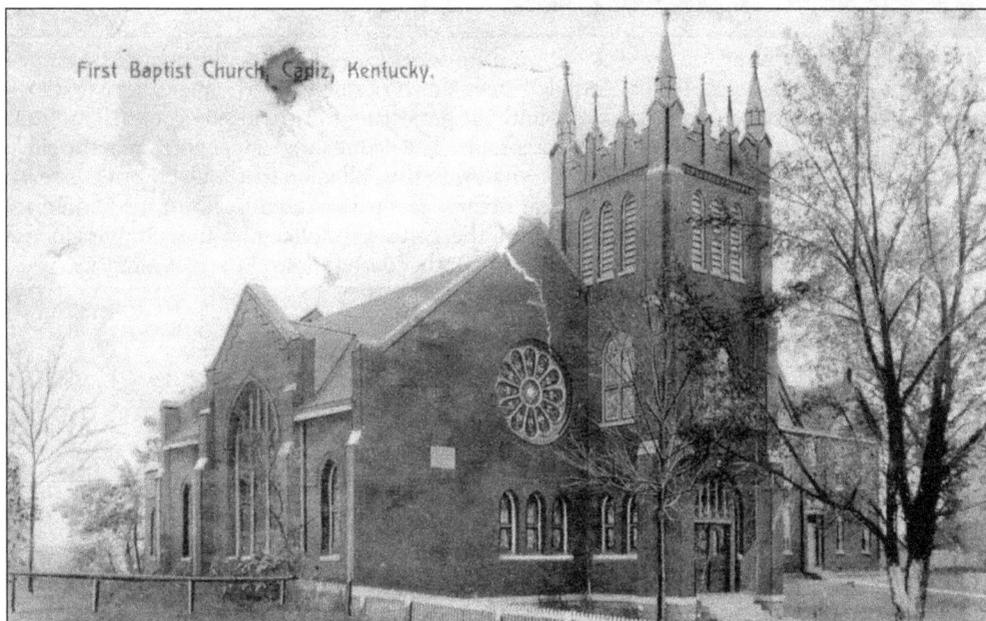

First Baptist Church, Cadiz, Kentucky.

In 1903, the First Baptist Church appointed a Building Committee consisting of W. C. White, Ben T. White, and E. S. Sumner to develop plans for a new house of worship. The structure featured in this postcard, mailed in 1911, was completed on March 20, 1904, and cost $9,785. The Gothic Revival–style structure is composed of an entrance bell tower and sanctuary. The first floor of the tower has Gothic-arched entrances on the north and west sides and an arched window on the east side. The upper portion of the tower also has an arched window on the east side and louvered openings for the bell. The building has large east and west gables, each containing massive arched stained-glass windows. A two-story brick addition was placed on the south end of the sanctuary in the 1950s to serve as a classroom building. Note Cadiz High School at right. (Courtesy William Turner.)

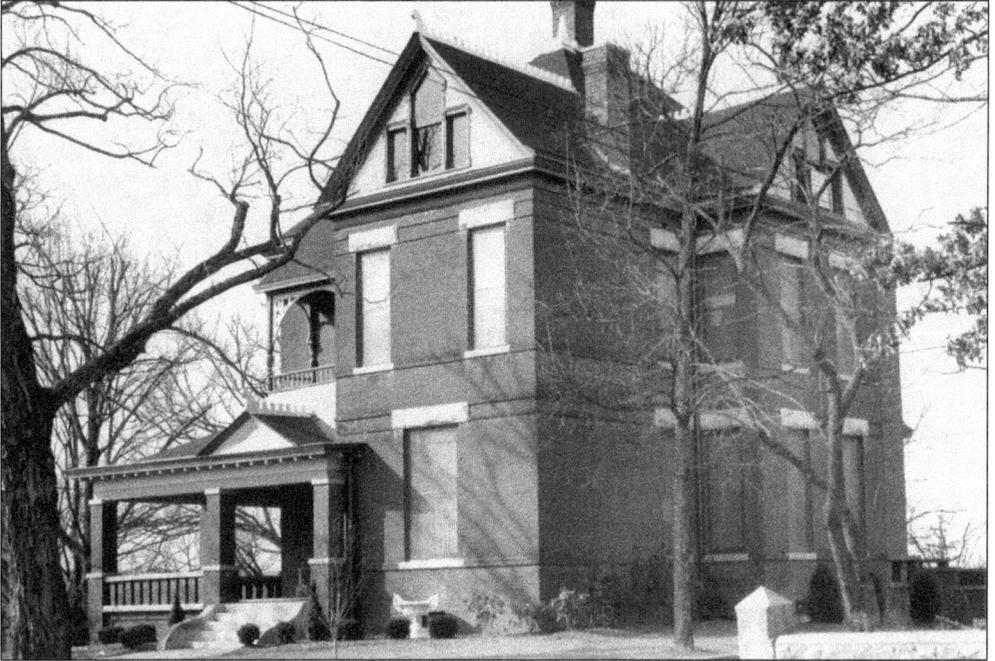

Built in 1885 in the Queen Anne style for Edward and Mary Grinter Street, the home was restored in the Victorian style around 1985 by John L. Street Jr., who named it Fairholme. The main block of the house is topped with a hipped roof and has projecting front and side gables. The front gable has raised brick stringcourses and a water table. The pedimented upper portion of the gable has wood shingling and a central three-part window in the Palladian motif. Upon Street's death in 2000, the home was conveyed to the local library. The parlor room is shown in the interior view and features simple furnishings dating from the 1940s. Fairholme now functions as a house museum and is open for tours and special events. (Both, courtesy John L. Street Library.)

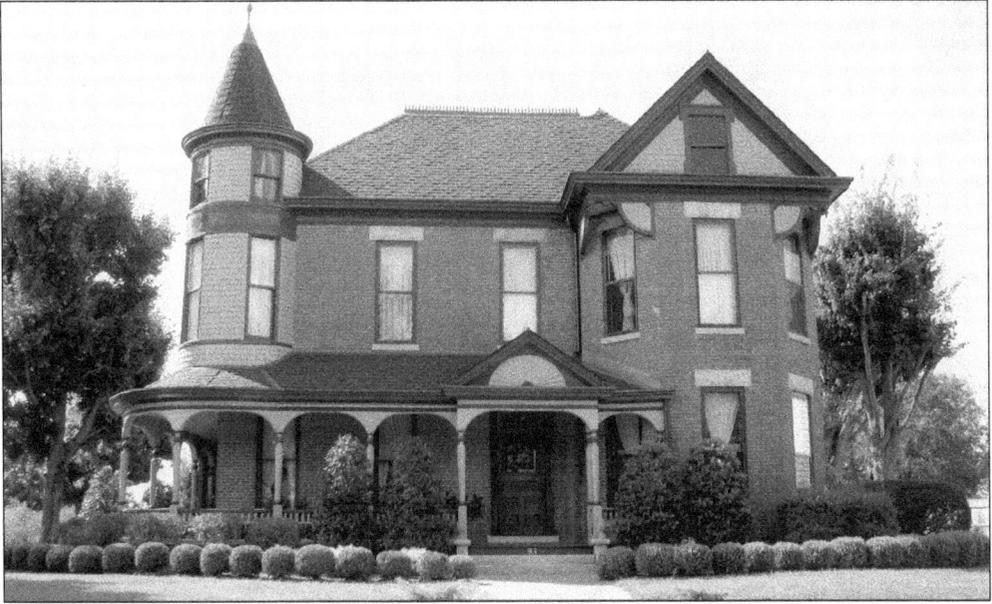

In 1879, Thomas Hill Grinter presented his daughter Georgia and her new husband, George McCain, with this two-story brick house, which featured a three–bay projection on the right side and a second-story oriel window on the southwest corner. In 1895, after the McCains and their youngest child died of tuberculosis, the home was sold at public auction and purchased by Georgia's brother, Daniel Grinter, who completely remodeled the structure in the Queen Anne style, with the addition of a steeply pitched slate roof and a turret to replace the oriel window. The modest porch that had formerly graced the home was replaced with an encircling veranda with a projecting bay beneath the turret. Grinter's daughters, Elizabeth Grinter Lawrence and Mary Grinter, lived there until their deaths.

The time appears to be a Sunday morning when J. Preston White Jr. and Mildred Glover White paused for the photographer before walking to church. Another couple, grown tired of waiting, appears to be striking off on their own to avoid being late for service. (Courtesy John L. Street Library.)

Constructed in 1908, this two-story frame residence was built in the Classical Revival style by John and Martha Burnett White on the site of Martha's family home. The one-story front porch runs the width of the front and has Doric columns and spindled balustrades. The four large front windows have ten-over-one sashes, and the one central window on the second floor has a six-over-one sash. A central dormer window provides light to the attic level. Henry C. White II inherited the home at his mother's death in 1966. (Courtesy Donna Bryan.)

This 1.5-story Colonial Revival house was constructed in 1908 using the lumber from the Burnetts' house on the adjoining lot to the west. The Burnett home had been razed to make way for a new "modern" home for the John Preston White family. The cottage has a gambrel roof incorporating the four-pier front porch into the main of the house.

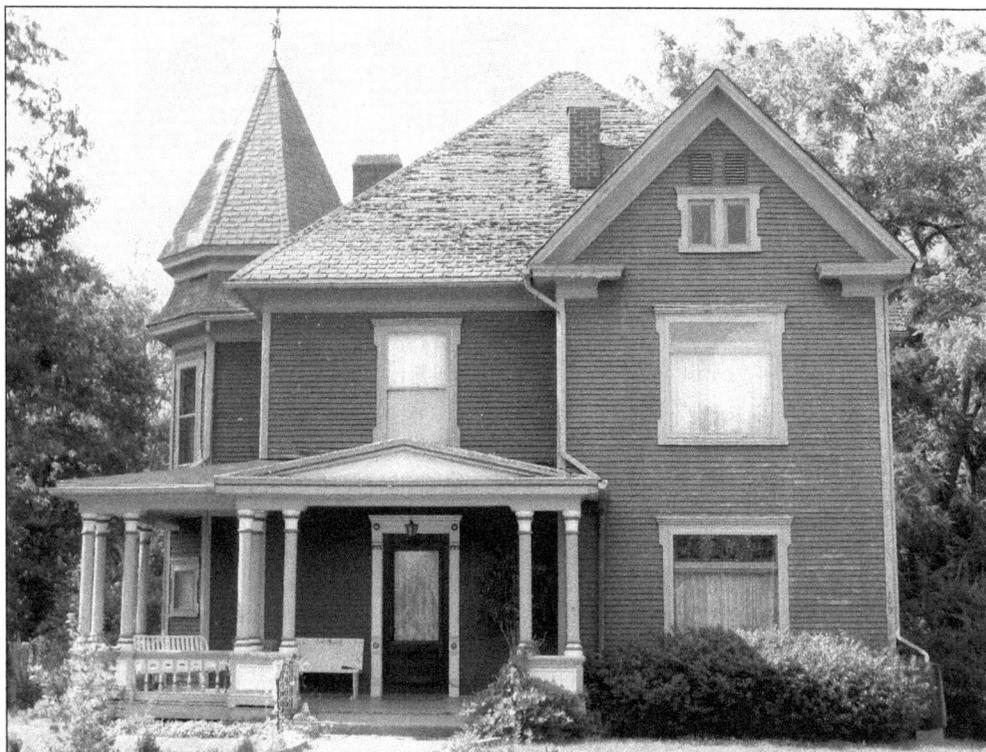

Built by Felix Grasty in the Queen Anne style around 1890, this two-story frame home is distinguished by its one-story front porch and hexagonal tower. The front porch is supported by group sets of Doric columns that rest upon a spindled and paneled balustrade. The hipped-roof main block of the house has slightly projecting front and west gables. A hexagonal cone attempts to create a tower effect on the west side of the house, while the first and second floors of the tower area are incorporated into the main block of the house.

Thomas F. McBride built this two-story Queen Anne–style home around 1890. The house has a projecting front gable with cut-away corners that is topped by a full pediment that encloses patterned shingling and a lunette window. The front door is surrounded by pilasters and is topped with a transom. The original front porch was removed in the 1950s but was replaced in 2010. The home has undergone extensive renovation through the years, and in addition to the front porch, a large rear addition was made in 2010. (Courtesy Dr. Terry Fuqua.)

This 1933 Colonial Revival house was built by Dr. Elias Futrell next to the property belonging to his twin brother, Dr. John Futrell. The gable front of the 1.5-story home is located under a sharply pitched roof. Limestone blocks were used to construct the foundation and the chimney.

T. G. Jones constructed this two-story Queen Anne–style frame home around 1878. The house was sold to E. E. Wash in 1902, and later owners included John Vinson and Charles Humphries. Dr. John Futrell purchased the house in 1929 and resided there until his death in 1974. Gary and Amanda Herndon Polete purchased the home in 1997 and renovated it with an eye for preservation. The couple opened the home as the Futrell House Bed and Breakfast on September 19, 2008. (Courtesy Gary Polete.)

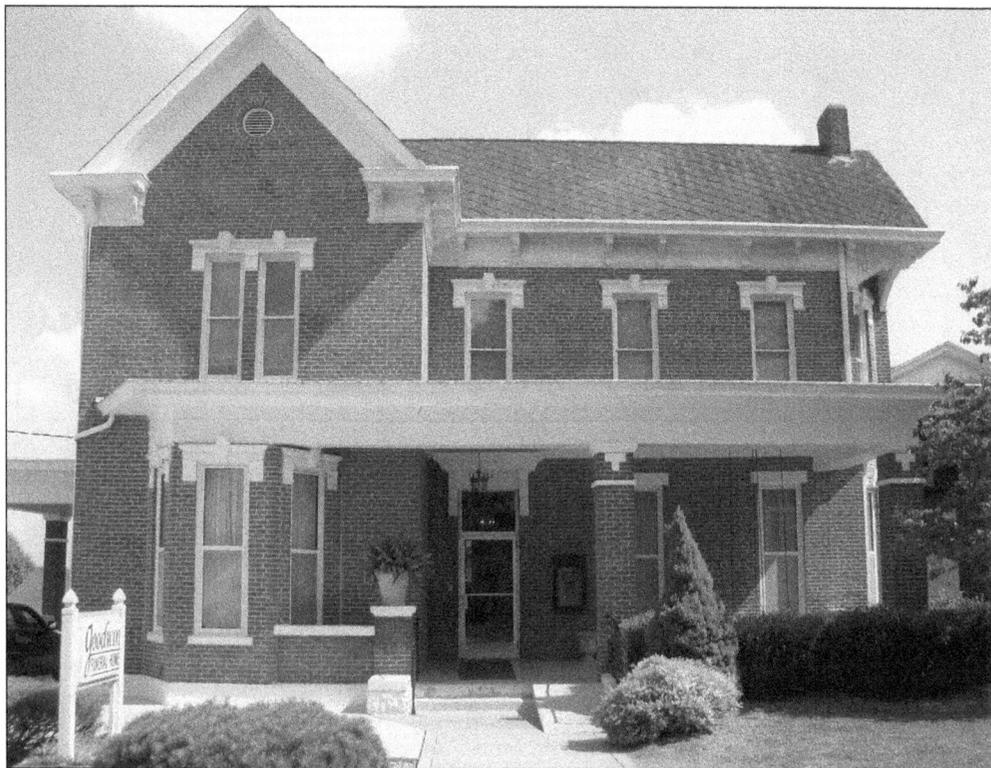

Burnett Wilford built this two-story brick ell-shaped Italianate house with a bracketed cornice in the late 1870s. The one-story front porch runs across the front of the house, and the porch roofline is incorporated in the top of the front bay window. Arthur K. Goodwin purchased the property in 1946 for use as the Goodwin Funeral Home and added a classically inspired chapel to the rear of the house in 1957. The main entrance portico to the chapel is at the southwest corner of the house and faces Main Street. Goodwin Funeral Home, Inc., is owned and operated by John R. Vinson III.

Arthur "A. K." Goodwin, a Cadiz and Trigg County funeral director from 1937 until his death in 1962, is pictured standing beside the pride of his funeral fleet, a 1957 Packard that served as a combination ambulance and hearse. (Courtesy John Vinson.)

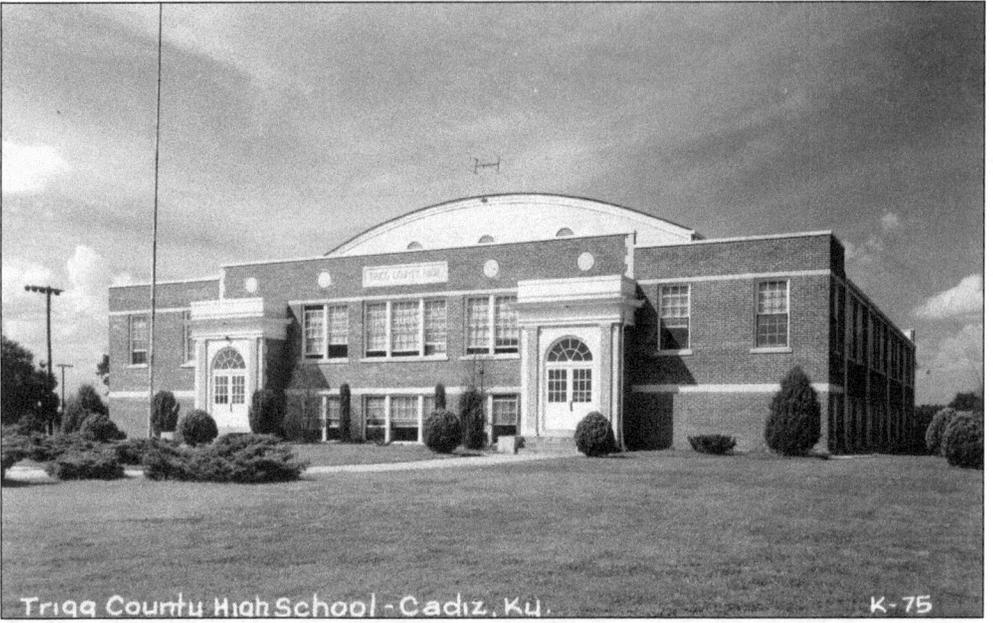

Trigg County High School - Cadiz, Ky. K-75

In 1936, the Works Progress Administration built Trigg County High School at the cost of $20,500. It opened on September 5, 1937, with 241 students and eight faculty members. It was destroyed by fire in the late night of June 19, 1960. A new $1-million facility was completed the next year and remains in service. (Above, courtesy William Turner; below, courtesy David and Barbara Shore.)

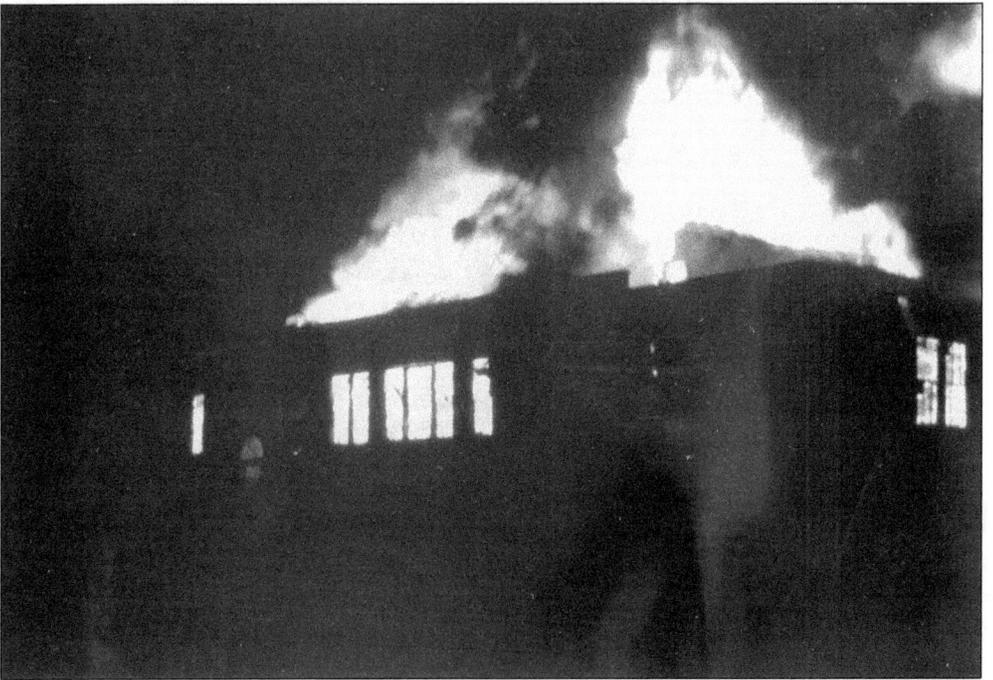

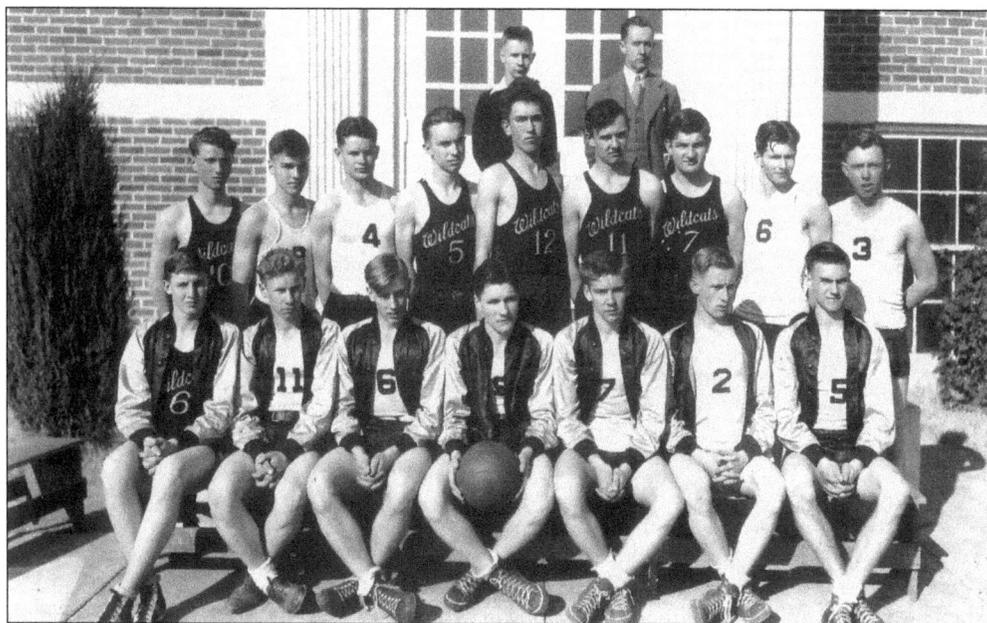

Shown here is the Trigg County Wildcat 1943–1944 basketball team. From left to right are (first row) Jackie Smith, Henry Richardson, Frank McAtee, team captain Winthrop Hopson, Tommy Cunningham, James Guess, and Joe Boren; (second row) Marvin Dunn, Robert B. Piercy, Keidell Bridges, Robert Thomas, G. T. Wallace, Rex Francis, Kenneth Bush, Clyde Turner, and Earlie Perry Jr.; (third row) manager Bill Redden and coach Lee Redden. (Courtesy the *Cadiz Record*.)

The 1942–1943 *Wildcat* included this photograph with the caption "These three lassies and one lad cut a pretty pattern in their black and white when they line up and lead those CATS fans in the peppy yells that spur those cagers on to V-I-C-T-O-R-Y. Ann Parent (right) is the only 'old-timer' on the 1943–1944 cheering squad, but Frances Thomas (left), Delores Crisp and John Shelby Street seem to have gotten the hang of things in a hurry!" (Courtesy Vicki Godwin.)

The Frank Street home stood in a large wooded lawn across the street from Trigg County High School. The house was typical of construction in the 1870s, with a "modern" Victorian gingerbread front porch added around 1900. The home was razed in 1958 in preparation for the construction of the new Cadiz Methodist Church. (Courtesy Cadiz Methodist Church.)

The White Eagle Restaurant was located across from the present-day Goodnight Motel, which during the 1930s and 1940s was the White Eagle Motel and Gift Shop. The restaurant was owned and operated by Rebecca and Mable Peal; their grandfather, Euphrates Peal, ran the motel and gift shop. At one time, the White Eagle included a balcony section and dance hall, which provided a great deal of entertainment. (Courtesy Lucille Witty.)

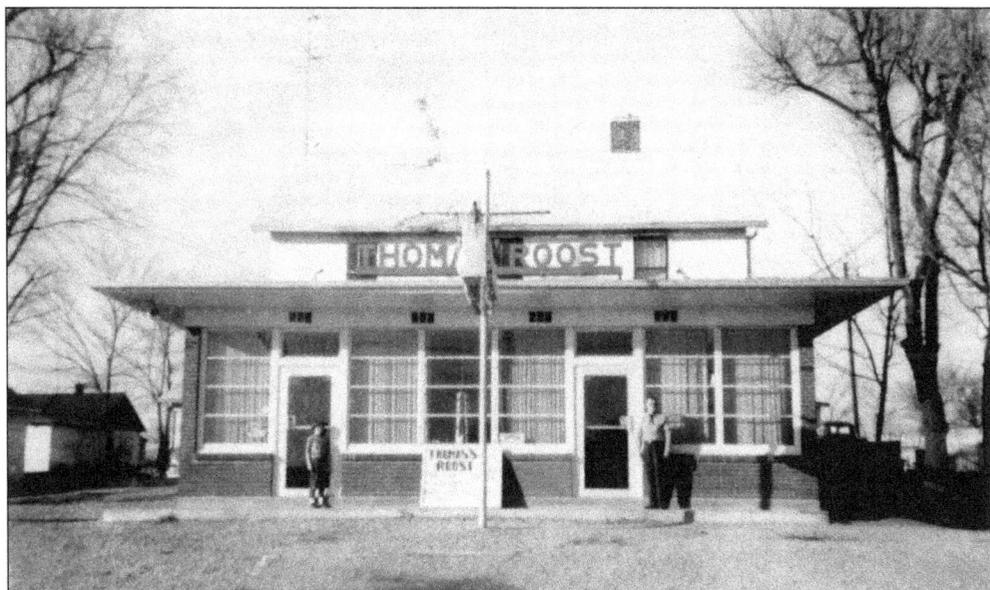

Vicki DeName (left) and her grandfather Cordie Thomas appear in this c. 1960 photograph, standing in front of Thomas's Roost. This popular restaurant was owned and operated by Cordie and Mina Wallis Thomas. Following a decade in the restaurant business, the couple retired in 1970. Kelly P'Pool Photography later occupied the building. The structure sat abandoned for several years and was demolished in the early 1990s. (Courtesy Vicki Godwin.)

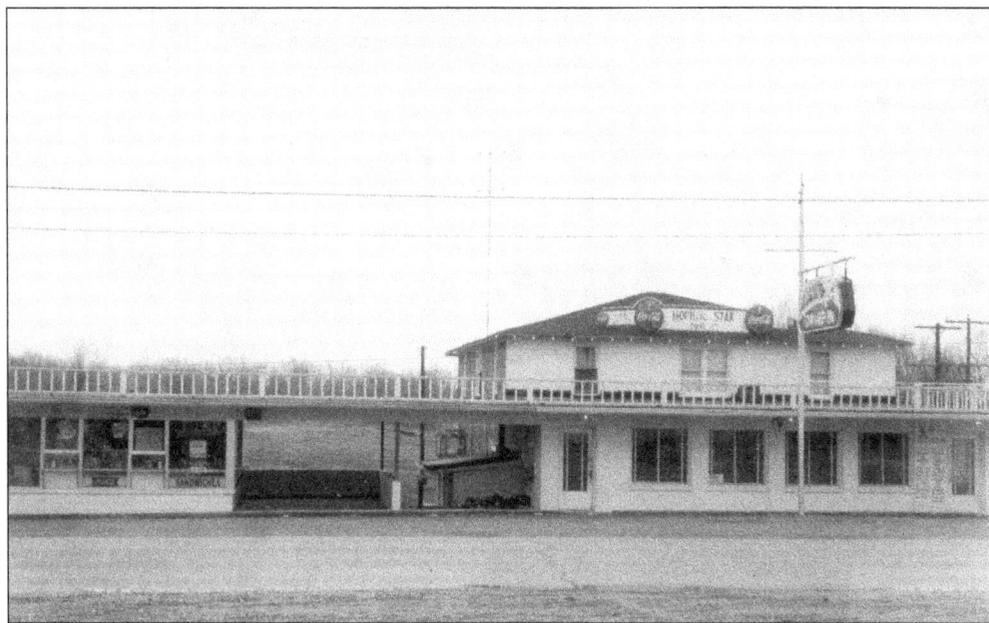

During the 1950s and 1960s, Morning Star Restaurant was a popular local diner. Morris and Martha Audas owned the Audas Dairy and operated it in this structure before adding the kitchen and dining area to the building. Audas drove his milk truck throughout the county collecting milk, which was then pasteurized, bottled, and delivered to the doorsteps of local residents. Audas Dairy also produced cream, butter, and a variety of sweet cream ice cream. This building is now home to the Cadiz Restaurant. (Courtesy Shirley Carr.)

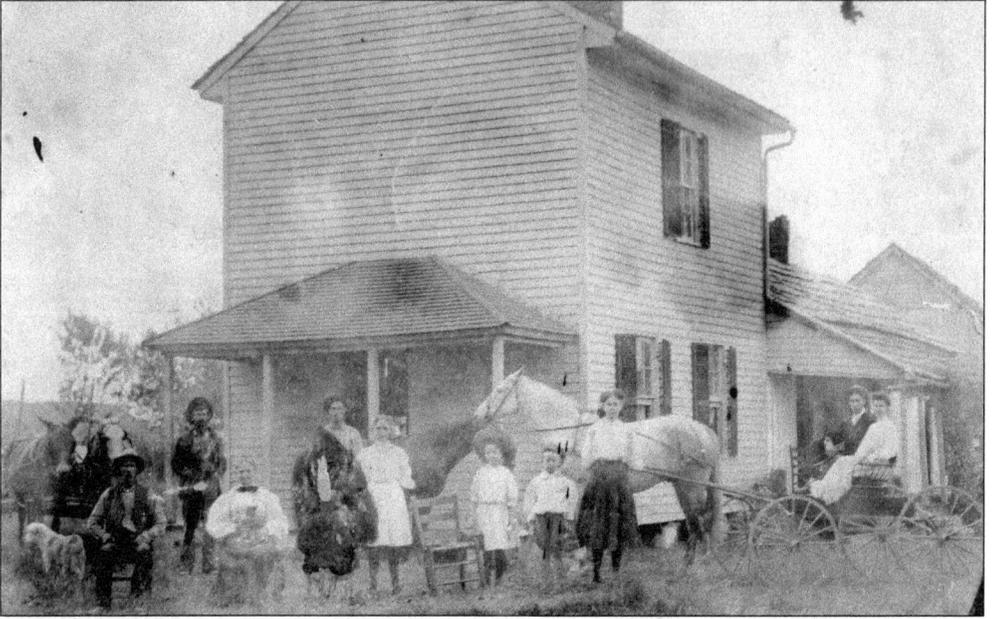

This landmark home features a two-story block with a two-room one-story ell at the rear. Its appearance indicates there may have been plans for the addition of a two-story font section never completed. This c. 1900 farm manager's home was located near the present site of the post office in East Cadiz. William Joseph and Sarah Bridges are seated at left; they are accompanied by several unidentified relatives. (Courtesy Lem Banister Jr.)

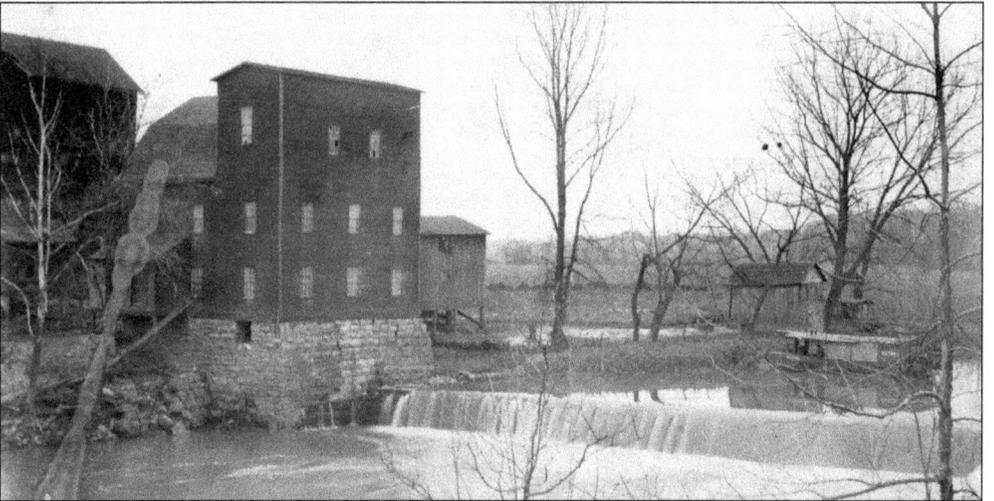

The Old Cadiz Mill was located on Little River approximately a half-mile east of the old iron bridge. The old road followed the hillside down to the bottoms in a southeastward direction behind the former site of the Cadiz Hardware store. The firm of Jones and Gatewood started construction of the first mill in 1869. The unfinished mill was sold to Robert Wilford in 1870, and he completed it that year at a cost of $30,000. According to Perrin's History of Trigg County, it was the largest mill in the county at that time. Wilford sold a one-third interest in the mill to Frank Street in 1884 and the remaining two-thirds to William Cleland White in 1888. Street sold his third to Percy White in 1889. When Percy White built the new mill west of Cadiz in 1910, he used the machinery from this site, which was then abandoned.

Seven

Montgomery, Cerulean Springs, and Wallonia

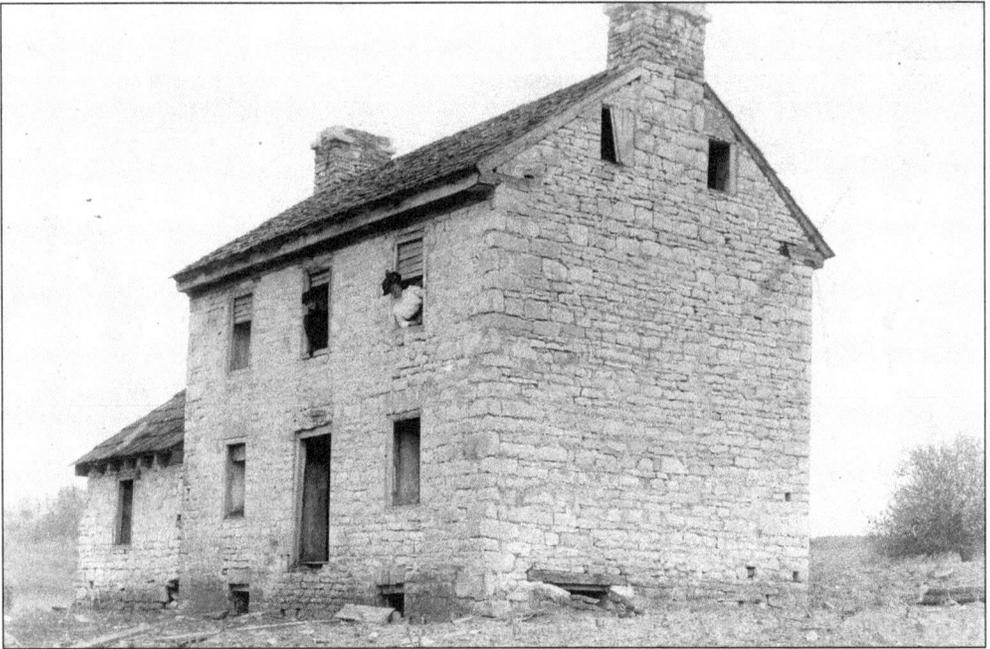

John McCaughan came to America in 1792 and eventually settled in the Kentucky Territory in what is now Trigg County. McCaughan built this rock house in the Federal style around 1814 with 2-foot-thick walls, a basement, two full stories, and an attic. The history of this residence, now the oldest standing house in Trigg County, includes its prior use as a home, an inn, and a stagecoach stop. This home is an excellent example of a two-story dry-stone house of the type commonly built by the Scotch-Irish in central Kentucky and is the only one of this type found in western Kentucky. (Courtesy Tom Vinson.)

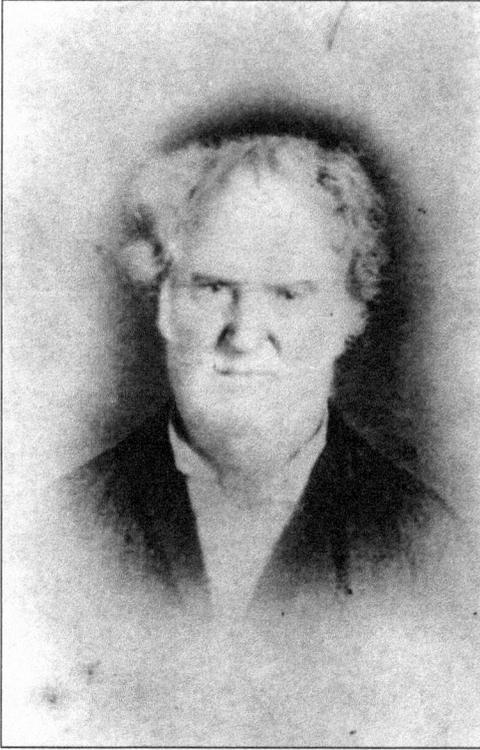

The farm manager of Pres. Thomas Jefferson's Monticello from 1800 to 1820, Edmund Bacon (1785–1866) came to Kentucky in search of land and settled near Montgomery. Captain Bacon was a great racehorse enthusiast and had a racetrack in the front yard of his home. (Courtesy David and Barbara Shore.)

Bacon purchased a large tract of land and built his simple tidewater plantation home from a plan drawn for him by former president Thomas Jefferson. In 1825, Bacon followed Jefferson's plan for the home, but rather than build it from the ground up, he gathered several abandoned cabins from his large plantation and incorporated them into his construction. This structure was destroyed by fire on December 16, 1960. (Courtesy William Turner.)

Dr. Thomas Wooldridge of Frankfort, Kentucky, and Eliza B. Cates were married in 1824, and around 1830, they moved to Trigg County, where they constructed this Federal-style farmhouse. After Dr. Woodridge's death in 1872, the home was sold to Gen. John Gaines, and it was later resold to his brother, J. R. Gaines, a bachelor who lived in the home until his death in 1909. The latter Gaines occupied the upstairs as a residence and used the first floor to stable his livestock during the winter. Brothers Van and J. Blair Alexander restored the home when they acquired it in 1909, and Blair became sole owner in 1930. The house was home to Mack and Georgia Alexander Hopson until they sold it to Smith Broadbent Jr. in 1944. Smith Broadbent III and his wife, Katie, have made it their home since 1963. (Courtesy Smith and Katie Broadbent.)

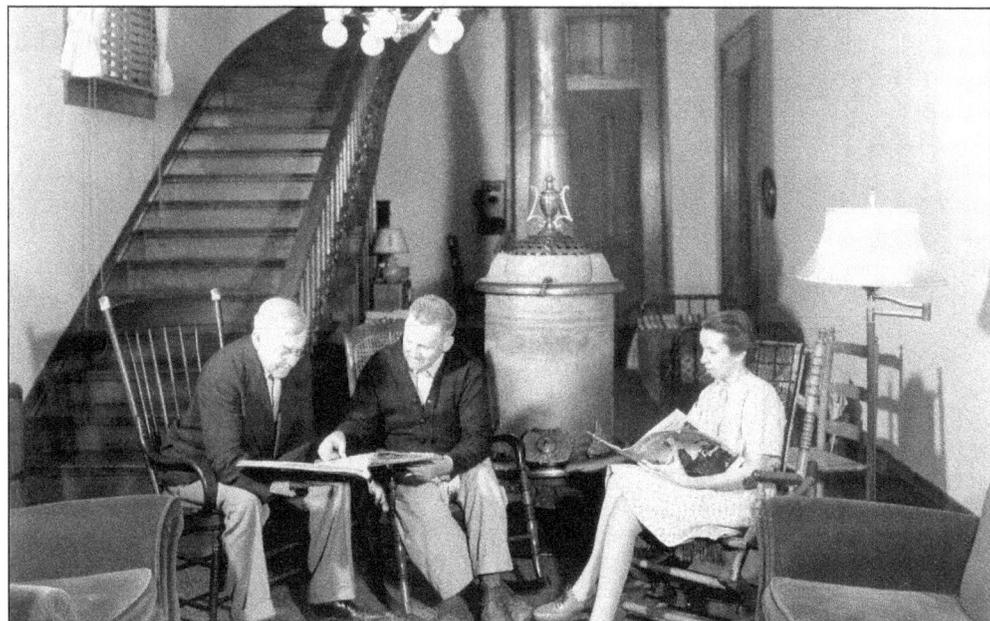

Seated from left to right are W. C. Lassetter, the editor of *Progressive Farmer*; Mack Hopson; and Georgia Alexander Hopson. Hopson operated a large livestock operation on the farm around Fair Acres, tending to as many as 4,000 sheep in 1943. Hopson utilized innovative farming techniques for the time and was being interviewed on the occasion of this photograph for a feature article in the *Progressive Farmer* regarding his farming operation. (Courtesy Smith and Katie Broadbent.)

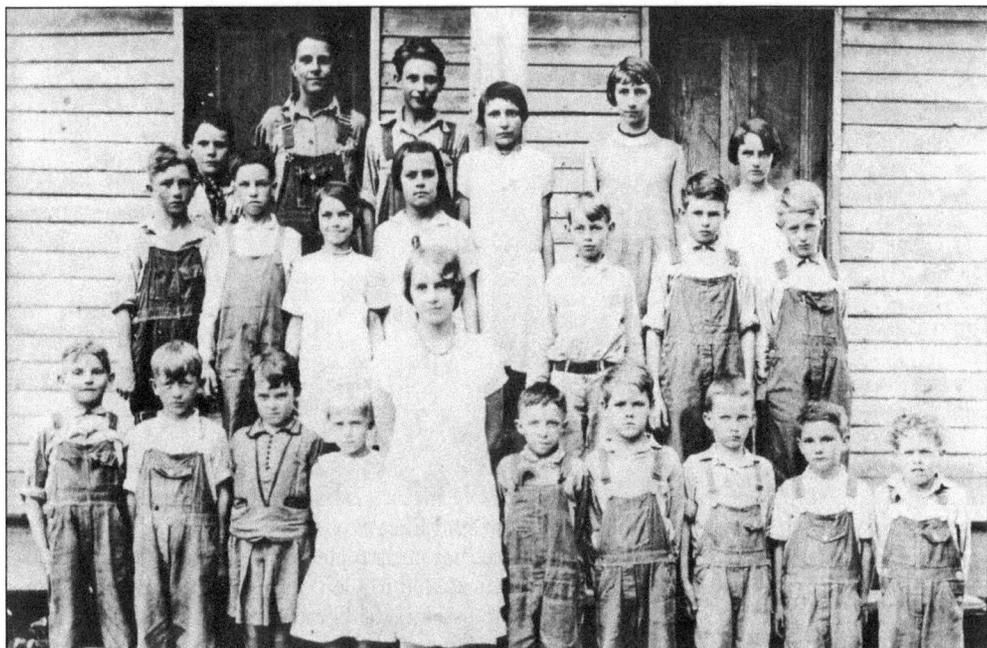

This group photograph was taken at the Montgomery White School around 1928. Pictured from left to right are (first row) Clyde Hite, Charles Adams, Dorothy Ricks Tilley, Mary Virginia Major, Elizabeth Miller (teacher), Harlon Sawyer, Clyde Aldridge, Robert Hall, Robert W. Hite, and Norris G. Hite; (second row) James Adams, Billy Sawyer, Nellie Sawyer, Thelma Aldridge, William Humphries, J. W. Major, and George Major; (third row) Catherine Hite Leneave, Rudolph Aldridge, Rudolph Hite, Imogene Hite P'Pool, Elizabeth Rogers Taylor, and Mary Grace Hall. (Courtesy Brenda Lile.)

The children attending the Montgomery School for African Americans gathered for a photograph on December 20, 1957. From left to right, the children pictured are (first row) Flora Jones, Henry Wharton, David Wharton, Lawrence Wharton, Billy Radford, Jessie Larkins, Robert Irvin, Rosie Anderson, Carolyn Wharton, Ronnie Redd, and Richard Wadlington; (second row) George Radford, Sheridan Hollowell, Rubin Irvin, Irene Manning, Lucy Diggs, Rose Lander, Pauletta Radford, Bertha Gude, Fannie Mae Bacon, Ella V. Gude, and Dorothy Ladd; (third row, beneath the "N") Barbara Hudson, James Grooms, Henry Wadlington, John Irvin, unidentified, Margaret Watkins, Faye Lander, and Eugene Wilson. (Courtesy Virginia Wharton.)

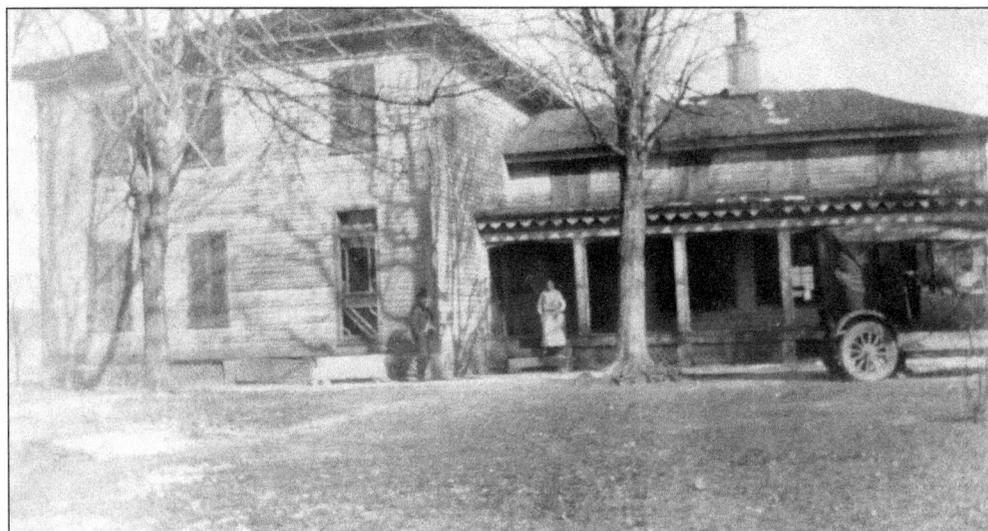

Research on this landmark is ongoing and has not yet yielded the full details of its long history. The information given is speculative, subject to future study. Though the location is referred to by some as "the Roach place" and by others as "the Golladay farm," it is certain that in the 1920s and 1930s, Tom Turner and E. O. "Pud" Stewart owned the farm that included the house and farm. The home was similar to the old Wooldridge home near Montgomery (now owned by Smith and Katie Broadbent) and was located on the farm at the northwest corner of the junction of the Cadiz and Cerulean Springs Roads. The house was last owned by John Lane, who tore it down in the early 1960s. (Courtesy Vicki Godwin.)

This August 21, 1916, photograph shows 5-year-old Jack and 13-year-old Bitsey Mitchell, regular workers on their father's farm in the Montgomery/Gracey Community. The boys are pictured with their father, B. F. Mitchell, worming and suckering their tobacco crop. "He worms and he suckers. Quite a worker, but he ain't old enough to go to school yet," the mother said about Jack. "Bitsey goes to Wallonia School when he isn't needed on the farm." An agent of the National Child Labor Committee took this photograph during data collection for a report to Congress. (Photograph by Lewis Hine, Courtesy Library of Congress.)

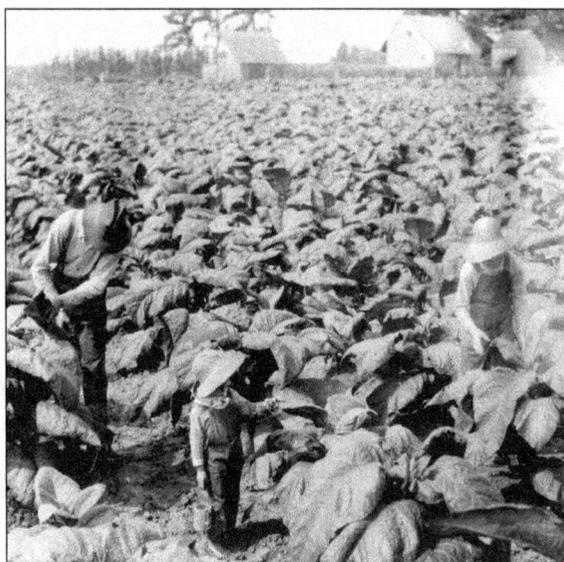

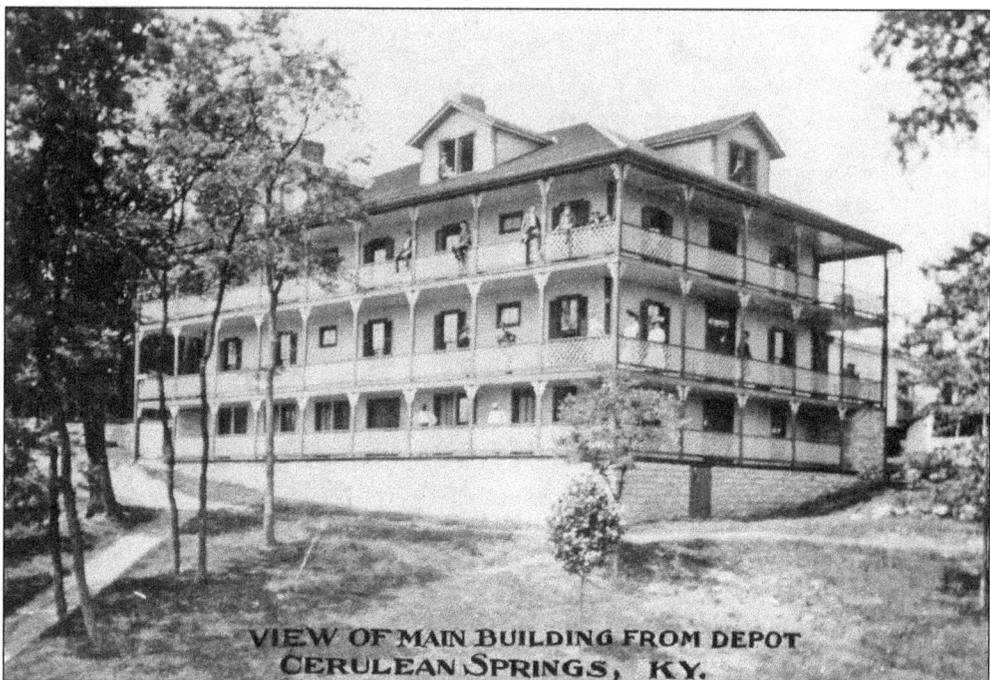

VIEW OF MAIN BUILDING FROM DEPOT
CERULEAN SPRINGS, KY.

For guests of the Cerulean Springs Hotel arriving by rail, this view of the three-story annex, built in 1901, would have been their first glimpse of the famous spa. This frame weatherboard addition provided rooms for 50 guests and featured 750 feet of gallery walkways. The building was painted white and trimmed in green with a wood-shingle roof. The hotel was completely destroyed by fire on the evening of August 29, 1925. The octagonal dancing pavilion below was built in 1905, and although it was spared by the fire, with the hotel gone, the pavilion fell into ruin. (Both, courtesy William Turner.)

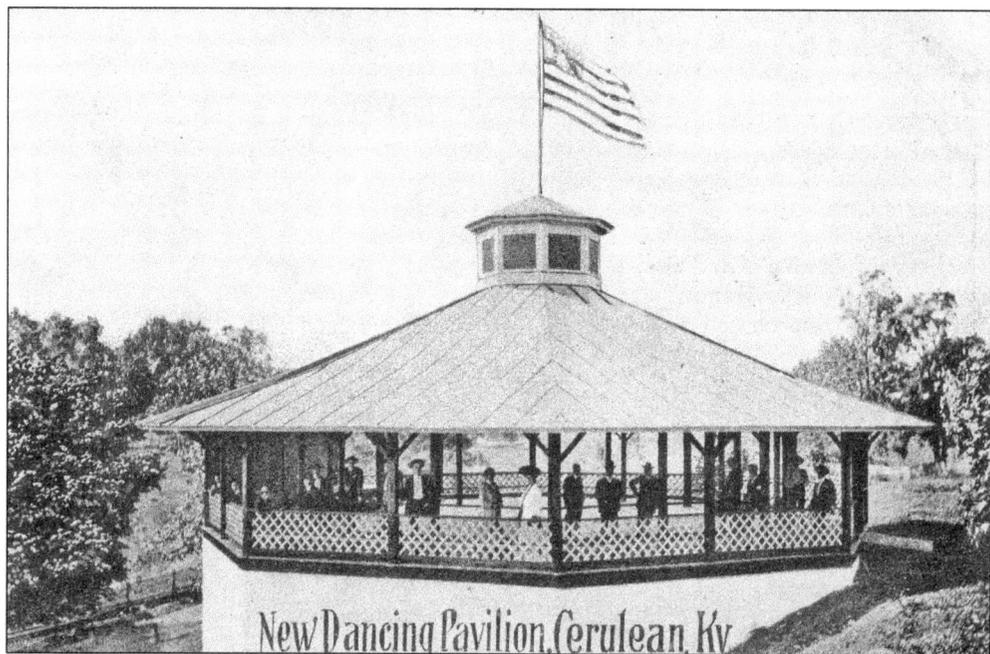

New Dancing Pavilion, Cerulean Ky.

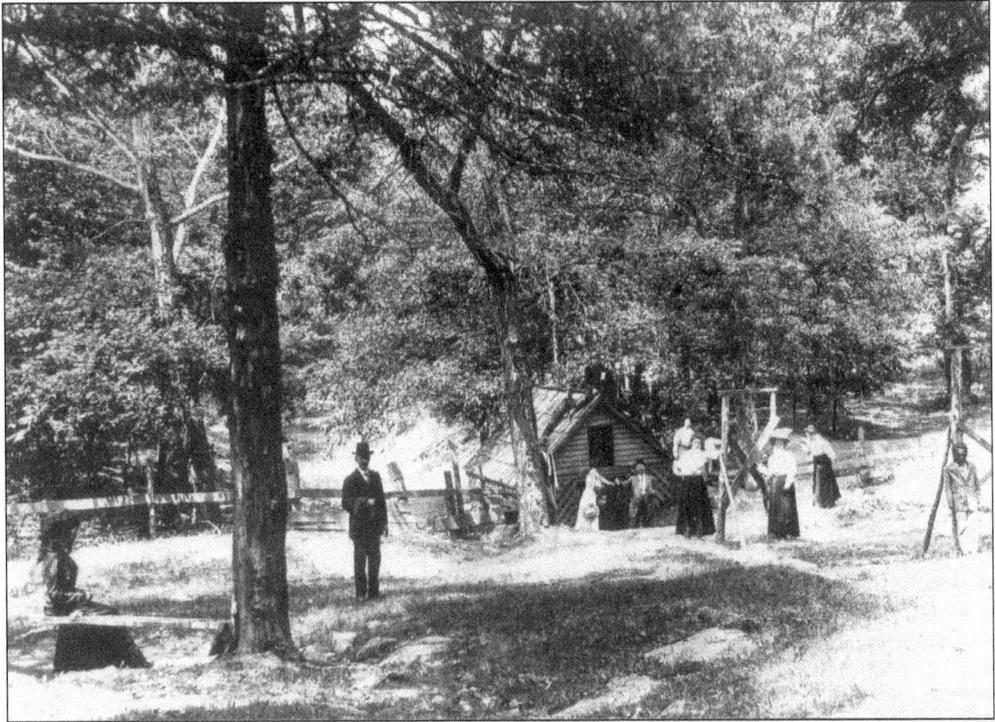

The heart of the Cerulean Springs Hotel was the Cerulean Blue sulfur spring on the banks of Muddy Fork Creek, seen here in 1909. The 1811 New Madrid Earthquake transformed the stream into a spring of blue sulfur water. Restoration of the springhouse was conducted in 1955 and again in 2006. (Courtesy William Turner.)

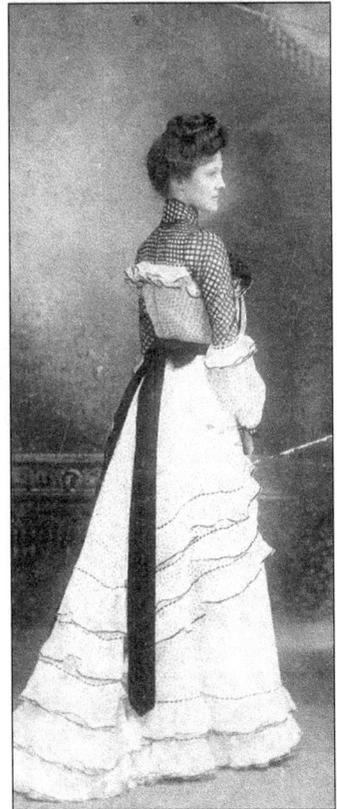

The following appeared in the *Kentuckian*, a local newspaper of the era. "Walker Gunn and Annie Lindsay were married at Cadiz, Kentucky, on Wednesday, October 19, 1892. Gunn is the handsome young landlord of the Cerulean Springs Hotel, and his bride is the daughter of Dr. L. Lindsay, one of the leading physicians of Cadiz. She is a brunette, tall, and handsome, and of stately bearing, and for the last two or three years since leaving school has reigned as one the captivating belles of Trigg County. Mr. Gunn is indeed fortunate in winning so charming a bride, and the *Kentuckian* unites with his many friends in extending congratulations." (Courtesy Mary Lou Roark.)

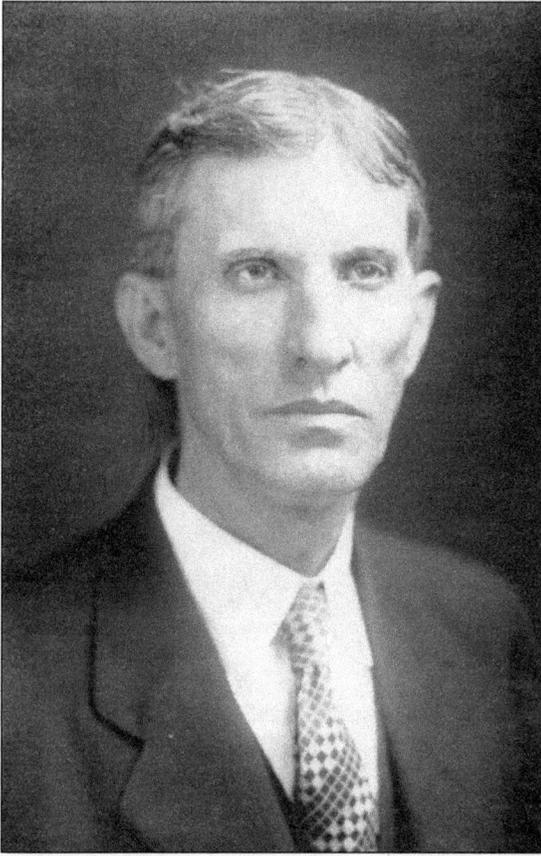

Thomas Oscar "Tom" Turner (1872–1955) was a farmer, merchant, hotelier, and a leader in the Muddy Fork Primitive Baptist Church. In 1914, he moved to Cadiz, where he owned and operated a hardware store, a clothing store, and the Ford dealership. Known by his initials, T. O. T.—or "Tight Old Tom," as he was jokingly called—represented Trigg County in the state senate from 1928 to 1938 and then as a member of the Kentucky General Assembly from 1938 to 1940. (Courtesy William Turner.)

Cerulean Springs Hotel maintained an operating farm of about 120 acres. Hog meat was a staple menu item. Pictured around 1914, hotelier Tom Turner stands with hogs near the concrete silo. Isham Harris, a farm laborer, is seen here assisting Turner. (Courtesy William Turner.)

120

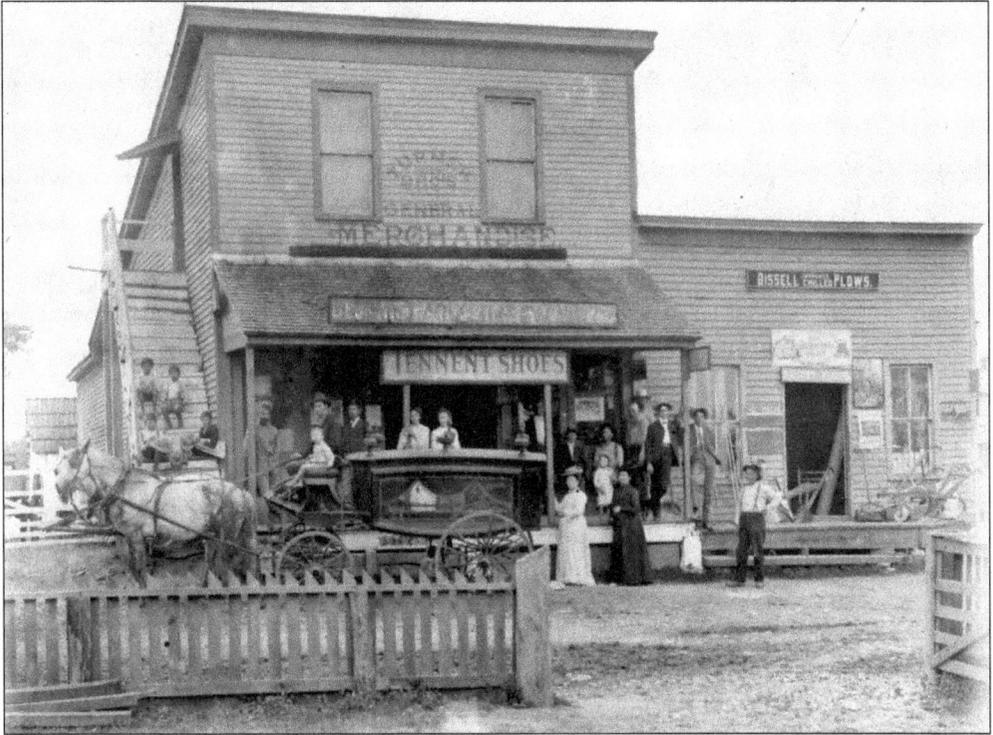

The Turner Brothers, Will and Tom, owned and operated this general store on Main Street in Cerulean Springs from 1896 until 1907. A group photographed on March 27, 1904, illustrates the variety of society and business activity that took place around a small community store. The building was torn down in 1937. (Courtesy William Turner.)

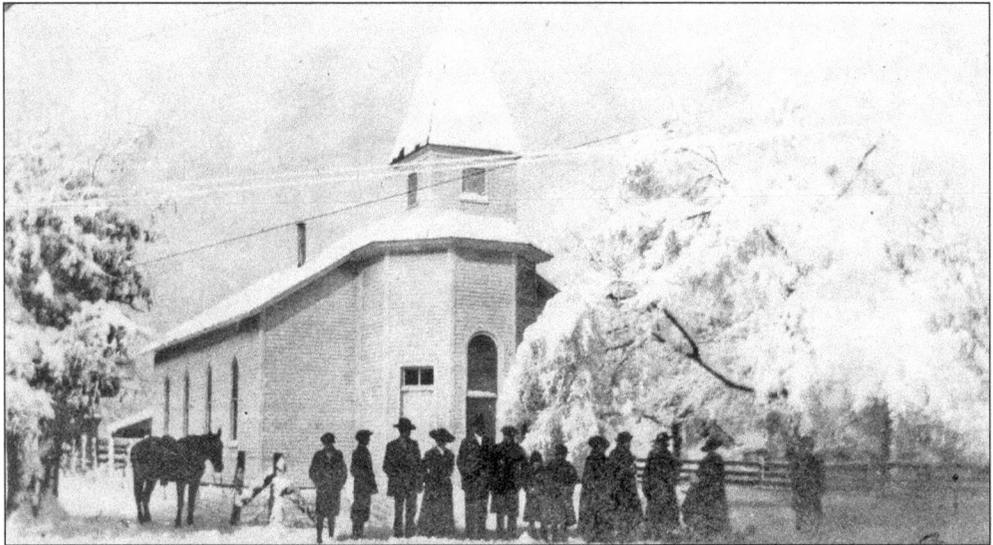

Congregants of the Cerulean Methodist Church appear as silhouettes in this c. 1918 photograph. The church was organized in the early 1890s and built this structure on the northwest corner of Main and Hopkinsville Streets about 1900. It was destroyed by fire on March 22, 1966. (Courtesy William Turner.)

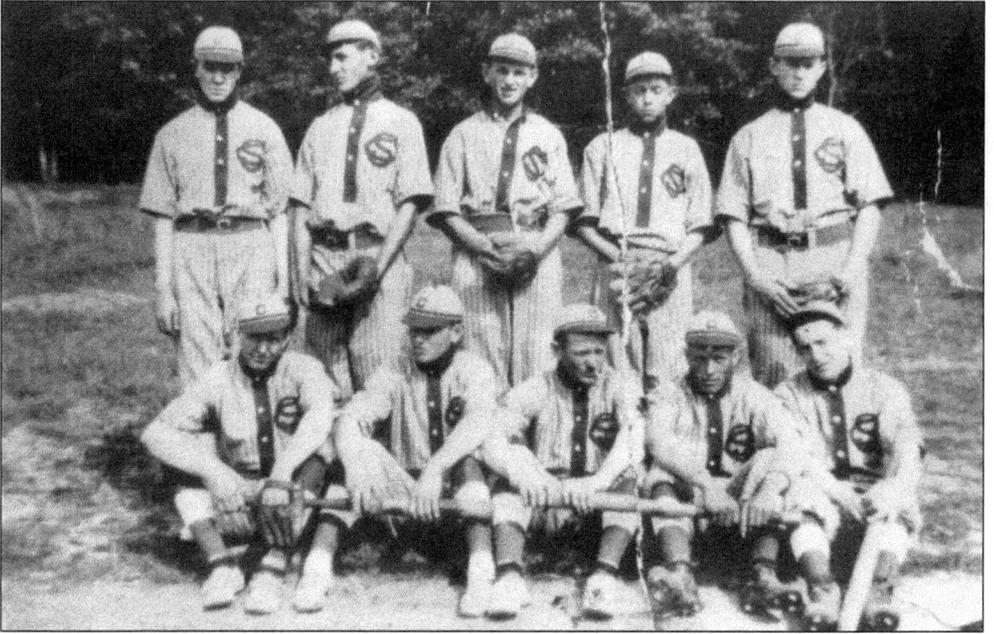

The Cerulean Sluggers baseball team is pictured here in 1917. From left to right are (first row) Alva Felix, Will Weller, Fred Solomon, Johnny Sizemore, and Turner Pursley; (second row) Ivan Ladd, Lawrence Felix, John Weller, Leo Stewart, and Elbert Solomon. (Courtesy William Turner.)

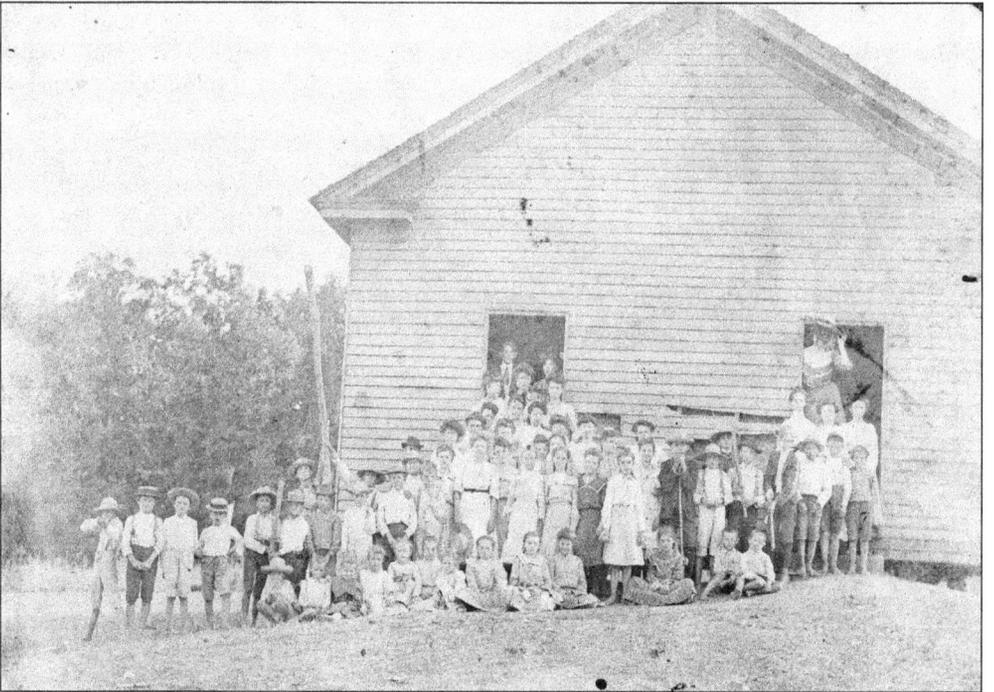

Approximately 60 Cerulean School children turned out in their finest for picture day about 1902. In a sign of the times, even in their straw hats, knee britches, and fancy dresses, most of the students' feet are bare. The last of the county's schools to be consolidated in 1937, grades one through eight continued in Cerulean until 1963. (Courtesy William Turner.)

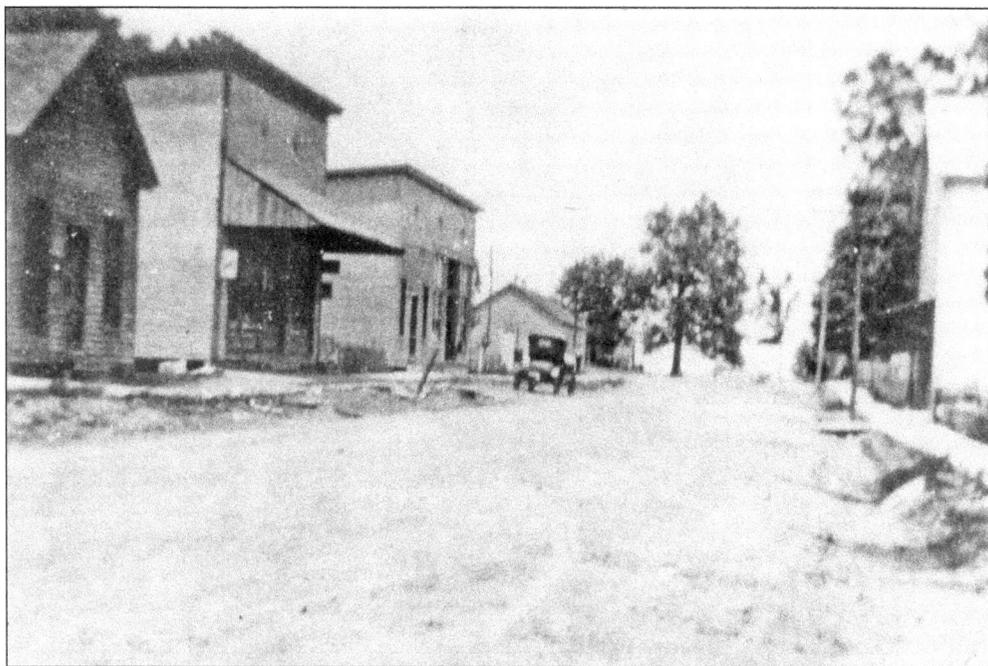

This c. 1920 scene includes a row of Cerulean stores in addition to the Masonic lodge (right) and a Ford Model T parked on the edge of the dusty street. The Muddy Fork Primitive Baptist Church is visible in the center background. (Courtesy William Turner.)

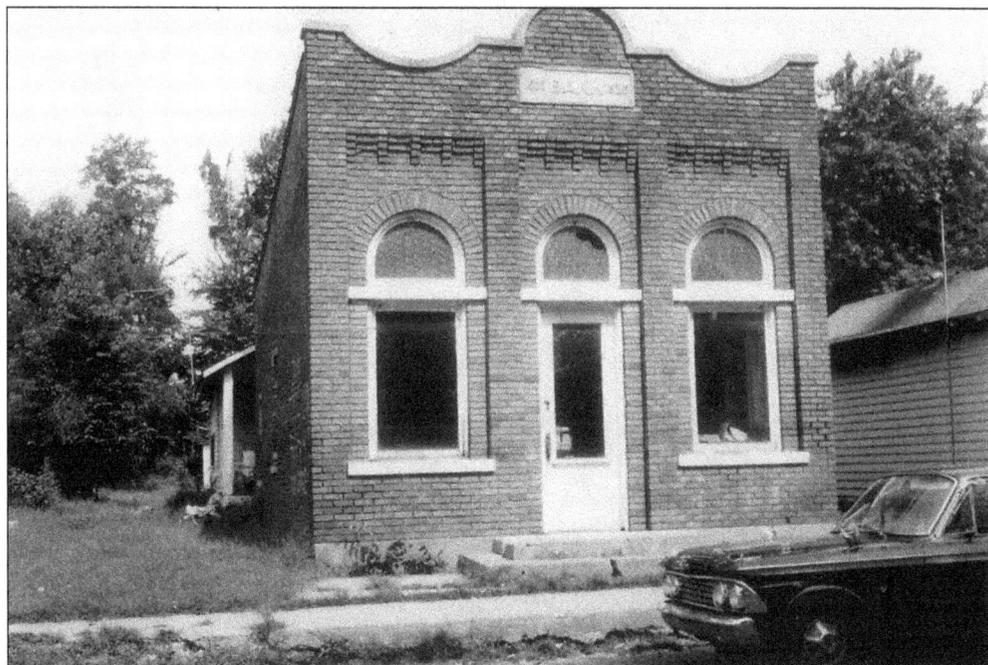

The Bank of Cerulean Springs was organized on June 8, 1903, and was opened September 23 of the same year with a capital stock of $15,000. On December 10, 1941, the bank closed due to deficiency of funds. The building was destroyed by fire on April 4, 1971. (Courtesy David and Barbara Shore.)

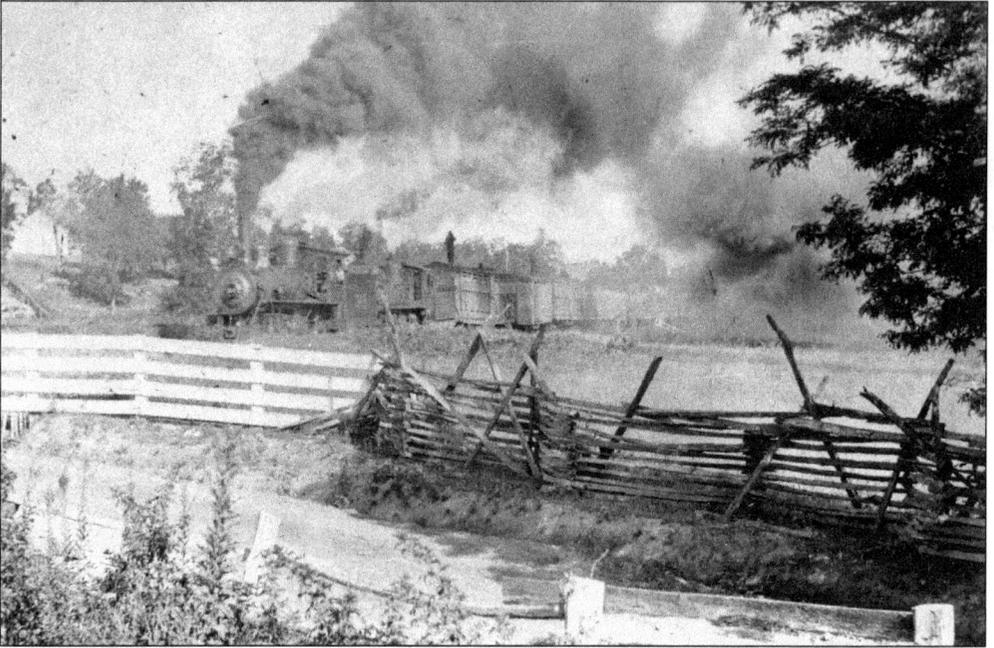

In August 1887, with the arrival of the first train over the Indiana, Alabama, and Texas Railroad, later the Illinois Central Railroad, life in Cerulean Springs was forever changed. Freight cars delivered catalog-ordered merchandise, fresh produce, and food products for the hotel and general stores. Swarms of passengers arrived in coaches intent on "taking the waters" for their health—as well as socializing at the hotel. (Courtesy William Turner.)

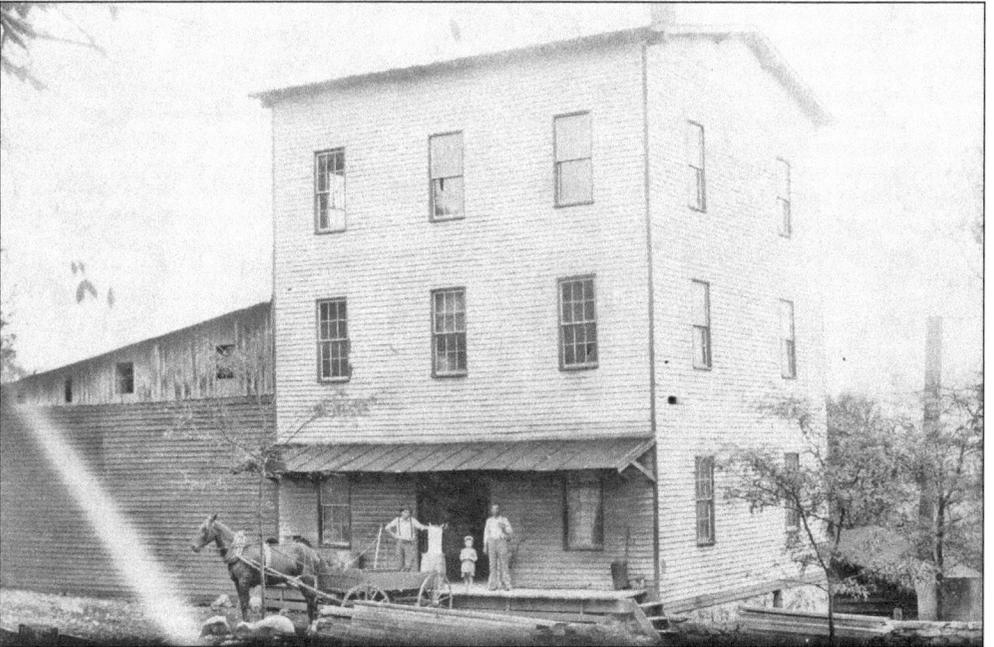

Stice's Mill is featured in this c. 1910 photograph. William Newton Stice relocated to Cerulean Springs from Dawson Springs in 1903, and he constructed the mill that same year. The mill was located near the railroad depot and remained in operation until 1946. (Courtesy William Turner.)

Constructed around 1928 for Smith D. Broadbent Sr., and his wife, Anna, this large bungalow remains in the family and is presently occupied by the couple's great-granddaughter Sarah Broadbent Rogers and her family. (Courtesy David and Barbara Shore.)

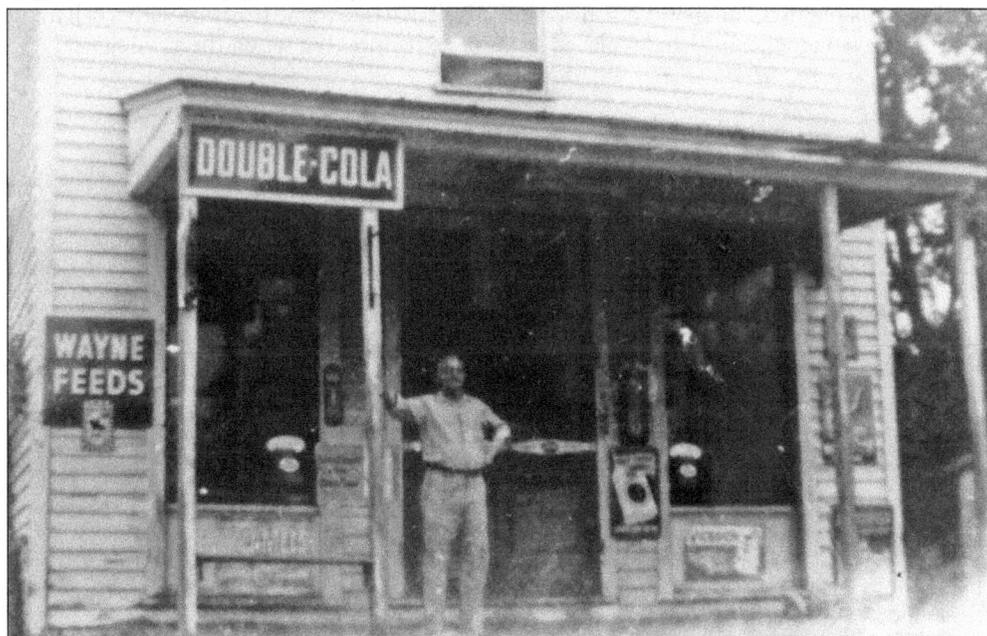

Clarence Murl Sanders Sr. (1893–1959) is pictured standing at the front of Sanders's Store, located at the intersection of present-day Wallonia Road and Rocky Ridge Road. Sanders's Store was established by Louis Fenton Sanders about 1930. The wooden structure featured here was demolished in 1957. Clarence Murl Sanders Jr. opened the new store later the same year as Sanders's IGA. A second IGA store was acquired in the Gateway Shopping Center in East Cadiz in 1968. The Wallonia store remained in the family until 1982. (Courtesy David and Barbara Shore.)

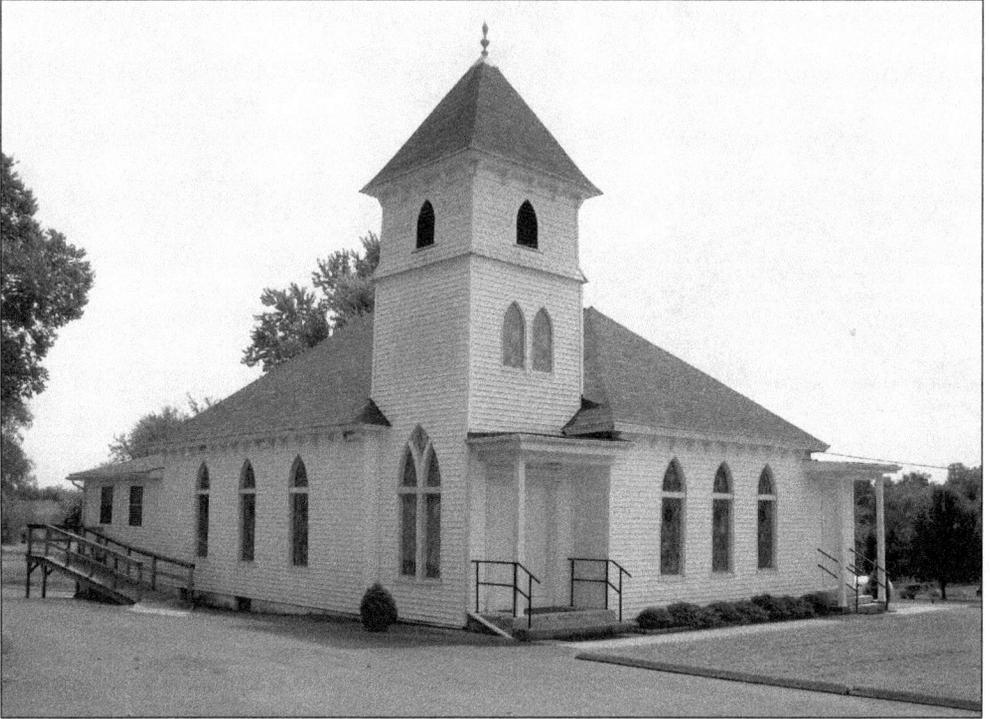

The Wallonia Baptist Church was organized in 1918. This white frame structure with a bell tower was constructed around 1930 and replaced an earlier structure that sat on the same site.

The Wallonia Institute of Learning was the alma mater of many successful men and women in various walks of life. The student body often numbered 100 or more and included students from Trigg and neighboring Caldwell County. Students came from throughout the area and from other states to attend the institute. The third schoolhouse, pictured here, was constructed in 1929. Mayfield's George Bingham and Cadiz's John Jefferson and John King all spoke at its dedication.

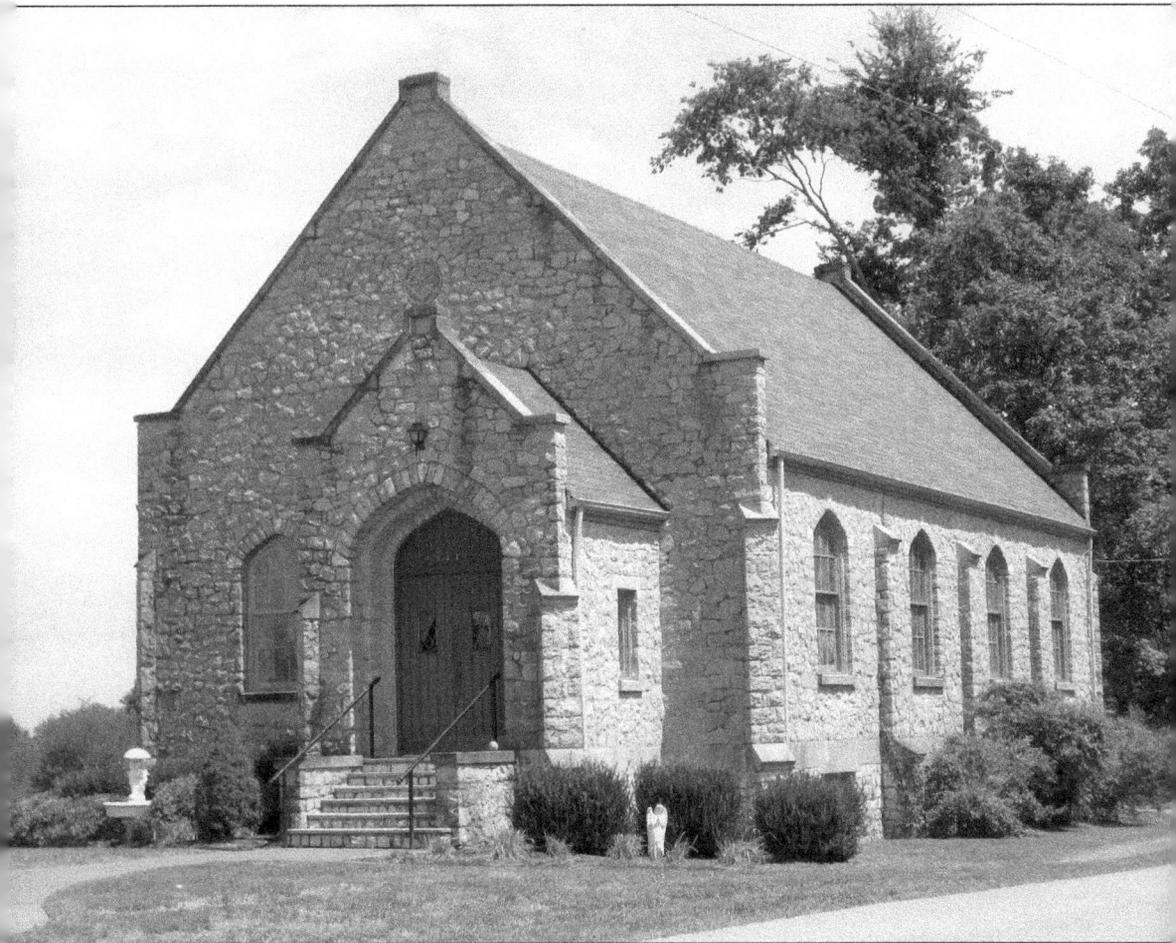

Dating from 1830, when it was organized in an arbor, Mount Zion Methodist Church has occupied four structures in its history. The first was an oak-log building constructed in 1832, the second was a white frame structure with cedar shingles built in 1847, and the third was dedicated in 1891. Most recently, this beautiful stone building was erected in 1943. Services were conducted in the homes of the church's congregants during the Civil War after Union troops occupied the church building.

Visit us at
arcadiapublishing.com

www.ingramcontent.com/pod-product-compliance
Lightning Source LLC
Chambersburg PA
CBHW050703150426

42813CB00055B/2446